The Circle of Light

A World Champion Hoop Dancer's Journey to Embracing
His Native Roots

By

Terry L. Goedel

Contents

About the Author

Terry L Goedel is a nine-time Native American, World Hoop Dance Champion. As a young man living on the Tulalip Reservation in Washington State, he struggled to identify his Native Roots. Watching three hoop dancers for the first time in 1971 he felt a light that changed his perception of who he was. He followed that light and, has been sharing his hoop dancing story on stages around the world for the past fifty-two years. He received his bachelor's degree from Brigham Young University and a master's degree in education from Chapman University. He taught high school and junior high math for thirty years in Southern California. For more information follow him at n8tivehoop.com.

the opportunity for so many years to express my Native heritage, then helping me to edit. Cover photos were taken by Monica Nwaigwe.

Acknowledgements

My wife, Joan who has helped me through all my language arts and grammatical struggles for the past forty-three years. She has patiently helped me to develop my thoughts and ideas.

To my children, Michael, Tara, Heather, and Erin who have listened to me share my stories throughout their lifetimes. Hopefully this will help fill in some of the gaps. These stories they have listened to many times and can recite them word for word with others. Thank you, Erin, for providing me a chance to share my story. There have been many ups and downs and you have helped my find a way through it all. It all started with an idea, and you have helped me to make it become real.

For all the friends that I have made along the way. You were there to lift me up when I needed you most. Many of you I talk about in this book. I appreciate your friendship and companionship along the way. My memories will always include our wonderful adventures together.

Thanks to the first editors who helped me, Kimberly Clement, and Cheryl Knight. I appreciate Kim helping me to organize my thoughts. When she told me how to prepare, I could picture the entire idea in my mind. I knew exactly where the highs and lows would be. Cheryl for providing me

Dedication

This book is dedicated to my mother, Grace Goedel who encouraged me in my youth to find the goodness of my Native Roots.

Chapter 1: A Rough Beginning

Mom sat in her chair, looking at the ceiling of our home, wondering if there was anything that she could do. She wasn't comfortably living back on the Indian Reservation anymore. It was 1955; my dad's new assignment from the Navy was in Adak, Alaska, a small Island along the Aleutian chain in the Bering Sea, where Alaska meets Russia. Mom wasn't used to living in a large city, especially while living in a small apartment in downtown San Diego, California. It was 3700 miles away. She was with three children, all under the age of five years, and she was seven months pregnant. She had grown up on the Tulalip Indian reservation, which was adjacent to a small town called Marysville in the State of Washington. The Navy assigned dad to Alaska but said that neither mom nor the children would be allowed to travel to or live in Adak.

Dad had finished another one of his many naval training sessions, this time in San Diego, California, and was transferred to Alaska as a part of his new assignment. He was now having difficulty working with his new commanding officer. He didn't know how he was going to get out from under his command and get back together with his family again. He knew mom was having a difficult time raising the children alone, and he wanted the family to be together. How he got into this situation was his own doing. After he finished

his training in San Diego, he was ready to move on to new adventures. One of his fellow Navy friends told him he could get transferred to work elsewhere if he requested a new assignment in a place where no other person would have requested. He had made the request and now found himself living in Adak, Alaska, alone.

The problem was that there weren't accommodations for family members in Adak, but dad didn't know that before he had made the request. Mom had her own ideas as to why the Navy wouldn't let her move there. It was a feeling that she had since they decided to get married. She had always felt like the service had a grudge against her because of her Native heritage. She had felt that same feeling from the first day she met one of dad's Naval supervisors. Dad had to figure out something if he was going to see his family anytime soon. One day the ranking commodore came to visit the base in Adak. After making his inspections, he asked all the midshipmen if there were any questions.

Dad raised his hand and asked, "Why is the navy trying to split up my family?"

The commodore surprisingly asked how the service was doing that, and dad said, "My wife thinks I'm up here with my girlfriend, and there's nowhere for my wife and family to live."

When the commodore left, his commanding officer got mad at him for asking questions, making him look bad, and felt he was out of line. He shipped him out to Kodiak, Alaska, the next day. It was a larger island, another transfer, but maybe with a chance to have his family come and live with him. He was willing to take the risk.

With the transfer happening immediately, he arrived late on a Saturday night and didn't get much sleep. He woke up a little late on Sunday and asked the other servicemen in the barracks if there were any churches that were close that he could attend. He thought of himself as a religious person and tried to attend church on a regular basis. Although with various events that had occurred in his life, he began to question his beliefs. He still had the yearning to feel the goodness he found from attending church on a regular basis. One of the sailors said that he was going to church and said,

"If you go to church with me today, I'll go with you next week." Dad agreed.

When he arrived at church, he noticed a few different things about the congregation he grew up attending in Wadena, Minnesota. The name of the church was the Church of Jesus Christ of Latter-Day Saints. The first question he had was why they didn't pass a collection plate at the end of the service. That seemed kind of odd to him because every church he had ever attended always passed the donation

plate at the end. He was told they didn't have a paid ministry. There were only about five families and a few servicemen that attended the small congregation, and they all welcomed him with open arms. After getting to know the members that day, one of the families invited dad over for dinner that evening. In all his days attending churches elsewhere, he had never had anyone invite him over for dinner. He began to wonder what kind of people these were. They seemed to be kind and friendly. He had his own encounters with doubt because of problems he had faced in his past. These people seemed to have a special happiness that he could feel that was reviving spiritual feelings inside of Him again. After dinner, he went to light up a cigarette and asked the family if they had an ashtray to use because he continued to smoke at that point in his life. They told him they didn't have an ashtray because as members of the church, they didn't smoke. They told him that he was welcome to go outside and smoke if he wanted to. He went out, lit up a cigarette, and thought to himself how good these people were and enjoyed visiting with them for the afternoon and evening.

In their conversation, they asked him about his family. He explained that the Navy couldn't bring them up to Alaska unless he had a home for them to live in because there was no family housing on the base. They suggested that he try using the Homestead Act, as Alaska was a territory and would be a territory until January 3, 1959. Homesteading

4

was an act of the United States under President Lincoln which was signed in 1862. President McKinley signed another act in 1898 extending the act in the Territory of Alaska. It was a way for people to obtain federal land, free with a few requirements. First, they needed to be living on the land. That would require dad to build a home and cultivate the land. He would also need to be at least 21, and he was 27 years old. His friends from church told him that if he applied for the homestead land and got it, they'd help him build a house. He applied and was granted homesteading land and began building a home with the help of his friends almost immediately. The home would only be 12 feet wide by 16 feet long. It was around June, which gave him extra daylight for building after work and warm weather as well. As he began working, he experienced the wonders of living in Alaska. It was quiet and peaceful, much different than living in San Diego. Fresh air, clean water, fewer people with plants and animals all around. There was plenty of fishing and hunting, which he thought was awesome. Having grown up on a farm in Minnesota, he enjoyed hunting rabbits and now enjoyed it in Alaska as well. After a few weeks, the basic house was finished, and he dug a well for water, which was also a requirement. After it was inspected by a representative from the Navy, he was given the go-ahead to send for his family.

Mom was excited by the thought of being with dad again, but the idea of moving with the kids was a little daunting. Mom and dad had three kids, and she had to prepare everything they needed to travel to Alaska with them alone. Most of the time, mom was taking care of the kids, bills, home, and everything else by herself. The Navy used its resources and shipped mom, Jerry, Cherie, and Gloria to Alaska on one of their Navy ships. Jerry was five years old, Cherie about three and a half, and Gloria was about fourteen months old. It was a long trip for mom with three children on a ship for several days. Trying to contain three little children on a huge, spacious metal ship can be a difficult task. Especially curious children that wanted to wander here and there but were confined to a small cabin. There were no televisions or telephones back then to keep their attention, but she did her best to keep them occupied throughout the trip. There was no need for her to cook; the mess hall took care of their three-square meals for the next few days. It was much easier trying to keep bunkbeds in a small cabin clean as well. She wasn't used to the rocking of the boat from side to side but was grateful they hadn't encountered stormy weather on the trip.

In the meantime, dad continued working on the base and kept going to the same church with his new friends. They had helped him obtain land and build a new home, and he was so excited to have a place for his wife and family to live.

When mom arrived with the children, she was happy to have a place to call home to be together as a family, even though it was small. She had grown up in a small home on the reservation, and she was used to living off the land there. Growing up, she learned to work together with her native community. Feeling like she was a part of nature again helped her to feel a bit at home. When dad took her to the church he had been attending, she was impressed with the congregation and their welcoming arms. Since she had left the reservation after marrying dad, she had never felt at home. The world, in general, was much different than what she had learned growing up. In most of the places she had lived around the country, she was the only native. She was still the only native but had found a place where she felt welcomed. They continued to attend church and made some wonderful lifelong friends. Mom had made the journey with three children, and it was time for her to deliver her fourth child. That's when I came along in the summer of 1955.

Having his family again made him feel complete. Dad enjoyed learning about pipe fitting and progressed in the field rapidly. He was mastering his new pipe fitting skills quickly, and he began looking for something more challenging to do. He felt like there were so many places around the country that would challenge him, and he wanted to visit them. Mom was looking after four children, all under the age of five, and one was a newborn. It was indeed a small

little apartment, but she felt like she was a part of nature once again.

Before dad was transferred to Alaska, he had been assigned to go back out to sea. Prior to his two-month-long journey, he had bought some hair clippers. He was always looking for new skills and challenges. He figured if he bought the clippers, he could learn to use them while at sea. Dad talked a sailor on the ship into allowing him to cut his hair. The sailor agreed that dad could practice on him if he'd continue to cut his hair while the ship was at sea. In turn, dad would agree to cut his hair if he told everyone where he was getting his haircut. He built his own little barber business on the ship and began giving all the sailors haircuts while they were at sea. By the time he returned to their home base, he had saved enough money to buy a new 55 Chevy. He had bought it in San Diego and had it shipped to Kodiak, Alaska. Mom was trying to figure out why he had a new car and was living in Alaska, but she couldn't live there. Now that dad was a barber, he would cut our hair too, and it was usually short. Pretty much always a buzz haircut for both myself and my brother.

We had a house, and dad was working on the base. He had the opportunity to be at home with all of us. With four children, mom needed all the help she could get. I was still an infant, but dad was there to help as I grew for the next couple of years. Although I was healthy and strong, I

continued to be afraid to walk on my own. They say that I would walk around holding on to all the furniture but would never take a step toward anybody without having something to hold on to.

About that time, they had bought the three older children metal skates that they could attach to the bottom of their shoes. It was cold in Alaska most of the year, and they would often bundle us up to go out and play, even in the spring; They had three pairs of skates. One pair for Jerry, one set for Cherie, and one for Gloria. Gloria was afraid to try and skate. You know how it is when you try skating for the first time. She had fallen a few too many times and decided that skating was not for her. One day mom and dad decided they would put the skates on me and see what would happen. They bundled us up, took us outside, put the skates on me, and away I skated. I was dressed in a little one-piece zip up red jump suit and wore an inverted white sailor's hat. I'm not sure why, but I just began skating. I could roller skate before I could walk. After that, they could barely take the skates off of me, and I didn't have a problem walking independently.

Dad was working on the base, enjoying his new home and the outdoors, and continued to cut hair for servicemen on the base. After a couple of years of serving in Alaska, he requested a transfer to the east coast because he said he wanted to visit more of the United States. He always loved a new, bigger, better adventure. This time, he was transferred

to Yorktown, Virginia. They had the 55 Chevy shipped to Seattle. We were all shipped down to Seattle, and then we drove the car to Virginia from there. On the trip, we stayed one night at a motel. We went to the grocery store to get a few things. While we were gone, two young missionaries from The Church of Jesus Christ of Latter Day Saints came and left a few pamphlets about the church on the door of our room. When the family returned, they asked the owner of the motel if he had seen who had left the information. The owner said that two young men came and left the pamphlets on our door and then left. He thought it was somebody that mom and dad knew. They didn't leave any information for any of the other tenets. We were traveling and didn't know anyone in the area. They always wondered who it was that left the information about the church they began attending in Alaska. When we arrived in Virginia, we found the local Ward (congregation) we had been attending in Alaska. Mom and dad decided to become members and were baptized into the church in February of 1956. Dad had been a smoker since he snuck out and began smoking back on his farm as a young man. He and mom both smoked up to that point and decided to stop with their decision to get baptized. Dad was close to being a chain smoker, and mom only smoked occasionally, but both decided to stop cold turkey.

After serving in Virginia for a short time, dad decided he would need more skills if he wanted to provide a better life

for his growing family and earn the rank of Chief Petty Officer. He applied to go to a welding school and was one of the one hundred or so Navy servicemen that applied. He was accepted and would need to move our family back to San Diego, California. Going back to California would be an easy transition for him and the family because they had already lived there once. It would require them to travel across the country again and through Wadena, Minnesota, where he would get the chance to meet his seventh and youngest sister for the first time. The sisters were; Helen, Verlie, Carol, Olga, Anita, Naomi, and Marian. He was the oldest of eight children and the only boy. That was part of the reason he left home at the age of 16 years old. He was the only boy on the farm and had to bear the brunt of the work. He had become tired of doing everything and thought he could do better on his own. One day he and his father, Carl Goedel got into a fight about him having to do everything. When it was over, dad let his father know that he would be moving out. The two of them talked things out and agreed that dad would leave. Carl gave dad ten dollars that he had saved and thought he would need. At the age of 16, dad moved out and would try to make a living on his own.

I was a young toddler now, older and a little more independent, but I think mom and dad still worried about me. From the time I was born, I often had difficulty swallowing. The doctors told Mom and Dad that it was because I had

11

extra-large tonsils. It was 1957 now, and we were traveling from Virginia to San Diego, California. We were in the middle of North Dakota when it happened. There were six of us traveling in the 55 Chevy. Dad was driving; Mom was feeding me a banana. I was only two years old. The other three children were sitting in the back seat. I began to choke and could not swallow or spit the food out of my mouth. It got stuck in my throat, and I wasn't able to breathe. Mom instinctively reached into my mouth, tried to remove the food, and then began patting me on the back to dislodge the food. Mom excitedly began telling dad that there was a problem with me. We were in the middle of nowhere. Dad pulled the car over to the side of the road. Mom and Dad quickly went into panic mode. There were no hospitals in sight, and even if there were, they were not available to Mom as a Native American. Mom was used to having people suggest she go to other hospitals because of her Native ancestry. She had always been treated as though she was a second-class member of society. What hospital would we go to if we found one? With nowhere to go and no one to ask, we were alone on a highway in the middle of the plains. Again, Mom patted my back. Then she reached into my mouth again to try and dislodge the food, but nothing was working. How could my mother be losing another child?

After they were first married, Dad was released from the Navy. The war was over, and there was no need for his

military service any longer. They returned to Wadena, Minnesota, where Mom got pregnant, and she and Dad lost their first child at birth. It had been a struggle for both of them. Eight years had passed, and the thought of losing another child welled up inside of her. Each passing day was less difficult, and now each anxious moment renewed thoughts of despair. It had turned Dad away from religion. He attended church religiously until the death of His first child. With that death, he had since lost a belief in God and a lesser need for religion in His life. When he spoke with the minister, dad was told there was not hope, the child had not been baptized before her death. He had found a newfound faith in God while living in Alaska but wasn't sure at the moment. Dad saw the difficult situation and pulled over the black 1955 Chevy that he loved. Mom and Dad watched as I began to turn blue; then I became lifeless in my Mom's arms.

" No, she cried, not again!"

She had lost her first child the day she was born. Her name was Toneena Lee. My Mother's plea went up to the Lord, "Please,"

"Please don't let him die. Is it the color of my skin? Is it my Native American heritage? Do I belong? Does he belong? I will raise him and dedicate him to your service, was her plea."

The other three kids sat quietly with tears in their eyes, wondering what was happening. They knew that something was wrong but were not sure exactly. They could tell by the sound of Mom and Dad's voices. They sat silently, not knowing what to do or what to think. Together my mother, father, brother, and two sisters solemnly bowed their heads and offered a prayer to Heaven. With their newfound faith, they prayed for a miracle. If only it had been a little different, a different road, a different day, a different food, "Why?" was their question. They pleaded with the Lord to bring me back to life. After the prayer, there was one last effort to revive me. Dad laid his hands on my head and gave me a blessing; he had been given the Aaronic Priesthood in Virginia and proceeded to give me a blessing. Then the miracle happened, one last pat on the back, I coughed lightly, then another pat, I coughed again stronger, and the banana was dislodged. I began breathing again. The color on my face returned as Mom held me close, offering a quiet, barely audible prayer of thanksgiving. I'm sure it was their faith that brought me back to life, but I don't think it was my time to leave this existence. The Lord tells us that our days are numbered, and mine weren't over yet. I guess the Lord had a different plan for me. My mother held me close in her arms until we found a motel along the way and slept for the night.

The next day we got a late start. It had been a long day and a difficult evening for Mom and Dad. We were traveling

through Montana. It was late, dad was tired and asked Mom to drive. After Mom began driving, Dad fell asleep in the passenger seat. The weather turned bad, and the roads became icy. Mom drove down a steep hill and hit a patch of ice. The car went careening off the side of the road into a ditch. Dad was now awake from the rough motion of the car and still trying to figure out what was going on. The car would become totaled in the accident. The contents of the car were strewn everywhere. Clothes, suitcases, and all our worldly possessions were strewn around the wrecked car. It was cold and dark. Dad and my sister were bleeding. Gloria had a cut, and Dad was bleeding from a cut on his ear. In the dark, they continued searching to find each family member. They found Jerry, Cherie, and Gloria, but they couldn't find me anywhere. They moved the suitcases and the wreckage and continued to try to locate me in the dark of the night. They kept looking everywhere for me in the cold snowing conditions but couldn't find me. Finally, a shout,

"I found him! I found him," someone yelled.

They found me bundled up in a small blanket, sound asleep as though nothing had happened. Dad and Gloria were taken to the hospital and had to receive stitches. Two mishaps back-to-back. Was the Lord blessing us or cursing us? We didn't know. Thankfully when they reported the wreck to the insurance company the next day, the insurance company paid off Mom and Dad for their 55 Chevy. That

day they went out and bought a VW Bus. It would be much more comfortable for a family of six, especially with all the traveling we were doing. It would be the vehicle that we would travel in for the next few years. We now had a little more space to move about, rest, and be together.

As children, we were close and did almost everything together all the time, including taking a bath. Usually, on a regular basis, they would put us all in the tub together. The four oldest children only had a five-year difference in age, and the oldest was seven or eight. Then one at a time, they would wash us, dry us and get us ready for bed. The order was always different as to who would get out first, second, third, or fourth. One day Mom left Jerry and me in the tub together to finish playing. There was a Coke bottle next to the tub, and I grabbed it to fill it with water. Jerry took it from me trying to protect me because it was made of glass, and I began to cry. He quickly gave it back to me to appease me. I took the coke bottle and hit him over the head with it. He held his head in pain and then took the bottle away from me and I began to cry. That's about the time when Mom showed up and saw what had happened. She told him that's why he should be nice to me, so I would be nice to him.

Chapter 2: Meeting The Chief

We continued our travels to San Diego with a stop in Washington to visit and meet Mom's family. When we walked into a relative's house, we passed a picture of Jesus on the wall. Upon seeing the picture, I told them that he was my friend and that I had seen him yesterday. Everyone was a bit surprised and laughed; Mom and Dad didn't try to explain to them what had happened to me earlier.

Dad was born in 1926 and Mom in 1928. Most of their young lives up to this point were spent living during the Great Depression. The Depression included the years from 1929-1939, with the worst years being 1932 and 1933 when they were very young. They both had to learn to live without many things and do with what they had. Many people across the country struggled to find work, eat, and live during that time period. Dad learned to live off a farm, and Mom learned to live off the Land on the Tulalip Reservation. After the depression came World War II which created a world of havoc of its own. Jobs were hard to come by, so when Dad joined the Navy, he saw it as an opportunity to learn a skill. Dad joined the Navy and was sure that it would be for the rest of his life.

After Dad had been in the Navy for a couple of years, he was stationed at Bremerton, Washington. It was while he was there he saw my Mom, Grace, for the first time. He

wondered if the two of them had met, and he asked her if they had. Mom thought he was just giving her a line. So she said she would go out with him if she could bring her friend. During their outing, something happened, and Dad got separated from the others. Mom and her friend hopped on a bus, and Dad thought she was trying to slip away from him. He figured out where they had gone, so he went to the place where he thought they were, and they all met up again. After talking, they figured out there had been a miscommunication between them, and then they just laughed about what had happened.

When they first met, World War II was still raging, and Dad participated in the Battle of Saipan and the Battle of the Philippines. Dad's job on the ship as a pipe fitter and welder was to make sure it would run and stay afloat. If there was anything that would cause the boat to sink, it was dads job to fix. Mom and Dad had three chaperoned dates together before Dad was sent back out to sea until the end of World War II. They began writing to each other during that time and wound up writing consistently to one another. By the time the war was over, he had been promoted to 3rd class petty officer. He was one of the individuals that had to observe the testing of the atomic bomb at Bikini Atoll. He used his welding mask to watch the event, being only eight miles away from the blast. There were other servicemen that were sent to check the site out, but Dad wasn't sent because

he was with the company's repair division. He always had to stay with the ship in case of problems. His main assignment was to keep the ship afloat.

After the war was over, Dad was stationed in San Diego, California. He had saved enough money to send to Mom. He told her to take a flight to California, and they would get married. He waited for several days, and she still hadn't arrived. Dad thought that she had taken the money and would never see her again. Then Dad received a telegram from her that said she would be arriving on a bus. It had taken her so long because she had to stop at every station between Marysville, Washington, and San Diego, California. When he went to pick her up at the bus station, he found out there were two bus stations in San Diego. So he kept going back and forth between the two bus stations hoping that he hadn't missed her somehow. He became worried that maybe she had arrived, and he didn't recognize her. They did only go on three dates up to this point. Prior to Mom's arrival, Dad went to his superior officer and asked permission for a short leave to get married. Dad was only 20, and Mom was only 17 years old, but since they were in California, the laws at the time dictated that he would need his officer's permission. The officer agreed to give permission after dad brought his fiancée to meet him. When the officer saw that Mom was Native, he refused to give him permission. Interracial marriage would not be legal in the

United States until 1967; it was October 1946. Dad was a full-blooded German, and Mom was a full-blooded Native American, an Indian. Society frowned upon interracial marriage at this particular time.

Not knowing what to do at this point, they checked the laws for Arizona and found if they made some adjustments, they could get married there. So Dad decided that he would make a fake ID card saying that he was 21 years old. Without Dad's knowledge, Mom also made a fake ID card saying that she was 18. It was October, and Mom's 18th birthday wouldn't actually happen until November. They called for a taxi with the idea that they would travel to Yuma, Arizona, which was 170 miles away. It was the closest place they could find to get married. When he found out how much it would cost to drive to Arizona, they told the taxi driver that they didn't have enough money. The taxi driver told them that he would be getting off in about 20 minutes and he would drive them to Arizona round trip for $75 dollars. They were married in Yuma, Arizona on October 15, 1946. Dad barely made it back to the ship before he would have been considered absent without official leave or AWOL. When he told the Captain that he had gotten married and requested time off, it was not provided to him. The captain said he couldn't have time off because he hadn't received his permission to get married. There were many of the sailors that told Dad that interracial marriages didn't work. They

also told him that Natives were drunks, and he shouldn't have married her.

With the family needing to travel through Washington, Mom thought it would be a good time for Dad to meet her father, Wilbur Mininnick, in Yakima, Washington. Wilbur and her Mom, Agnes, had given Mom up to her grandparents at birth, but Wilbur was Mom's real paternal father. Her Mom, Agnes had remarried and died after giving birth to her fourth child, but she had the opportunity to visit with her father. It was an introduction for Dad in many ways.

They were on the Yakama Indian reservation visiting Wilbur. It was another reservation that Mom was familiar with. Her Mom and Dad had both remarried, and she had half brothers and sisters on the Yakama and Tulalip Reservations. I'm sure Mom and her dad, Wilbur, were making a new connection at this point. Mom was familiar with Yakima, Toppenish, Wapato, and the surrounding area. They visited the places she was familiar with and the family and friends that were living there. While there, Wilbur took Mom and Dad to a Native American ceremony on the reservation. Dad was excited to understand Mom and the way she grew up. He enjoyed learning about different cultures and meeting people from different walks of life. He had always had an interest in American Indians since he was a little boy. Growing up in Wadena, Minnesota dad's mascot was the "Mighty, Mighty, Indian". The mascot had been

named after Chief Wadena, an Ojibwe Indian Chief in the late 19th century in the northwest area of Minnesota. Dad enjoyed and had an interest in photography back then, too. Photography was new and kind of a mechanical hobby for him. He had several different cameras over the years and took pictures of us as our family grew. The night Wilbur took them to the Native American Ceremony, Dad had carried his camera with him. When the opportunity presented itself, he snapped a picture. The bright light bulb went off, and it lit up the entire hall. Everyone in the entire lodge immediately stopped what they were doing, and it became very quiet. Wilbur was one of the chiefs of the tribe at the time and stood up to speak.

While looking out into space, he said,

"There will be no pictures taken during this ceremony."

Then he sat down and didn't say anything else.

After his words, the ceremony continued, but Dad had learned an important lesson about taking pictures during Native ceremonies. There are some events where pictures are allowed if you ask and are given permission. There are other events where pictures are not allowed. He said he never made that mistake again. Later when he went to visit his father-in-law's house, where they were staying, Dad noticed that there was a pile of things being placed in one of the rooms. He asked Mom what was going on. She told him that

they were gathering things for him. Every time he mentioned that he liked something, they would put it in a pile. She asked him to stop telling them that he liked things. That was another important lesson Dad had to learn about Native customs.

After a few days of visiting with family in Yakima, we drove to the Tulalip Reservation on the west coast to have Dad meet Grace's grandfather. Her grandmother Agnes had passed away while they were living on the farm in Minnesota. Mom always said that her grandmother was so nice to her while bringing her up. At the time of her grandmother's passing, they were too poor to travel across the country to attend the funeral. Her mother, Agnes Sese, was from the Tulalip Indian Reservation, and her father, Wilbur Meninick was from the Yakama Indian Reservation. Agnes and Wilbur were married in September 1927. They divorced right after Mom's birth, and Agnes moved in with her grandmother. Her grandmother, Katie, was a midwife and delivered Grace in November of 1928 on the Tulalip Indian Reservation. Her grandmother had a dog they called Tullum Tum Tump and said that while her mother was in labor, the dog whined, moped, and was very upset. When she was born, her grandmother held her up for everyone to see, and the puppy was so happy. He was jumping up and down and yipping away as though they were long-lost friends. The

dog always laid with Grace and protected her until the day the dog died.

When Grace was born, her mother Agnes gave her up to her grandmother Katie and her step-grandfather, who lived on the Tulalip Reservation. Katie didn't have any formal education and brought Mom up the best way she knew how. Her paternal grandfather was killed on the railroad tracks by a drunk, so Mom was raised by Agnes and her step-grandfather, Ambrose Bagley. She always thought of Agnes and Ambrose as her real father and mother. She said they had such a happy disposition and were always laughing about life. Mom shared that same happy disposition with all of us children. She always taught us to find the good in life and not to worry about the results; it would all take care of itself. Her real mother and father both remarried, and so Grace grew up with step-siblings on both sides of the family.

Dad had grown up as a Lutheran, and Mom had learned about the Catholic religion by attending catechism. She was also familiar with the Indian Shaker religion that her father was a part of. When World War II was over, Dad, like many other servicemen, returned home. He and Mom would begin their new lives there. They began to attend the Lutheran church in Minnesota, and that's where Mom joined the Lutheran religion. They lived with his mom and dad for a while, then built something like a basement house or earth home. Eventually, they bought a refrigeration box train car

to build as a home. It cost about $50 for the boxcar and $50 to have it towed to his family's farm. They farmed for a couple of years and were actually doing pretty well, then came a bad year of crops, and they didn't know what they were going to do.

At that point, there were still no children, so Grace went to the doctor. The doctor notified her that she had an infection that was preventing her from getting pregnant. She took the medication the doctor prescribed, and she got pregnant soon after with their first child. Their first child was born on the 4th of April, 1949. The name of their baby daughter was Toneena Lee Goedel. The baby lived for only a day and then passed away. It was difficult for both of them, especially for Mom because she was living far from her home in Tulalip. She was returning for the first time in several years. She was now married and had four children.

Chapter 3: The Break

Dad was only in San Diego for six months to attend welding school. After he completed his course, we were shipped off to Newport, Rhode Island. It was another trip across the country. This would be in a nice bigger Volkswagen bus. It was an automobile that was made for our family. It had seats in the back that were big enough for any of us to take a nap on one of the back seats and there was enough room for our luggage too. It was like a step up from the camping that we had been doing up to this point.

In Providence, Rhode Island, we lived in military housing. Military housing is different from a regular neighborhood. Everyone that lives in the neighborhood is usually from anywhere around the country. We got used to meeting people from different places. It's like everyone in the service is displaced from their real home, and they make the place where they are living, their home. Everybody has the same task, to go out and meet new people. Once you make a friend, it's possible they may be gone the next day. You become kind of guarded, not knowing how long you'll know them. On any day, your best friend could move out, or a new family could move in next door. There were warm and cold days, but the cold days seemed to stand out more. We had plenty of days where it snowed, and the snow plows pushed the snow into large mounds everywhere, especially

along the streets. We used to ride down the steep snow banks and had fun playing in the snow for a little while. Once, the snow was so deep, I climbed up to the top of one of the new large snow piles. Then I sank deep into it. My siblings ran in and had to have Dad come and pull me out. It was always a joy going back into the house to warm up. We had radiators in our home. We would warm our hands with them; then we would place our wet coats and gloves on them. Anytime we came in from the cold, we would go warm up by the radiators. Occasionally we would go downstairs and look at the boiler in the basement of our home. Dad usually didn't want us playing around it and said we could get injured. He enjoyed working on our boiler because that was the kind of work he did in the Navy. They had radiators and wooden floors in the schools also. The wood floors were squeaky when we'd walk on them.

In the spring, summer, and fall, we played around the yard and on swing sets in the area. On the base, they often have local playgrounds for the children to play on. Mom and I would walk the older kids to the bus stop in the mornings, and I would carry a small lunch pail, pretending like I was in school. I was like many other kids would pretend that I could write cursive and just make a bunch of swirling lines and then try to make T's and I's. Mom tried to dress us in the most fashionable clothes she could find for us. We wore jeans, nice shirts and converse tennis shoes to school. We

looked nice but still usually felt out of place wherever we went. It's hard to live in a place for a year or two and then move to a new place somewhere around the country. We dressed like the other kids, but we still looked different. We always found a way to fit in, but we always felt much more comfortable with one another. One day a salesman came by and sold Mom and Dad a package of family pictures. He was like a door-to-door salesman. He would come and take family pictures in our home. A date was set, and the photographer came by to take pictures for us. Dad put on his Navy suit, and Mom put on a nice dress. Mom always dressed nice, in fashion. She had all of us children dressed nicely for the pictures as well. That is one of the good things that came from living there was the photos we took. We had many family photos taken with the four oldest siblings.

One summer day, me and all of my siblings were outside playing. The sun was beating down; it was hot, and Mom thought it would be nice to have all of us play in the sprinklers to cool off. She pulled the hose out to the front of the house, hooked up a spinning sprinkler, and then turned on the water. They were sprinklers that rotated around and sprayed water in a circle. The water was cold, which was exhilarating, but it was tough for us to run through with our eyes open. We would hold our heads up as high as we could or down and try to block the water with our hands and run through as fast as we could. We had a fun time. There were

other kids from the neighborhood that soon joined in on the fun. Our splashing and laughter could be heard throughout the neighborhood. We would take turns running through the middle or around the edge of the sprinkler. We lined up to run through one at a time. Each child would take a turn running through the sprinklers. Many times, we would just close our eyes as we ran through. At the head of the line was my older sister Cherie's turn to go through next. She stood waiting patiently for me to get all the way through the spraying water. I had run through the sprinklers, but then I decided to turn around and go back through the way that I had started. It wasn't a good idea for me to go back the opposite way. As Cherie ran through towards me, I was running towards her. She and I met somewhere in the middle. My head was down, and so was her's; we collided head-on. Because I was shorter than she was, It was my head colliding with her nose. My head collided with her nose, and we both went down dazed, lying in the sprinkling water. There was blood running down Cherie's face, and Mom knew it wasn't good. She quickly picked Cherie up out from the sprinkling water and could see that something was terribly wrong. Cherie's nose was bleeding profusely, and I was lying in the sprinkling water, holding my head and crying. Mom gathered us together, had somebody turn off the water, quickly packed us in the car, and rushed us all to the hospital. Cherie was crying, holding her nose, and there

was blood everywhere on the towel around her nose. I'm not sure if that's why I was always afraid of going to the doctor or not. My other siblings and I sat in the back seat quietly. I felt so bad for her and cried that she had been hurt. Even though my head was hurt, I didn't say anything. We just sat there in our wet bathing suits covered with towels as we went to the hospital. When Dad arrived, and Mom asked him for help, he couldn't even go in and see what had happened to Cherie. He always had a weak stomach for injuries and that kind of stuff. He stayed with the other two siblings and me. I had broken her nose, and the doctors would need to set it. Although I didn't go in and see the doctor, I never enjoyed seeing one. It usually meant to me that it was a bad thing.

I think it was difficult for me to go to the doctor after that, especially if I was told that I was going to get a shot. One day, Mom took us all to the doctor before the new school year was to begin. It was time for me to get a shot. I knew it because I had heard Mom telling Dad that I needed to get a shot. Mom took me into the waiting room to wait for my doctor's appointment. Then the nurse greeted us and escorted us to the next available waiting room. I sat there as quietly as I could and waited for just the right moment; then, when the doctor came in through the door with the needle for my shot, I dashed out past him. I knew that needles and I didn't get along, and I raced off. The doctors, nurses, and Mom had to chase me as I ran down the hall and completely

out of the hospital. I didn't know where I was going; I just didn't want to be in there. I never did like hospitals and doctors. I guess I just wasn't a very good patient. After they caught me, they took me back to the doctor's office. That's where I received the shot I had tried to avoid. When we returned home, I wasn't feeling well. I usually would get sick anytime I received a shot. Mom gave us all popsicles. Since I was feeling sick, I chose first the yellow banana-flavored popsicle, my favorite.

It was 1960, and it had been five years since I was born. We were in Rhode Island when my younger brother, Oscar, was born. I was so excited to have him come home from the hospital. He was five years younger than me, and Jerry, my older brother, was five years older than me. When they brought him home, I was kind of embarrassed and frightened. Mom and Dad asked me if I wanted to hold him. I replied, "My hands are dirty."

It was probably the only time in my youth that I had known that my hands were dirty. I was just afraid to hold him. I don't know why. When they sat me down and placed him in my lap, it was such a good feeling to hold him in my little arms. After a few moments, I hopped up and went along my merry way. I think I just needed some attention. I was now a middle child and wouldn't get as much attention. I usually didn't complain about things and just adjusted to what life offered me. When we went shopping, I was often

the last one to get anything. On a number of occasions, I recall Mom and Dad saying, "We didn't get you anything?" I would just tell them it was o.k. because I didn't need anything. I think I felt that way most of the time while I was growing up.

I had lots of energy and was always up and about. I didn't realize that it was a part of being ADD. We had good times and some bad times. I vaguely remember celebrating any of my birthdays when I was young, but I do have pictures that let me know we did celebrate birthdays with parties. It was at one of my birthday parties that I ran out the door so quickly that I broke the screen door. I was running out of the house when somebody running in front of me closed the screen door real fast. I wound up running right through the screen. I don't think Mom and Dad were really happy about it, but it had to be pretty funny. I think I fell down and got hurt, so they didn't really punish me.

Chapter 4: The Swamps

Dad got transferred again, and we moved from Rhode Island to Florida. We camped along the way as usual. Occasionally we would stop at a KOA camp place. As we traveled, we learned to play games in the car. We'd try to identify the letters of the alphabet on license plates from different places. I personally began identifying the numbers on license plates. I would add and subtract the numbers from one another and try to see how high I could add the numbers. I would begin with the number one and go as high as the numbers would add up to. I would use the numbers two and three and subtract them to get the number one. Then the numbers two and three were already there, and I'd try to make the number four. I would use any of the numbers on the license plate to find all the additional numbers available. It was a game I continued to play in my mind almost every time we were traveling in the car. As we traveled, there would be pools, ponds, lakes, playgrounds, and activities. There would sometimes be bathrooms and showers or bathhouses that we could use. It was where we would often take showers between places that we were traveling to. Oftentimes, we'd camp in a tent, but we'd occasionally use the VW bus to sleep in as well. On this particular trip, we stopped at a campsite. My younger brother, Oscar, had his hair shaved into a Mohawk design. They had tried to get me to have the same haircut, but I told them I didn't want my

hair cut that way. It was too embarrassing for me to have that kind of haircut, and I didn't want to look like an Indian. Oscar was the youngest at the time, and whenever they needed to find him, they could easily see him. I think it was usually easy to spot any of us; we were the kids that were usually darker than anyone else, especially in the summertime.

We moved to Jacksonville, Florida, and that's where our youngest sister, Lorna, was born. She was eight years younger than me. There were now six kids in the family. There were times when Mom would come home from grocery shopping, and we would consume an entire loaf of bread by making sandwiches in one sitting. You had to eat quickly, or you got left out. Even though I was probably a pretty picky eater, Mom knew the things that we all enjoyed eating and made sure that each of us would get enough to eat. Dad would make me and my sister eat squash and a few other things that we didn't enjoy until we felt sick.

He said, "You can't leave the table until you finish your squash."

He grew up loving all vegetables and wanted the same thing for us. We'd sit there for what seemed like hours, but it was probably only ten minutes trying to finish. Finally, after sitting with the vegetables in front of us for a while, he would excuse us from the table.

I loved carrots, string beans, and especially butter. Jerry, Cherie, and Gloria would often give me butter to eat by a spoonful. It would make them sick, and I would just eat it like candy. I still use lots of butter on things. Mom and Dad loved all the food from the South, okra, field peas, collards, and grits. Mom learned to make chicken and pastry, chicken and dumplings, along with other southern dishes. She had learned to cook many different kinds of foods on the Reservation and was always willing to try cooking a new dish from any of the places we lived. We loved eating Mom's fried chicken and would all fight to be able to eat the gizzards. She would cook fish anytime we could have it. She grew up near the water and loved fish, berries, salmon, and dehydrated clams. It was a savory dish that her grandmother would cook. She didn't know how she made it but she loved eating it as a little girl. Dad would often take us fishing on the jetties close to where the base was. The jetties were barriers that were constructed to protect the harbor in the area. They were made of large rocks that we had to climb on. He loved fishing and eating fish as well. I don't think I've ever enjoyed eating fish. I got a fishbone stuck in my throat when I was little. I hate the thought of getting a bone stuck in my throat again, although the taste isn't really appealing to me anyway.

When dad would take us shrimping, we would wade little ways into the water. Jerry and Dad would have a net that they

would throw into the water to catch the shrimp. The net was circular and was about fifteen feet across. There were weights all around the perimeter of the net. The net would be thrown out in a circular motion covering a large area of the water. It would cause the shrimp to swim into the middle of the circle. When the net was retrieved with a long rope, the shrimp would be caught in the middle. We could tell if there were any shrimp in the water because when we would get in, the shrimp would kind of pinch at our legs. We were so afraid of them. We would rush out of the water as fast as we could and stand up on the large rocks and watch. Mom and Dad would cook the fish and shrimp, and I loved eating shrimp.

Dad was usually gone during the day. Mom would cook, clean the house, and manage the six children. She tried to make us responsible for helping her clean the house. One time, one of us children left an apple core on the furniture. Mom got so mad at us after cleaning the house all day that we all got a whipping. She had a difficult time trying to raise all six kids. There was one time when mom sat in the closet crying till dad came home. Mom tried to instill in us the importance of having pride in what we owned. Our reward or maybe her reward would sometimes be to go and eat a meal on the ship that Dad was serving on. Occasionally he would take us all to the base where he worked, and we would board one of the huge battleships for dinner. Oftentimes the

ships were tied to one another, and we would have to travel from ship to ship. I would help my older sister, Gloria walk across the metal planks between them. It was so fun to me, but it was scary to her. I would hold her hand and help her as much as she needed me to. When we arrived at the last gangway, I would run and jump on the metal walkways. They would wine and dine us with what we thought was the greatest meal. I'm sure it was great for Mom as well. She wouldn't have to cook or clean. We'd get to play cards and other games while we were there too. Dad was a big cribbage player. It's a sailor's math game and a game that he played most of his life. It's game that he taught me, and I've taught my son as well. We learned to play other games as well including Chinese checkers, checkers, rummy, monopoly, and many of the board games of the time. He would sometimes play his accordion or harmonica. One day he showed all of the kids how to play the harmonica. We all got a turn to try to use it correctly. Mom and Dad were surprised when I quickly figured out how to play it. When playing the harmonica, you breathe in or out through the harmonica. Breathing in through the harmonica would provide one note, and exhaling through the same place would give a different note. As you move the harmonica to the right or left, the notes change. You don't have every note, but enough to create a song. He used to play the same few songs, and when I began to play one of those songs, they were both amazed

that I figured it out so quickly. I never really played the accordion but I thought it was very interesting.

While living in Florida, I had the same teacher for kindergarten and first grade; Her name was Mrs. Lemon. I don't know why, but she stands out in my mind. Prior to me having her, my older sister had her as a teacher as well. We were having a class party one day. Various parents brought chips, drinks, and refreshments for all the students to enjoy. Every student was sitting at their seat, and the treats were placed before us to enjoy. When Mom and Dad showed up, I sat there the whole time and didn't even move out of my chair. I wouldn't eat, drink or interact with any of the other students or the teacher. Mom and Dad were kind of talking together in a whisper over at the back of the room. I could vaguely hear the teacher telling them that I would usually interact with the other students and didn't know what was wrong. Mom, Dad, and Mrs. Lemon were all confused as to why I wasn't acting in my normal fashion. So Mom and Dad pretended like they were leaving the party. I think they were watching from around the corner of one of the doors. When they were gone, they said I went about my normal activities, playing with other children and having fun. I was really shy when I was little, to the point that I would just stop doing what I was supposed to be doing when they were there.

I was so shy in class. In the younger grades, it was common for students to bring something from home and talk

about it and share it in front of the class, which is called sharing time. Mrs. Lemon would always try to convince me to bring something from home to talk about. I wasn't going to get in front of the class and talk. One time, Mrs. Lemon made me stand up, stand in front of the class and tell what our family had eaten for dinner the night before. I made up some grand dinner in my mind that sounded wonderful. As I stood before the class, she began asking me questions.

She said something like, "what did you have for dinner last night?"

I wouldn't answer, so she asked another question, "did you have a roast?"

Then I said, "yes."

Then she asked, "Did you have potatoes or anything else?"

That's when I created this wonderful meal that we didn't even have. I felt embarrassed to tell the kids whatever it was that we really had, so I just made up a meal that I thought sounded really good. Dad wasn't making the money he needed in the Navy for all six of us, so we often had to do with a little less. I don't think we ever did without the basic needs because Mom had a way of making home-cooked meals. She would often cook homemade bread, and we would use that bread for our sandwiches at school. She was

an excellent cook, and while growing up, I loved watching her in the kitchen all the time. I would often watch her, and eat little bits and pieces of this and that when she cooked. She was always trying to get me to try different things, but I only ate the things I liked. I would eat the vegetables right out of the can or out of the pot she was cooking in. She made bread, desserts, cinnamon rolls, and many things from scratch. For most of our lives, Mom made the best cinnamon rolls in the world. There were regular cinnamon rolls and sticky bun cinnamon rolls. It's a dessert that she taught my sisters to cook as they grew up as well.

We lived in two different homes in Florida. While in our first home, there was severe flooding that caused the streets to be submerged in water. It might have been the effects of Hurricane Dora that went through Florida during that time. I watched people travel up and down the streets in row boats. We were always worried about snakes when we lived there, too. I could see fish swimming in the water during that time, and snakes were a danger everywhere all the time. Occasionally, we felt brave enough to venture out into the shallow parts of the flooded streets. Mom reminded us of the dangers and tried to occupy our time doing something else in the house. While living in the area, Jerry would go out and hunt snakes and bring them home. One day, he brought a really large, dead snake home and laid it out in the carport. It was a black moccasin and was about ten feet long. He went

into the house and told Mom that he had killed a snake and asked her to come out to the carport to see it. Mom opened the door and saw the snake. She gave a scream and had a fit. She told him to get rid of it. Jerry had a way of getting into mischief; it was just fun to him.

We watched different shows on our television at the time, and our family would occasionally go to watch movies at the base theater. There were a lot of movies about army men or Cowboys and Indians. While growing up, Jerry and I played army or cowboy, and Indians all the time. We both had our own cowboy hats and little play-six shooters too. My friends were always trying to get me to pretend to be an Indian. I always adamantly told them that I was going to be the cowboy. I told them that I was going to win, not lose. All the movies or television shows that I watched would always depict the Indians as the bad guys and or the losers. Once, Mom and Dad took us to ride horses so I could feel like a real cowboy! I felt like a real cowboy. I had watched how they rode the horses on television and so it seemed pretty easy for me to ride. Mom and dad said that I looked like a natural cowboy.

While living in that same house, my friend and I thought that it would be fun to parachute like in the movies. We would jump off of the trash cans or small walls and hold a towel or blanket over our heads and pretend to be parachuting. One day, we decided to try something more

daring. I went into the house and grabbed a blanket from the closet for each of us and kind of snuck outside. Then somehow, we figured out a way to climb on top of the roof. When we got up there, it seemed to be a little bit higher than we expected it to be. We looked at each other as if to say; you go first. After we sat there for a few moments, my older friend decided that it would be better for me to jump first since we were at my house. After thinking about it and having practiced by jumping off all our shorter ledges, I decided it was time. I jumped off the roof and tried to use the blanket as a parachute. I don't remember the blanket working too well. It was a pretty hard fall, and the blanket didn't ease my fall at all. On the way down, I let go of the blanket because it didn't seem to be slowing me down and to help brace myself for the fall. When I hit the ground, it did not feel too good. My friend asked me how it was. I said that it was fun even though I could hardly speak, having had the wind knocked out of me. I looked up at my friend and told him it was his turn to jump. It was then that my mother came out because she had heard noises from the roof and wanted to see what was happening. She looked at my friend on the roof and kind of screamed and told him he needed to get down immediately. She gave a sigh of relief and told us we were not allowed to jump off anything that was taller than we were. I sat there on the ground, wishing that my friend

had gone first, but I never tried jumping off anything that high again.

While living in Florida, I wound up attending two different schools, yet I was still in the first grade. We lived in a neighborhood with lots of families on every side of us. We had bikes and would ride up and down the streets and play with all the kids in the neighborhood. I was once chased by a dog as I was riding in an adjacent neighborhood. The big dog came running after me as I rode by a house. I jumped off my bike and put the bike between the dog and me before the owner came out and retrieved his dog. I tried not to go far from home because there were so many things I was afraid of, including; the dogs, the alligators, and the snakes.

The second home we lived in was near a swamp. I was about seven to eight years old, and Jerry was eleven to twelve years old at the time. While walking around the swamp we could often see alligators in the area on occasion. We lived on a cul de sac, and the swamp was directly behind our house. There was a drainage canal behind our house that fed into the everglades. At Christmas time, we'd celebrate it like most Christians. We had gatherings at church and school parties and celebrations. We had a fake Christmas tree, and all the siblings loved getting to decorate it. We'd put ornaments, and silver tinsel all over the tree and string popcorn to put on the tree. On Christmas Day, Mom would always bake a birthday cake for Jesus. She would put candles

43

on the cake, and we would sing Happy Birthday to Jesus, then we would all blow out the candles together. Early Christmas mornings were usually filled with presents excitement, laughter, clothes, and toys. We'd play with our new things throughout the day. Jerry and I were always happy to receive something to do with Cowboys and Indians or Army.

There were lots of trees and bushes all around our house. Jerry was a young teenager at the time and used to go around and hunt animals with his friends. He was always going out into the swamps with them. I was about seven to eight years old at the time. At Christmas time, Jerry received a new BB gun. After he got his new gun, he would regularly go out to the swamp, set up glass bottles or cans, and shoot them with his gun. He would put the objects on one side of the drainage ditch and shoot from the other side, and he got to be pretty good. I would always ask him if I could shoot the BB gun, but he would never let me shoot it. One day I asked him if I could shoot his gun, and he continued to tell me no. I told him I was going to go in to tell Mom he wasn't sharing with me. He got mad at me as I began to walk towards the house and shot me in the back. I started crying because it hurt, but I was mad too. As I went running into the house to tell Mom, he chased after me, and he told me that he would let me shoot his gun. I started shooting the gun for a little while when he said that he wanted his gun back. I told him I wasn't done,

and he started walking towards me to take the gun away from me. As he approached me, I shot him once, he continued towards me, and then I shot him a second time. When he took the gun away from me, I got mad and told him that I was going to tell on him. I began running to the house to tell Mom, and he told me that I would get in more trouble than him because I shot him twice. He said that I would get in twice as much trouble. I didn't want to get in trouble, so I had to do what he said. He told me to follow him into the swamp. I followed him as we began to jump over the ditches and watery areas. I remember following him down past this pond and into a wooded area. I looked at the water; it was dark, murky, and looked black. There was white moss hanging from almost all the trees. I looked carefully at every step I took to make sure there wasn't a snake, an alligator, or anything else I didn't know about. When we arrived at the wooded area, it became dark, and it was spooky to me. The sun could barely break through to the ground. There were shadows everywhere. Then we came upon a place that looked like a hidden fort. It was built with old plywood, two-by-fours, and broken branches with leaves from the trees in the area. Then all of a sudden, a bunch of older, young teenage boys jumped out of what seemed like nowhere. There were 10-12 boys or so, and they quickly approached me with raised fists; they appeared to be ready to beat me up.

Then Jerry said, "It's ok, he's with me. He's my little brother; he won't say a thing."

After he told them that I was okay, most of the boys began to take out cigarettes, lit them, and began smoking. They continued to probe Jerry about if I was really safe to have around. They thought I would tell somebody about them. Then they formed a circle around me and said they would beat me up if I didn't smoke a cigarette. Jerry said if I didn't try it he would tell Mom that I shot him twice with the BB gun. They tried to make me smoke a cigarette to prove that I would be ok. I remember putting the cigarette in my lips, but I didn't know what to do. It just sat there, and all the boys started laughing at me. They teased me because I was little and didn't know how to smoke.

One of the boys took the cigarette from my lips and said, "I'll show you how you do it."

Then others joined in, laughing at me and smoking their own cigarettes. Although I hadn't smoked the cigarette, I felt like I had done something wrong by putting it to my lips. I didn't want to smoke. It was then that I promised myself that I'd never get in that situation again. Even though I was young, I felt terrible about it.

I don't remember ever feeling so bad. Jerry said that if I told on him, he would tell on me, and I would get in even more trouble than he would. A day or two had passed, and I

didn't want to go outside and play or go to the backyard. Every time Jerry wanted me to do something, he would tell me that if I didn't do it, he'd tell Mom that I shot him twice and that I had been smoking. I don't know how long it was before Mom found out about the cigarettes, but she did find out. One day she was washing the clothes when she found a bunch of tobacco in the clothes that she had washed, and she also found an empty cigarette package. Jerry had left some cigarettes in the pants pocket of a pair of his jeans. She asked me if I knew about the cigarettes, and I started crying, telling her I didn't do anything wrong. Then she began to talk with me until she got the whole scoop out of me. It was hard enough to face Mom being mad at me, but she said she would let Dad deal with us when he got home. That put fear in me, and I cried my eyes out, insisting that I hadn't done anything wrong. When Dad came home, and he found out what had occurred, he tried to make us smoke a cigar. I don't know where the cigar came from. I cried the whole evening, saying that I didn't want to smoke and that I didn't like it. Jerry took the cigar and smoked it until he got sick. I think Dad wanted him to get sick from smoking the cigar, hoping that he'd never smoke again. I made a commitment in my heart that I would never let that happen again in my life. It was a tough learning experience for somebody as young as I was.

I knew that I was tricked into what could be called smoking, but I just let the cigarette sit on my lip. I didn't

think I had really smoked a cigarette. I felt bad and told God that I was sorry for what I had done. Even though I felt that I had repented, I always wondered if I was forgiven, even though I was only about eight years old. I was eight years old now, and it was time for me to decide if I wanted to get baptized. I still remember an overwhelming feeling in the church that God loved me. I was interviewed by the bishop, the pastor of the congregation. He asked me if I knew what I needed to do if I wanted to be baptized. I had to promise to live right and help others in all I did. I told him that I wanted to be baptized. Dad baptized me in a font in a church building in Jacksonville, Florida, in December of 1963. On the following Sunday, I remember standing on a pew at the back of the church to bear my testimony of God. They had a microphone that they would bring around to each person wanting to speak. I had felt something so warm and strong. I stood on the back row in the pew, so I could be seen. Mom had to raise her hand so the man bringing the microphone around would bring it to me. I stood there with the microphone in my hands and looked around the congregation and could see that everybody had turned around to listen to me. I wasn't ever willing to stand before a group and speak, but this seemed to be a little different. I was feeling something that made me feel so good, it was like a light inside of me was burning. As I began to speak, I felt this wonderful feeling inside that came over me, and I began

to cry. I shared my feelings the best I could. I told everybody that I loved God, and I knew that he loved me. I had a testimony of God at a very young age. Later in life, I remember seeing a young eight-year-old stand with that same zeal and commitment to God. I cried when he shared his thoughts too.

Jerry had a friend die while we were living in that area. There was a funeral home right next to the church we attended, with a driveway separating the two. I think he became sad and uncertain about life. After his friend died, he seemed to not care about the consequences of life. I later recall one night when the police brought Jerry home. He had been caught with some other kids in the neighborhood getting into trouble. All of us siblings tried to peek into the living room and watch what was happening, but we were sent to bed. The police left with him, and Mom and Dad had to pick him up from the station.

Chapter 5: The Nails

Jerry and I did things together, and he would often have me do things just to have fun with me. One time we went walking to an area that I had never seen before. There was a place that looked like a mudhole. It was a different-looking kind of dirt with water near the edges. At least, that's what it looked like to me. He told me to go and stand in the mud and see what would happen. He told me to just stand still and try not to wiggle. So, I walked over into the muddy-looking area and just stood there. Then I slowly began to sink into the mud. I became worried and tried to get my feet out, but I began sinking quicker. He told me not to struggle because it would make things worse. Then he told me that I was fine. It was fun and funny until I got up to my knees, and then I began to panic. I remember him calmly giving me a branch from a tree to hold onto as he stood at the edge, and he pulled me out of it. I don't remember how we explained all the mud on my clothes to Mom. I found out later that it wasn't mud; it was quicksand.

Our family would go to church together as a family. We often took a shortcut back road to church that we, as children, called the bumpty road. There were little bumps and ridges on the entire dirt road, and the faster we went, the duster and bumpier it got. Dad would drive down that road fast in our VW bus to give us a thrill. He also dove over a snake on the

road one day. He drove over it once, then turned around and drove over it again about four times. All the kids were embarrassed or scared and squatted down in the VW so we couldn't be seen. If we were going somewhere, we were all in that VW bus. One day, we were driving the VW from town. Dad was driving, and all of the kids were in the back of the bus. We didn't have seatbelts back then. We would stand to move around from seat to seat. We would usually be told to sit down before we would begin, but we were free to move around. I stood up as Dad began to make a turn at a light. I think he sped up a little to try and get through the intersection before the light turned red. As he began the turn, I began to stand up to change from the front seat to the back and wasn'tx aware that we were turning. The VW bus leaned because of the speed of the vehicle, and I began tipping over and leaning against the door. Then the door of the VW swung open, and I began falling out. Almost instantly, Jerry reached over and grabbed me as I began going out the door. He grabbed my arm, and I held on to his as he pulled me back into the vehicle. Dad immediately pulled over and then made sure everybody was sitting down and ensured the door was properly closed. I was grateful for Jerry pulling me back into the bus.

While living in the home next to the swamp, there used to be these fogging trucks that would drive around the neighborhood and spray insect killers to control the

mosquitoes. In the evenings, they would drive down each street in the neighborhood and spray what looked like fog coming from a fog machine on wheels. It was a pretty dense fog that it sprayed. So much that it made it difficult to see where you were if you were in it. Mom told us several times not to run in the fog because it was poisonous. One day, all the kids in the neighborhood were running behind the truck in and through the smoke. They were screaming and yelling like a celebration. When we saw the neighborhood kids running through it, we thought it would be okay for us as well. So, the four older siblings ran outside and followed the truck around the neighborhood, running and playing with all the other children. Mom came looking for us, and when she found us running through the smoke, we all got in trouble and got a good spanking.

That home by the swamp wasn't a home that was on the base. We lived there for a while, but we finally lost it to bankruptcy. The bankruptcy was a sad day for each of us. My sisters, Cherie, Gloria, and I sat on the steps when the people came to repossess all of our things. We told them that all the furniture was ours, and they couldn't take it. They carried it away anyway. We cried, telling them it was ours. Mom and Dad tried to console us, but we continued crying. We had to move on to the base housing after that. They tried to buy the home, but it was difficult for them to try to make ends meet with six children. As a serviceman, Dad didn't

really have a high-paying salary. Our parents had wanted to try and buy a house and all the furniture necessary for it as well.

I know there were many times when we struggled as a family financially. I think it was more difficult for Mom and us children. Dad was usually off at work or out at sea, and Mom was at home trying her best to take care of six children alone. As a child, I didn't really know what was happening. I can only recall the events that told us how we were doing. When they came and took our furniture, something told me that it wasn't right. Mom and Dad had gone through bankruptcy. I didn't even know what that meant. I just know that it was rough. Gloria, Cherie, and I would sit on the steps by the mailbox and just hope that the mailman would deliver a check and we wouldn't be broke. If the money didn't come on a particular day, then we would sit and cry for a few minutes. Although there were some hard times, there were some good years, also. We didn't always struggle. It just seemed that way. Many times we were unaware of how bad our situation really was. Mom and Dad had a way of making things look more positive than they really were.

I began wondering when I was young if I was different from all the other children in the neighborhood. Occasionally Mom would tell us that we were Indians from Snohomish, Washington. I don't think we ever thought anything about it. Dad told us we were German too. Our last

name was Goedel, but people always mispronounced it, and we were made fun of because of it as we moved from place to place. When we finally found a way to say it, we started telling everyone how to say it the way we liked it. We were occasionally made fun of because we were darker than most other kids too. We were Natives, living off the reservation, but we didn't know it and didn't really fit in. We looked darker than most of the other kids in the neighborhood. It was about that time that Billy Mills won the gold medal in 10,000 meters run in the 1964 Olympics. Mom told us that it was in our Native blood to excel in sports. It was one of the times that Mom proudly shared with us information about our Native Heritage. She spoke of another Gold Olympic athlete who had participated earlier by the name of Jim Thorpe too.

There were so many events that happened during this time period in our lives. In 1962 there was the Cuban missile crisis that had our family worried. Mom and dad collected extra food supplies just in case any disasters might occur. Leaders of the church had cautioned and warned us to prepare for storms in our lives. In 1963, President Kennedy was assassinated. I was eight years old at time and was in second grade. The whole community was in shock. I watched on television of the president traveling in Texas when it happened. The Civil Rights Movement was in full swing, and we often had people say mean things to us

because of our skin color. As riots would be shown on television, mom would often tell us of the unfair things that had happened to her on the reservation. We were living in the south, and you were either black or white. I was neither black nor white, but I wasn't white, so I wasn't treated fairly. One day while I was out playing in the neighborhood. I was attacked by a couple of the neighborhood children. They were telling me that I was different and I had to pay the price. They held me down and took two pieces of wood with nails in each piece and hit the side of my face with them. I ran home screaming to tell Mom. When she saw me, I still had one of the pieces of wood that was attached to the nail dangling from my face. I still have scars that can be seen. I don't know who the kids were, but my siblings were afraid and sad for me. Yeah, we tried our best to fit in, but it was difficult especially during that time period in America. I felt like I fit in when I was with my siblings, but we were always living in new communities and neighbors. It was a difficult time for many people. I didn't know why somebody would hate me so much that they'd drive nails through my cheeks. I hadn't done anything wrong, my skin was just the wrong color.

We did things together as a family whenever it was possible. We would usually go to the drive-in theaters in our VW Van. Before we went, Mom would begin making popcorn for us to take. She'd start cooking popcorn in the

afternoon and then put it in a couple of large brown grocery bags. Somebody would buy candy for us, and we'd take drinks with us too. When we arrived, there was usually a playground for us to play at. I don't think we worried about the mosquitos, but there were plenty of them. Prior to the movie coming on the big screen, we could occasionally see lightning bugs or fireflies. We'd run around trying to catch them and put them in containers of some sort. I think it was usually a clear soda bottle. We were all amazed at how a bug could light up. At night they looked like blinking stars in the trees. We would follow the lights and chase them all around the area. We would save them in a jar or bottle and then have to let them all go before the movie would begin. Before the movie started, the previews came on; we'd have to go and sit in the car. You could see all the kids running to their cars. Mom and Dad would place the speakers on the windows of the van for sound. It wasn't always easy to watch the movie with so many people in the car, but it was fun, especially when the smallest ones would finally fall asleep.

Chapter 6: Off To Texas

Dad finally earned the rank of Chief Petty Officer while we were living in Florida, and he was subsequently transferred from Florida to Texas for his new assignment. When people find out that I'm native American, they often ask me if my Dad was a chief. I often tell them yes. Sometimes I say a chief, and sometimes I say he was a chief petty officer in the Navy. His new assignment was to oversee the Recreation Facilities. It included arts and crafts, physical education, movie theaters, pool facilities, welding, and pipe fitting. Of course, we would drive to our new destination and camp along the way. We took a few days to pack our things and began our next journey. Moving every few years became an ordinary thing for us. Prior to leaving, through the Navy, Dad secured a place for us to live when we arrived in Texas. There were now six children in the family, and the VW bus wasn't as roomy as it had been, but it would suffice. When we arrived, the living quarters that had been secured were not ready for us to move into. Mom and Dad had a discussion about it and decided that we would stay at the beach until it was ready, which was about two weeks. The beach was South Padre Island in the Corpus Christi area. For all of the children, we thought we were in heaven to be able to camp at the beach. It was the best two weeks of my young life. We got to play at the beach every day. Waking up with the sand at our feet, we'd walk on the beach early in the morning and

collect the various sea shells we'd find on the beach. We each kept a special collection of our own. There were jellyfish called man o'wars that we'd see too. They looked like bubbles to us, and we'd step on them and pop them with our feet. That was until one of us got stung, and then we were more careful. Most of the time, we didn't realize that we had sand all over us. I'd usually play in the water with my older sister Gloria. The two older kids would be in the deeper water with bigger waves, and the younger ones with Mom and Dad. Gloria and I would wade out into the waves as far as we could, then run away from the waves as fast as we could and try not to be covered by the wave. We thought we understood how the waves came in and became pretty good at judging how far, fast, and big the waves were. Once, we got too close to a big wave, and it came crashing down on us. Gloria and I were holding hands, and we both thought we would never come up from the floor of the ocean. When I got up out of the water, I began walking when I realized I was going in the wrong direction. I had become disoriented and didn't know which way I was going. Then, of course, another wave was right behind it, and I got hit by another wave almost immediately. Once I got my bearings, I quickly continued towards the shore. It was a little while before I was willing to go out into the deeper water. When we got too tired, we could easily go and take a little nap in the shade of our tent.

It wasn't until I was older that I found out that Mom and Dad didn't have enough money to get a hotel or motel for the two weeks. So, they decided to have the family go camping on the beach for that time. They just told us it was our vacation, and we believed them. We would cook s'mores, and hot dogs at the beach and oftentimes would eat bologna or peanut butter and jelly sandwiches too. We were supposed to be in school, but they didn't know where we would be living, so we didn't have to go. We really were on vacation!

While living in Corpus Christi, Texas, there were a few events that made an impression on me. We lived in a house that had been renovated. At one time, it was the captain's quarters of a base. It seemed to be pretty big, especially in comparison to what we have lived in previously. It had a big playroom for all the kids to play in. There was a building that had a little store close to the house where we would walk to and buy snacks, soft drinks, and candy. We could buy a soda pop for ten cents from the vending machine. One summer, Jerry, Cherie, and Gloria went out to pick cotton for spending money and buy clothes for school. It was difficult work, and they only worked for a day or two. I can remember wanting to pick cotton too, but I was too little. There were gas stations that would often have gas wars during that time period. The gas was about .29 cents a gallon back then. We could buy five or more watermelons for a dollar. Dad

worked with the youth program at church. We would always get to go with them to their activities. I used to love to go roller skating with them. Once, they had cream puffs for their dessert, and I ate them till I got sick.

Back then, we had a washer that used a roller for when the clothes were finished. The roller was used to remove the excess water from the clothes; then they could be hung out to dry. I was always trying to help Mom around the kitchen and watched her do things. I would watch her cook in the kitchen and learn to cook basic things by watching her. I also tried to figure out how to wash the clothes. After the clothes were washed, She would place them in the roller, and the roller would wring the water out of the clothes. One day, I asked her if I could help, and she said that I could, but I had to be really careful. After a couple of minutes, I don't know how it happened, but somehow my hand got too close to the roller, and my hand began to run through the wringer. I began screaming, and Mom knew immediately what was happening. She quickly unplugged the washing machine. By then, It had rolled my arm all the way up to my shoulder. After Mom turned off the machine, she unlatched the roller and took my arm out. She felt so bad and pampered me for the next few days. She took me to the doctor to make sure I was okay. They put my arm in a sling, and I was sore for a few days but not seriously injured.

Dad worked as the base recreation supervisor. During part of the time there, we lived on the base not too far from where he worked. We would walk to his work to see what he was doing. In the morning or in the evenings, it wasn't unusual to hear taps being played. Everything and everyone on the base would come to a standstill. I would see cars stop where they were or any of those in the military stop and face the United States flag. It helped me to see the reverence that people held for the flag and our country. It gave me a sense of pride for living in America and that my dad served in the military. We'd often hear the military bands play the Navy theme song, Anchors Aweigh. I became accustomed to seeing people in navy fatigues. They would wear their everyday work clothes or be dressed in nice uniforms depending upon the occasion and their rank. That was all a normal part of life growing up around military personnel. I could wander around and watch people playing basketball, swimming, or any different event. In the evenings, Dad would take our family to the movies for free on the base. He would escort the entire family up to the person taking the tickets. There was usually a rope that he would remove to let us all go through; then he would return it to the stand that was holding it. A military person was there supervising, who would let us all in and escort us to the theater. There was also popcorn, candy, and drinks that we got to enjoy as well. During the summer and in the daytime, we could go

swimming for free whenever we wanted to. All of the children learned to swim pretty well over the years. Many of the single servicemen would know us. There were a few that would play with us at the pool. On one occasion, there was a sailor that started playing really rough with us. The sailor held me under the water for a really long time. I thought I was going to drown that day, and I came up gasping for air. He looked at me and laughed. I got out of the pool and waited for the sailor to leave before I returned. Dad was over the ceramic shop and the guns that the military used too. He would take the older kids to the ceramic shop, and Cherie learned to work pottery very well. Jerry was older now and got a job working at the commissary, the military grocery store, as a bag boy. They would hire young boys to bag the groceries for everyone. He would usually receive tips for helping them with their groceries out to their cars. When he'd come home, Mom and Dad would give him advice on how to do a better job. He would show all of the siblings his money, and we'd be so jealous.

One evening, Dad invited a sailor from work over to cook us breakfast for our dinner. He cooked eggs, ham, and green potatoes. I always thought of it as green eggs and ham. It looked pretty disgusting to me, but it was our dinner, so I ate it the best I could. We were living at the old captain's quarters off base at the time. We were all sleeping soundly in the house after the meal. During the night, Cherie woke

up and walked to Mom and Dad's bedroom and told them she wasn't feeling good. Dad got up and, in a rush, began making us all get up and go outside. It wasn't easy trying to do that in the middle of the night. After he got me up, I laid down in the entryway of the house because I was so sleepy. Then Dad urgently tried to get everybody to get outside. Just about everybody in the house was coughing and throwing up. He was speaking loudly and telling us that there was a gas leak in the house, causing everybody to get sick. Dad finally got the family and his sailor friend out of the house and into the cars. We raced to the base in the two cars to try and get to the hospital. When we got to the base, Dad showed his military ID at the entrance to the base. He told the guard that he and everyone in the following car were to be let through. He explained that the car behind him was with him. I was in that car, and I can remember seeing Dad as he talked with the guard. The guard didn't want us to go through. Dad backed up and yelled at the guard. The guard at the base didn't want to let us in because we weren't all military. Dad got mad and told him he would be demoted if he didn't let us in. So the guard let us in, and we went to the hospital. We needed fresh air to help us all feel better. Before we left, Dad found out that the stove had been left on slightly. It was the gas that had made us all sick, but gratefully we were safe.

Dad built metal monkey bars that we would play on too. It was really a removable truck canopy that Dad had made

for somebody. He had welded metal pipes that would be lifted onto the back bed of a truck. Dad had built it for someone. They were supposed to pick it up, and it remained in the front of our yard till then. We used it like our own little monkey bars. As it became dark, we would settle down, and we would go from playing on the monkey bars to lying on the ground and looking up at the stars. We would try and see if we could spot satellites in the skies. At least that's what Dad said we were looking for. We never knew if he was telling the truth about things or not. He always had a silly answer for everything.

Mom and Dad taught us to do some silly things also. Mom would sometimes have us look for what she called "flea's mittens on the floor." We would be crawling around on the floor and looking for flea mittens. If we could find the right color or lint and the right size, she would be all excited and tell us, we had found a flea's mitten. It was a way that she would have us pick up other trash on the floor while we were down there. She would have us do the same thing out in the yard as we would look for four-leaf clovers.

Dad would have us looking for strange things, too; once we asked him why when the cars passed, there was a clicking sound, and the car's lights got really bright or really dim. He told us that the cars were winking at each other. We wondered for the longest time how they knew how to wink at each other. Back then, cars had a small switch that a

person would use with their foot to change the headlights to bright or dim. Later we would ask him to turn the car around when there was an island between the different lanes of traffic. He would tell us that we didn't have one of those new island jumper cars and would have to go the long way around. We also asked him why horses always slept standing up. He told us that if horses lied down, they would die. We tried to find horses that lied down to sleep for the longest time.

Chapter 7: Strange Happenings

There were spiritual things that happened to us as well. We all had a room right down the hall from Mom and Dad's room. They could see us go across the hall if we got up during the night. Once in the middle of the night, they saw Cherie and Gloria go into the bathroom. They had gotten up to go to the bathroom, and they could hear them playing. After a little while, Dad told them to stop playing and go to bed. Mom and Dad could hear them giggling. Then they saw Gloria go back to bed, and they still heard more giggling. After a few minutes, Dad told the girls again to go to bed. Pretty soon, the light went off, and they saw Cherie go to bed. Mom and Dad were puzzled as to what had happened during the night. They asked what had been going on. The girls said they were just playing. Then Mom and Dad asked with whom they were playing. Cherie and Gloria said they were playing with a little girl. They described the little girl to them and told them she said she was their sister. We always believed it was our oldest sister that had passed away at birth. Cherie and Gloria also had a young spirit with brown hair, visiting them when we lived in Jacksonville, Florida.

There were times when it seemed like there were too many of us or not enough money or something. Mom would make us a sandwich, give us an apple and cook popcorn for us to take to school for lunch. I always felt so embarrassed

to let anyone see me eating my popcorn at school for lunch, but the smell of popcorn is pretty hard to hide. I would hold the baggie with popcorn close to my mouth while it was inside my brown paper lunch bag. One day a student could smell or see that I was eating popcorn. He came over and sat next to me, then asked if I would trade my popcorn for something he had. He said I could have anything in his lunch for my bag of popcorn. He had a chocolate cupcake that looked really good to me, so I traded for it. That's when I realized how valuable my popcorn was in a school setting. I was always able to trade my popcorn for anything I wanted after that. That's until a boy brought a bag of popcorn to school and announced to everybody that he had it. I could still trade my popcorn for many things. When Dad was a young man, his mom would have him go around the community and sell popcorn around town. His family had a secret, special "pink popcorn" recipe that they wouldn't share with anybody. A large company found out about their recipe and tried to buy it, but his mom declined the offer. Usually, our popcorn was regular; when it was our so-called "pink popcorn", I could trade for so much more. I still have the family recipe to this day and occasionally make it for my family.

Our family could occasionally be found going up and down the roads in Florida and Texas, collecting pop bottles in our VW bus. Then we'd take them into the store to redeem

them. Mom or Dad would drive ahead of us, and all the kids would walk through the ditches looking for bottles, except the babies. After we collected a few, we would put the bottles in the back of the VW bus. We would walk up and down the roads for hours and collect as many as we could. After a few hours, we would have the back of our van filled with bottles. When we were all done, we would take them to a local grocery store to cash them in. We would put all the bottles into a couple of grocery carts. Once in Texas, I took in two full carts of bottles. I stood in line, and I could see all of the people around me watching me. I was probably a mess because I had been collecting from the ditch. The bottles were a mess too. Most people had the usual six-packs of empty bottles that they were turning in for credit. I had all the dirty bottles counted, and the lady asked me how many there were.

I said, "there are 517 bottles".

They were all dirty, and she picked them up carefully with her fingers and began counting one, two, three, four, five, and then asked;

"How many are there?"

I said, "there are 517 bottles".

After she counted about ten

She asked one more time, "How many bottles are there?'

I said, "There are 517 bottles."

She said, "Ok, 517 bottles seems about right."

Then she called for one of the bag boys to take the basket of bottles to the back of the store.

She gave me credit, and I took the $10.34; we got two cents for every bottle out to everybody waiting in the van. Then we went to get hamburgers, fries, drinks, and milkshakes, and we'd buy food for home. A hamburger would cost 15 cents, 20 cents if you included fries. Then we would share drinks with each other. I would usually get anything I wanted to eat afterward because I was the only one that was willing to turn the bottles in. I remember enjoying some of my first hamburgers called a whopper there.

As siblings, we would often play games with one another. We became close because every time we moved, we already had each other. Our Captain's quarter's house in Corpus Christi, Texas, was kind of large. It had a playroom, three or four bedrooms, a big living room, a nice-sized kitchen, and two bathrooms. There was a large yard too. It had screens around the outside of the house enclosing the porch as well. That protected us from mosquitoes at night. I would often play hide and seek with the older siblings. I was number four, the youngest of the big kids. We would hide anywhere in the house, in laundry baskets, under the bed, on

the porch, behind curtains, or anywhere that we felt was a good hiding place. Whenever they went looking for each other, I was always the first one to be found. When they would find a good place, I would use it for the next game and still get found first. One day, I finally thought of the best hiding place in the world. I knew they would never find me in this place. When our oldest brother, Jerry, started counting, Cherie took off in one direction, Gloria in another, and I headed to the kitchen. When I arrived, I opened the refrigerator door and started moving the food around on the shelves. As quickly as I could, I somehow began squeezing my little body into one of the shelves. I could still hear Jerry counting out loud. I gently pulled the refrigerator door closed. That's when I heard a click, and the door wouldn't open again. Back then, there was a latch on the handle of the door on the outside that would prevent the door from opening except from the outside. Have you ever wondered if the light in the refrigerator goes off when you close the refrigerator door? I can speak as a witness that the light goes off when the refrigerator door closes. It's not something that anybody else should try to experience. I don't even know how I fit in and closed the door, but I did. After only a second or two in the dark, I began to panic and started to bang on the door. I had indeed found the perfect hiding place. Jerry quickly found Cherie and Gloria then he and the girls continued looking all around the house for me. He looked in

every room inside and out. He quickly checked out all the best hiding places. There wasn't anywhere to hide in the kitchen except the small closet. As he walked through the kitchen, he said he heard a funny muffled noise but couldn't tell where it was coming from. He walked through the kitchen once again, and he could still hear the noise. As he walked through the kitchen the second time, he could still hear that funny sound. The third time Jerry said that he kept hearing this banging and muffled yelling and kept looking. Finally, he stopped in front of the refrigerator door and said to himself,

"No, he didn't."

He opened the door, and I was screaming. I hopped out as quickly as I could. What a surprise to find your little brother hiding in the refrigerator. Mom scolded me and sat us all down and explained the dangers of what had just happened. It's been over a lifetime that I've began to understand the Grace of God. Grace is something that you can't do for yourself. I had made a huge error in judgement and placed myself in a terrible situation. When my older brother Jerry helped me, he did something for me that I couldn't do for myself.

I struggled in school as a young man, even through the fifth and sixth grades. I used to daydream all the time. Some things I would know and understand, and other things I

didn't have a clue as to what was going on. I had been placed in a very slow reading group. There was one girl in my class who always said "saw" when she would read the word "was" and would say "was" when she would read the word "saw." I wondered how she could make that mistake. Back then, I didn't know about people who had dyslexia. I was brown, like most of the kids in my reading group, but I couldn't really understand what they were saying to me. They started having me recite things I had never heard before. Uno, dos, tres, quatro, cinco, ces, cieta, ocho, nueva, dias, over and over again. I didn't know what I was saying; I just kept saying it over and over again because the entire group was saying it. They thought I was Hispanic. They would try to communicate with me in Spanish, but I didn't understand what they were saying. The only part of school that I liked was recess, singing, and dancing, and I loved to watch the movie projectors. I was amazed at how the movie tape would wind throughout the machine. There were instructions and diagrams that would show how the tape should follow. After watching it several times I knew how to do it, and many times the teachers couldn't do it. Occasionally I would tell them how to do it and I became the teacher's media specialist. Besides that, there wasn't much that I liked about it. It was the third or fourth school that I had attended, and I was only in the fifth or sixth grade. I got left out of many things and didn't get the help that I needed when I was

young. I was starting sixth grade when Mom and Dad told us that we were going to move to Alaska. As children, we all loved living in Corpus Christi and visiting South Padre island on a regular basis. We didn't really want to move to Alaska, but Mom and Dad had a way of making the future look exciting. They told us how much fun the snow would be and the hunting and fishing would be exciting too. Dad had grown up on a farm and continued to enjoy raising animals whenever we lived. He raised, bred, sold rabbits and we would eat them like chicken and dumplings or fried chicken. We had chickens too. One year during Easter season dad bought some eggs to incubate and hatch. We would go and look at the eggs every day. One day the chickens began to hatch. We watched in amazement as each chick would get out of its eggshell. There was one last chick that couldn't quite break out of its shell. One of the kids broke it open so the chick could get out. The chick died right after it was broken. When dad came home, he told us we were supposed to let the chick break it itself. That made the chicken strong enough to live.

Dad began building a huge 60-foot trailer on the base that we would pull to Alaska. He supervised the area of the base, which provided him the opportunity with easy access to buy the supplies he needed to build it. It made it cheaper to build it there too. He traded a nice motorcycle he had purchased, the VW bus and a few other things for a used Jeep Wiley and

a black Labrador named Prince. The day arrived, and we packed the trailer and headed on our four thousand, two-hundred-and-fifty-mile trip to Anchorage, Alaska. Dad had retired from the Navy, and our military days were over. This was when my life began to change drastically.

Chapter 8: The Long Road Trip

Our journey on the Alcan (Alaska/Canada) highway trip was quite an event. The highway was built during World War II to connect Alaska with the lower forty-eight states. It begins in Dawson Creek, British Columbia, continues through Whitehorse Junction in the Yukon, and on to Delta Junction, Alaska. My Dad had just finished his twenty years of service in the Navy, and he, along with my Mom, decided to make the retirement move to Alaska. It was October 1, 1965, when Dad retired from the Navy. He spent many months preparing by building a huge trailer that we were going to tow to Alaska. He used the pipe fitter and welding skills he had learned during his service in the Navy. He found some plans and began to build a fifty-foot trailer that we would live in once we got there. Dad had made all the preparations necessary for the trip. He had purchased a Jeep to pull the trailer. Right after he purchased the Jeep Wiley, the engine blew. It was just weeks before we made the trip, and he had to replace the engine with something other than a Jeep engine. The trailer was built out of iron to ensure strength and stability. Little did he know that the trailer he had built had been built too well.

We had packed out things, loaded them up in the trailer, and all piled into the Jeep and were ready for the first day of the journey. We hadn't driven but a hundred miles or so, and

Dad hit a pothole in the road. The trailer's axles were sheared off, making the trailer immobile. Never had Dad dreamed that he would make a trailer that was too heavy; it was probably the one thing that he hadn't considered. He just thought he was making it sturdy. Dad drove to the closest town and rented a U-Haul, and came back and loaded the trailer with all the most important things that we owned. The plan was to drive to town, get us a motel room, and Dad would work for the next few days building a new, more compact trailer. When he had finished the new trailer, we took it to our old immobile trailer, and Mom and Dad began selling everything that they could. We might have had the first-yard sale ever on a freeway. Mom and Dad sold everything they could and just left the rest. The new, smaller trailer was only big enough for everybody to take the essentials. Everybody had to rummage through his or her clothes, toys, and belongings to figure out what they were going to take with them. We needed to go to Austin, Texas, first because Mom had completed classes to become a beautician. She had scheduled to take a test there to get her license. While we were there, Dad found a place to continue building our new, smaller trailer, which we would pull to Alaska. In the meantime, Mom took her test and passed. She would use her beautician's license when we got to Alaska. On the trip, there was Dad, Mom, Jerry, Cherie, Gloria, myself, Oscar, Lorna, and Prince, our black Labrador all-

trying to fit in a Jeep that was really too small for us. We had become accustomed to traveling in our VW Bus, but it wouldn't be strong enough to pull the trailer on the trip. Most of us children were small enough that we managed to fit. We packed our new trailer, and off we went. We were on the road again, headed to Alaska.

We had many memorable adventures on that trip. Of course, we tried to camp all along the way. When we got to the United States/Canada border, the rangers made Mom and Dad prove they had enough money for our family to get to Alaska. Back then there were other checkpoints along the way to ensure any travelers would be able to make it to Alaska safely. We were told that it was kind of late in the year to be driving the Al-Can, but they let us continue. Mom and Dad had planned for us to camp all the way up to Alaska, but Mother Nature had her own idea.

We camped here and there along the way in the U.S. and pitched a tent to camp after eight to ten and sometimes twelve hours of driving a day. The journey would take seventy-five hours of driving for just an average automobile; it would probably be ninety hours or more now that we were pulling a trailer over some harsh terrain. That would require that we travel from eleven to fourteen days if we traveled eight hours a day.

It was October, and the weather began to turn cold as we traveled north. We entered a campsite in Canada, and Dad thought he would just clear some snow and put a tent down. He went to put the spikes down, but the ground was frozen. As he began to hammer, the tent spikes just bent and became useless. Dad thought he would try some sturdy sixteen-penny nails instead; those bent as well, and our attempt to become true Natives was abandoned, even though we were true Natives in every sense of the word. Instead, we found refuge for the night at a visitor's cabin in a park. Of course, nobody else was there because it was too late in the year, and we had the cabin all to ourselves. Most sane people wouldn't and don't make camping trips or take vacations through Canada in October. We made a fire, cooked some food, and then all went to sleep for a little while. A park ranger came by to see what we were up to, and we explained that we didn't know where the nearest motel was and needed a place to sleep. He said it would be o.k. for the night and left us to ourselves. We were all sprawled out on the top of the tables, asleep in our sleeping bags. In the middle of the night, everybody started getting sick and throwing up. The room had filled with smoke, and there wasn't enough fresh air in the room. We had made a fire to keep us warm, and during the night, the room had filled with smoke. There was a problem with the air damper in the smoke stack. It was stuck in the wrong position. When Dad tried to regulate the flow

of air, it broke somehow. That caused the smoke to slowly come back out of the smokestack, making all of us get sick. Again, we all got our things together, packed up, and went back out to the car. It wasn't a long rest, but Dad had enough sleep to just continue driving. In a few minutes, we were snuggled together in the back seats as we continued on our way in the cold fall morning. We sat and lay in every conceivable position that we could. Sometimes we would take turns lying on the floor to have more space to sleep.

We stopped at various places in Canada to gas up, eat and go to the bathroom. Sometimes it was just a break to get out of the car. We weren't used to the cold weather, so sometimes we hurriedly got back in the car to stay warm. We had to be careful making sure there was enough gas in the gas tank, too, because we didn't know where the next place that gas would be available. We used a road map to guide us, and I think all the kids learned to read a road map on the trip. We always wanted to know where we were and how far we had to go. Usually, we had a state map, but we used a map of British Columbia too. Traveling every day for ten to twelve hours became monotonous. There were many new things to see. We were always seeing some kind of animal like a; Moose, raccoon, deer, bear, or other animals. After seeing the first wild animal we were keenly observant of any other wild animals as we traveled. Seeing a ptarmigan (said, tamigan) for the first time was amazing. It's a beautiful bird,

like a pheasant, that changes colors in the winter to white, and at other times of the year, it's brown. As we traveled usually the widow would fog, and we'd write on them, play games on them like tic tac toe, or hangman with each other too. The windows would become messy, and we'd wipe them off with our sleeves or jackets to view the scenery as we traveled. For most of the trip, there were usually large trees all around us, preventing us to see too far into the forest.

When we experienced the Canadian chocolate candy, I thought it tasted so different to me, but all the rest of the family loved it. When we would stop to gas up the Jeep, the gas stations often looked like little country stores. I continued to watch the different license plates, and I made the numbers more complex and continued to find ways to make the numbers bigger. I would now multiply and divide numbers as well as add and subtract them as I did before. I never told anybody that I was playing the game in my head. I would just keep track of the numbers that I was finding.

One day the jeep wouldn't start after we gassed up, and Dad couldn't figure out why. He talked to a mechanic at the gas station we had stopped at, and the guy said the gas wasn't getting to the fuel pump. The mechanic went over and blew into the gas tank. Then he told Dad to try and start the engine, and it started right up. After that, each time we stopped to fill up, one of the kids had to go out and blow air into the gas tank to build up the pressure for gas to get to the carburetor.

We had to stop three, four or five times in a day. All the kids had at least one try at it. After everyone had at least one turn, they said they didn't want to do it anymore because it was embarrassing. So guess who got to do it from that point on? It was me. People would often come up and tap on Dad's window and tell him there was a strange kid siphoning the gas from his vehicle.

Chapter 9: The Ravine

We continued our fun-filled journey on the Alcan highway. The roads were not always the best; sometimes, they were just dirt or gravel roads. It was considered a major feat for the Alcan to have been built. The first day we saw snow for the first time, it was a big deal. Each day after that, it became more monotonous. One day the weather slowly worsened. We had become accustomed to it snowing, so we didn't really notice it anymore. It began to snow, and the roads became icy. We were in an area where the roads became windy, and the driving conditions were worsening. We had driven most of the way up a windy, snowy mountain road. With all the snow outside, none of us realized that we were up in the mountains. As we began our ascent on a windy hill, we found the road to be so icy that it became difficult to pass. We had made it up about three-fourths of the way up when the tires began slipping, and our car and trailer began to roll backward. Dad yelled for everybody to jump out of the car. Startled, we all exited as quickly as we could as the car continued to slide back toward the edge of the road. Even after we exited the car, we watched the car and trailer as it continued to slide back toward the steep ravine. It was still snowing heavily and we were doing our best to just stand up on the slippery surfaces. There had been no rails installed to contain motorists from falling down the steep embankment. Thankfully, the car and trailer stopped at

the edge, and we were all safe for the Moment. Dad pulled the emergency brake and got out of the car himself. Everybody was out of the car, and Dad was doing his best to prevent the car and trailer from disaster. There was ice everywhere and no way to really control the icy conditions. Dad found a few large rocks he had uncovered in the snow by the side of the road and placed them behind the tires. He told Mom and all of us kids to go to the top of the road and see if we could find some sand or dirt to give the car tires traction. There were 50-gallon tanks with dirt in placed in them strategically at different points along the Alcan highway for that exact reason. We attempted to retrieve it from the container, but the dirt was frozen, and we weren't able to get any of the sand from the barrels. We searched the area near the top of the mountain, and we started kicking the snow around on the side of the road. As we kicked the snow, we finally uncovered dirt. After we loosened the dirt, we began using our sweaters and jackets to fill with dirt as quickly as we could. When we had our jackets almost filled, we heard a huge commercial truck approaching. It was traveling extremely fast. Mom began waving her arms to alert the trucker that the roads were icy up ahead. The trucker slowed slightly but continued zooming past us out of sight and down the hill. We waited and listened silently and heard nothing. We figured that Dad, the Jeep, and the trailer were all alright. Moments later, we finished filling our clothing

with dirt and quickly headed down the hill. It probably wasn't enough, but it would have to do.

After a few moments and some quick hustling, Mom and all of us older kids were down the hill and had our sweatshirts full of dirt for Dad. The two smaller children stayed at the top of the hill with Cherie. We had dirt all over us, and our tennis shoes were covered with dirt and ice. Our feet and hands were freezing, but we were just doing our best to help in our dire situation. Dad took the dirt and put it down on the icy road to help the tires get traction. First, he put it under the tires; then he made a trail on the road for the tires to gain traction on our ascent up the hill. He used the dirt as much as it would cover when he had placed the dirt on the road, he gave each of us our coats back and told all of us to go up the hill and wait at the top of the mountain.

After the dirt had been placed on the road, Dad sent all the kids except Jerry up the hill to stay out of the way. Dad told me to go up the hill with all the other kids, but I refused to go with the others. I don't know why I told him no because I was always pretty obedient to whatever he told me to do. On this particular day, I told him I wanted to stay with him. So I hopped up into the Jeep and sat between him and Jerry. He instructed us to be ready to jump out of the Jeep if necessary. As he put the 4-wheel drive into gear, he pushed my legs out of the way to ensure he would have plenty of room to shift. We began our ascent up the icy road and were

doing pretty well for a little while when the wheels on the Jeep began to slip again. The tires were spinning on the icy road, and before long, we were again sliding backward. Dad hit the brakes, then he pulled the emergency brake and yelled for Jerry and me to jump. Jerry was next to the door and bailed in a panic without hesitation to safety. I knew this was all that we had; the Jeep, the trailer, the clothes; there wasn't anything else. We had already had so many things that we had encountered on this trip. I couldn't believe that we were going to lose everything. When I jumped out of the Jeep, I left the door open. I couldn't let go of the door. I pressed my hands to hold the car door to keep the car and trailer from crashing into the ravine. I was an eleven-year-old boy, probably only seventy-five pounds or so, not knowing what I was doing. I just remember pushing against the door and holding it with all my might while yelling with all my energy, "NO!"

To my surprise, the Jeep and the trailer stopped immediately, just inches from the edge of the ravine. When the Jeep and trailer had come to a standstill, Dad was surprised to see me holding the door open. He had been on the other side of the car and could barely see me standing there. Then he ordered all the kids up the hill once again to get dirt to help us up the road. We retrieved more dirt, and Dad made a trail up to the top of the hill. This time the Jeep and our trailer made it to the top. After we got to the top, we

could hear more trucks passing us. We could hear a fast clump, clump, clump of their snow chains. We found out later, when we stopped to gas up that it was a bad storm that had rolled through, and we were caught in the middle of it. Later when I related to Mom what had happened, she said that it was my faith that had stopped the Jeep and trailer from rolling down into the ravine. I told my Mom that I had lost a dime that I had in my sweater. She just laughed that I was worried about my dime and not my life.

Having Prince in the car with us that day was so nice. He was such a good and obedient Labrador. When all six of us children got back in the car, we snuggled up to him, trying to warm up. I don't know if he loved it more than us or if we loved it more than him. We would cuddle up to him often on the trip because of the cold weather. Prince was definitely a member of our family. When possible, we would listen to the radio whenever we had reception. Certain songs would come on the radio, and my older sisters would sing the songs. Prince would waggle his tail as we would sometimes sing the songs to him. I would make the sounds of the extra instrumental parts of the song. Mom and Dad would laugh that I would know all the parts. Occasionally they would hear me singing something like boom, boom, boom, boom or other sounds that I would make. I knew most of the words as well and would sing along with them. I wasn't really trained in music but I appreciated it.

We arrived at Whitehorse, Canada, and had nowhere to sleep. Dad found another visitor's cabin for us to sleep in. So we slept in the cabin, and he built a fire for us. Again we had problems in the middle of the night with the fire he had built, and we got a little carbon monoxide poisoning. He corrected the problem, and we got to sleep there through the night. We all got a little sick and continued to feel sick through the next day. When we woke the next morning, it was so cold that our jeep wouldn't start. Dad went out into the cold and drained the oil and antifreeze. Then he put it by the fire to warm it up, but the car still wouldn't start, so we said a prayer. We didn't know what we were going to do. There was a good Samaritan that came by and helped us out. He saw the predicament that we were in and said he would assist us however he could. He pulled our Jeep and trailer with his truck, and the Jeep started. Dad didn't turn the car off again for the rest of the trip because he thought the engine might freeze up again. They followed behind us the rest of the way to Anchorage. He looked like the actor on the TV show Gunsmoke, James Arness, so that's what we called him, "Gunsmoke".

When we arrived at Tote Junction early in the morning, the checkpoint at the border to travel from Canada to Alaska was closed. We had to sleep in the car and let it run through the night to stay warm. That was where we slept. After we crossed the Canadian/Alaska border, the Jeep got stuck in

2nd gear, and Dad had to drive the remaining 350 miles of the trip in 2nd gear. Instead of driving 50 or 60 miles an hour, we would now be driving 25 or 30 miles an hour for the rest of the trip. What should have taken us half a day to finish our trip wound up taking us 12 to 14 hours for the final day of travel? When we finally made it to Anchorage, it was dark, and there was snow everywhere. Dad pulled the Jeep into the parking lot and got us a room in a motel. That's where the car died, and we only had enough money for groceries and one room for one night. He bought the one room, and the eight of us all slept in it that night. Having spent the last couple of weeks with harsh sleeping conditions, we loved having a warm room to sleep in even if most of us were sleeping on the floor. With the remaining money, Mom and Dad bought food for us to eat. They told us that God would provide for us tomorrow.

Chapter 10: Anchorage

The next morning when we woke up, there was 2 feet of snow, and it was 20 below zero. It didn't seem like all the fun that Mom and Dad had promised us. We had already experienced snow and cold, and by now, we weren't impressed. Dad called the military chaplain and told him about our situation. The chaplain provided a hotel called Chitty's Motel on the outskirts of Anchorage, and they were kind enough to bring us some needed food as well. We would stay there for a few days. The next day we went out to a local church and told them of our situation. They provided an opportunity for Dad to work, but it wasn't enough to pay to feed our family of eight. He would need to go out and look for work on his own. They did provide food and winter clothing for us, though.

The following day Dad went out looking for a job. He went to the welder's union in downtown Anchorage and asked if there was any work in the area. He was told that there wasn't any. Dad thought there would be plenty of job opportunities for him because there had been a major earthquake there just the year before. They said there was nothing for him in town, but there were some jobs in the oil fields in the North Slopes of Alaska. After talking with a man most of the day, who was also a veteran, the man told him if he could get to the oil fields, he could work as an apprentice.

Dad was an expert welder, but he said he would take the job anyway. The man said he would have to take a helicopter to the oil fields, and it would cost $20. Dad told the man that he was flat broke and had spent every penny he had to get to Alaska. He shared with him his situation, and the man said he would give him the twenty dollars to get him there if Dad promised to pay him back. Dad got to the airfield and paid the twenty-dollar fees. He boarded a helicopter that took him halfway there. When they arrived, the pilot told everybody that it was the end of the line and everybody would have to get out. Dad would need to pay for the second leg of the helicopter trip. Then the pilot told him it would cost him another $20 for the next part of the flight. Dad stood there outside, not knowing what to do. It was cold; he didn't have the clothing he needed to be wearing, he was freezing, and he didn't have any money. He begged the pilot to let him ride to the oil rigs and promised he would pay him back. The man said it would cost $20 dollars or he couldn't go. Dad fell to his knees and begged him, and started crying and pleading with him. He said I have a wife and six kids and no money to provide for them. The man felt sorry for him and let him have a free ride. When he got there, the only work they had for him was to pick up the scraps, called butts, left by the welders. He was getting the minimum pay that the union would allow, but he was grateful to be working.

After he had been there for several weeks, there was a day when a storm moved into the area, causing a strong wind to begin to blow. The ocean waves were crashing into the platform, and the movement of it could be felt by everyone. These are like little islands, platforms in the middle of the Sea. It's Alaska, in the wintertime, where the weather outside is freezing, and the ocean water is just as dangerous. The foreman asked if any welders would go to the top of a tower to weld a crack. It was important that it be done because the wind could cause more damage. The foreman couldn't find anybody to do the job because it was a union, and with such bad winter conditions, nobody was required to do the work. Dad heard the boss asking for volunteers. When nobody offered, he volunteered to do it. The foreman asked Dad how much experience he had. He said he had been welding in the Navy for the past 15 years and could weld anything. The foreman sent him up the swaying tower against the will of the union foreman and asked him to make the necessary weld. Dad was afraid of heights, but he said he thought about his family at home and went up the tower and made the necessary weld. The foreman went up after he finished and checked the weld and said it was one of the best welds he had ever seen. The foreman changed his status from apprentice to journeyman welder. Soon after that, they changed his status, and he became a foreman as well. He became one of the highest-paid union welders in the state.

They later offered him a job as one of the top welders in the state, but he turned it down because he would have to be gone all the time, and he wanted to spend time with his family.

In the meantime, we settled in the motel and started going to a school a couple of blocks away. In a matter of weeks, we had left the motel and were living a few blocks away and across the street from the elementary school in a trailer court. We didn't have a very big trailer, but it was home. I walked about a block and had to cross a major street to school. It was so cold. I don't remember anybody from that school. Gloria and I had to walk to school together. I didn't remember anybody from any of the schools I went to up to this point in my life. One morning when I arrived at school, there were kids ice skating on a skating rink in front of the school. It wasn't there the day before, and it looked so fun. I asked somebody where to get the skates, and they told me that you had to bring your own. Eventually, somebody let me borrow their skates for recess. They asked me if I had ever ice skated before, and I told them I hadn't. They told me it was hard to ice skate, but I wanted to try so bad. I put the ice skates on, skated away, and had the best recess that I could ever remember. I hated to take the skates off. It was a while before I got my own ice skates; at Christmas time, I couldn't wait to go back to school to use them. We used to ice skate for recess and play broomball or hockey. It wasn't

long after that, and I'm not sure when or why, but we moved to a place called Seward, Alaska. It was a different part of town, and now we had to take a big yellow bus to school. We lived in a smaller trailer, and Mom was the nanny or babysitter for a family there. Dad hadn't yet become really successful at his new job. We walked to the bus stop in the cold, dark mornings. We would wait as long as we could in the trailer before we would walk out to the bus stop because it was so cold. Mom would fix us oatmeal or pancakes in the morning. She wanted us to have a good meal because it was so cold outside. I loved putting Aunt Jemima syrup with lots of butter on my pancakes. It would be dark when we went to school, and it would be dark when we came home too. I could see my breath and the breath of everyone else as we waited at the bus stop. There wasn't a lot of daylight outside in the winter. I don't know how long we lived there, but I didn't finish the school year there. It was in the springtime that we moved to Eagle River, Alaska. I had started 6th grade in Corpus Christi during the fall, then went to a school in North Anchorage, moved to Seward, and I finally was going to finish my 6th-grade year in Eagle River, Alaska. It was the fourth school I would attend in one school year. It was the seventh or eighth school that I had attended up to this point in my life.

Chapter 11: Eagle River

We were coming to the end of winter, and it was approaching spring. Dad had been working out in the oil fields and had been making good money for several months. Together Mom and Dad saved enough money and decided to purchase two and a half acres of land and a trailer in a place called Eagle River. Eagle River was about 12 miles north of Anchorage. They had found a piece of land on the side of a mountain and close to a river. The land was three and a half miles up the old Eagle River Road. There was a giant rock to mark the place that you had to turn off to our house. It must have been 7-8 feet tall and 4-5 feet wide. The rock had been painted yellow. We always told people to go 3 ½ miles up the Old Eagle River Road and turn right at the yellow rock. Then go to the first road and take a right. Take the first driveway on the right and turn up that road. That was our new home.

It was nice to have a place that seemed like it was our own home. We had already lived in a motel and two different trailers in two separate places while living in Alaska. The first one was kind of small. In the dining room area, there was a seating area that could be converted into two beds. One of those beds was mine, and one was Jerry's. We didn't have much area for living quarters, but we did the best we could. It was a used trailer that Dad had purchased from a dealer in

Anchorage. He had to have the trailer delivered but needed clear an area and pour concrete to put the trailer on first. We got to go out and watch as he cleared the area and got to walk around the property and see what was really there. We found out that there was no running water on our land. Dad converted the trailer we had pulled to Alaska into a water-toting machine. He placed a large 500-pound metal barrel in the trailer, and we would go up the valley towards the glacier. Then we found a place where there was water running down in a stream. Nobody was living in that area, so we just pulled up next to where the water was accessible. We would use a hose to let the water go from the spring into the huge barrel. It would take a few hours to fill the large tank. That was what we used for our drinking and living water. It was a trip we took every Saturday. While the tank was filling up, we'd explore the area, and eventually, we would pick berries and just enjoy the outdoors. We had to heat our water to take a bath, and all the little kids would take a bath once a week in a large metal tub. We didn't have indoor plumbing, so we had to dig a big hole in the ground that Dad would build into an outhouse. We all hated using the outhouse, especially in the dead of winter. I think most of us kids would use the bathrooms at school every chance we got. In the winter it was really cold too. We eventually bought a bigger trailer, and Dad put in a septic tank in the ground. Then the Sullivans who lived across the road helped

Dad drill down for water. They had to drill about 500 feet down to get to the water. It was what Mr. Sullivan did for a living. That was the water we used for our house. Up to that point, we all took only one bath a week in a round tin tub on Saturday night. At first, we only had a water pump we used to get the water. We would have to pour a little water in the pump to prime it and then begin pumping till the water would begin flowing out of the spout. After a couple of months, we got a water pump and plumbing put in. We finally had running water in the house, and we could take a bath daily and had indoor plumbing too.

Getting in and out of our place wasn't always that easy. Most of the roads were dirt roads at the time, and when it got cold and snowy, it could be a disaster. In the spring, the roads would get muddy and hard to drive in. One day Dad and I were off somewhere. As we left our driveway and turned onto the first major street, we got a flat tire. It was a fairly new car, so it was weird that the tire was flat. It was a new, black push-button Valiant. It was cold and wintery. There was snow and ice on the road. Dad was in a hurry, so he got the tire jack out and began fixing the tire. Then something happened under the car, so Dad reached up under the back of the car when suddenly, the car jack slipped. The car fell down on him. He started yelling for help, but I couldn't do anything. He tried his best to get out from under the car but couldn't. The spare tire was off, and the car was on the

wheelbase, and much of the weight was on Dad. He yelled to me to get help. I did the only thing that I could think of and began trying to lift the car. As I was attempting to lift the car, I must have lifted it slightly, and he slid himself out from under the car. He looked at me in pain, but he was grateful to get out from under the car. I helped him finish changing the tire because he was in too much pain. We went back home, and Mom took him to the hospital. The doctor bandaged up his three cracked ribs and gave him pain medication.

That one street had plenty of memories. Neighbors across the street had a boy that was my age who became my best friend, Don Zimmerman. He lived across two properties and across the main street. There was a ditch on both sides of the road. It was the road I walked on if I was going to see Donnie or if he was coming to my house. Later we had snowmobiles and would drive the road all winter long. I think from our driveway to the next driveway was probably half a mile. In the winter, we would tie our dog prince to a sled. Then one of the kids would walk half a mile to the next driveway and yell or whistle for Prince. He would pull whoever was on our sled from one driveway to another. It was our own little dog sledding adventure. In other places like Fire Lake, people would drive their cars or trucks onto the lakes and let the automobiles pull them around using a rope. It was definitely an adventure living in Alaska.

When we moved to Eagle River, I was still in the 6th grade and attended Eagle River Elementary for the last part of the school year. I enjoyed my friends for the first time but was still struggling academically. I had lived in Alaska for about a year, and I had already been to three different schools, and I don't remember the name of any of them except Eagle River Elementary. Over the years that we lived there, Don and I became the best of friends. I did a lot of things with him. I can't recall if he was in my class that first year or not. We had to take the bus together to school. It was a long cold wait at the bus stop that was never fun. In the fall, they would prepare an area for an ice-skating rink at the school. It was always exciting to me when they would fill the rink with water, and we'd get to ice skate for recess.

I vaguely remember any of the things I did in the final part of my 6th grade year. We learned some dances, and most of the boys hated dancing, but I loved it. I thought it was so much fun and thought it was so easy. Little did I know that I would dance for most of my life. We would square dance and had to dance with the girls. Most of the boys hated that part, but there were a few that were beginning to enjoy dancing with the girls. It didn't matter to me, though; I just enjoyed trying to learn the dances that we were taught. The only other thing that I remember in 6th grade was skating for recess and having a track meet at the end of the school year. There was one kid that was so fast. His name was Steve

Bullock. I thought he was the most popular kid in school. He ran so fast that he looked like he was running in slow motion. I became friends with him and made many new friends because of him. It was something that I had never really experienced before.

Chapter 12: Finding My Passion

When my 6th grade school year was almost over, I wanted to try out for one of the local baseball teams. All my friends at school were begging me to try out, telling me that everyone played. I was excited to go home and tell Mom and Dad. I went home and begged my parents to play, but they wouldn't let me try out. They said they would see if I could next year because they didn't have time to take me, it was too far, and it would be inconvenient for me to attend. We only had one car at the time, and Dad used it to go to work. Every day I went back to school, and my friends asked me if I was going to try out. I continued asking my parents, but they continued to tell me no. When I had asked to play baseball, they told me that I just couldn't. After several attempts to win them over, they finally, hesitantly, let me try out that year. We practiced at the baseball field that was adjacent to the elementary school. I was all excited to play that first year. All the guys in school played on the local Little League baseball teams. There were two teams in Eagle River and two teams in Peter's Creek which was about 5 miles north of us, that was our entire league. I went to tryouts and learned the game as I went through the practices. I didn't know how to throw the baseball, catch the ball, or hit the ball. I had to be taught all the facets of the game from scratch. I was just beginning, but most of the other kids had been playing for several years. After the tryouts it came time to be

drafted by one of the two teams. Steve Bullock's Dad was the coach of the Angels. Steve was excitedly telling his Dad to pick me.

Steve kept on saying, "Dad, pick Terry Goedel."

That's when his Dad told him that it wasn't his pick. It was the pick of the coach from the Reds.

Then the coach from the Reds said, "I'll take Terry Goedel."

He didn't even know who I was. He had heard the other coach try to choose me, so he chose me instead. I had to play on a team other than the team that most of my friends played on. I was so sad to be playing on the Reds. Soon school was out for the year, and we would go to the baseball field and play baseball every day. The only day that I didn't play was on Sundays. We attended a Branch, a small Ward (congregation) in Peter's Creek on Ski road. It took us about thirty minutes to drive to church. We attended priesthood meetings in the morning for the men and relief society for the women. Then we'd drive back home and return for Sunday School and primary (for the children) later that day. In the evening, we'd attend Sacrament Meetings. Every Sunday, we'd drive to church three times and return home to Eagle River. We'd drive past the field after church, and I'd see all my friends out there playing. They'd usually wave to me as we passed by.

Donnie and I would usually walk to town to play ball. It was three and a half miles to the field, but it was downhill most of the way. Eventually, we got bikes and would ride to the field. It was a lot of fun riding into town because most of it was downhill. It was the return trip, going back home, that was difficult. We had two steep hills that we had to go up that were tough. We would walk our bikes up most of the second hill. We would ride as long as we could, then we walked the bikes the rest of the way. The Old Eagle River Road was a dirt road at the time, maybe even more like a gravel road. It wasn't the easiest road to ride a bike on. I got a spider bike for Christmas that I rode to town on when I was in the 6th grade.

I later used the bike to help me deliver the newspaper to our local community. It was pretty fun at first, especially when I got paid for the first time. When the weather started getting colder, I wasn't as enthused. Then there was a German Shepard that began to chase me at a particular house. I stopped delivering the paper to their house. The newspaper company called my parents and me and told me I'd have to deliver the paper that day or they'd discontinue using me. Mom drove me over there and went to the door with me to deliver the paper to their home. As we approached the house, we could hear the dog barking at us. I told Mom I didn't want to deliver anymore. She told me it would be okay and she'd talk with the family. Mom knocked

on the door, and the female owner of the house opened the door slightly. The dog, a German Shepard, tried to attack us through the small opening of the door. As the dog continued to press toward us, it finally got its head through the opening. Mom raised her hand to hit the dog, and the owners took the dog to another room in the house and returned. The lady got mad at Mom and me for skipping their regular delivery. Mom told her I wouldn't deliver to their house again. When we got home, mom called the newspaper and told them I wouldn't be delivering for them anymore.

During that first year of baseball, I learned a lot and became a pretty good player. I played first base all year and learned to pitch a little as well. When we would go to play in the summer, we would play a game called work up. Each player played their position until we got one of the batters out. Then we would work up to eventually become one of the batters. We adjusted depending on how many players there were. A player would begin in right field, then move from there to center field, left field, 3rd base, shortstop, second base, first base, pitcher, catcher, and then batter. I learned all the positions and learned to pitch some too. I quickly learned the game because we played it every day. I would watch what the good players were doing and copy them. Sometimes they would explain to me what I needed to correct or improve upon. The group that played regularly included; myself and Donnie, his brother Greg, Steve and

Mark Bullock, Billy Watkins, Durstin and his brother Turley, Larry Ryan, Mike Stratton, Mike Stewart, Danny, Steven and Roxy Knecht and Mark Johnson and his sister Patty. The girls would play when we needed extra players, and they became pretty good. We all became really good friends.

Toward the end of my first year, one day the coach came up to me and told me that I made the All-Star Team.

I was like, "Oh, ok."

I didn't even know what the All-Star team was all about. The coach announced the players selected for the All-Star team, and all the kids on the team were happy and excited for me. I didn't have a clue as to what was happening. When the season was over, we practiced and prepared for the All-Star games that we were to play. When the time came for the tournament, I was as ready as I could be. I could tell a big difference in the competition at this level. All the players seem to be very good. It was made up of 11 and 12-year-olds, and I was considered an 11-year-old. At the start of the first game, the coach seemed to be taking a long time getting us signed in to play for the tournament. The coach pulled me aside and told me that I wasn't able to play because I had the wrong kind of birth certificate. I had to sit on the bench that first year. We lost two games straight. I asked the coach to put me in the game; I told him that I could get a hit off the

pitcher in the game. I remember him putting Donnie in the game, and he got a hit. Donnie was in the same grade as me, but he was older than me and considered a 12-year-old. It was his last year playing little league. I wanted to get into the game so bad but didn't get a chance to play that year.

I became more involved in church as well. We were a small branch, (congregation) which is like a ward, just with not so many people. In my first eleven years of attending, I was a part of Primary, which is for elementary aged kids. I enjoyed going to church and learning about people of faith in the scriptures. I believed in God from the time I was young. I felt his protective hand in my life from my birth. At twelve years old, I became a Deacon in the church. My responsibilities would include passing the sacrament in church. Mom made sure that I was always dressed nicely in a white shirt, tie, nice slacks, and dress pants. Mom would always tell me that she was proud of me and my service. She would always make sure my clothes were ironed, and I looked my best. On Wednesday night, we would meet at church for Young Men's and Young Women's or what we called mutual. The young men from the ages of twelve to eighteen would have scouts. We would have campouts and learn all the aspects of the Boy Scouts of America.

That year the school district began building a new junior high school. When the school year began, they hadn't finished building the school, so they made all the seventh

graders through seniors go to Chugiak High School. It was only a few years old, having been built in 1964, and it was 1967. I was supposed to still be in junior high school but I found myself to be the youngest freshman ever. I had to go to school with Jerry, Cherie, and Gloria. Jerry and Cherie were happy to be in a new high school, and Gloria felt like she was in a new junior high, but none of them felt like I should be going to school with them. We were the Chugiak Mustangs. There was one section of the school for the Junior High School 7th and 8th graders where Gloria and I attended. I started playing other sports that year too. I was around the bigger sibling more now and wanted to be like them, but I also wanted to enjoy the activities of my youth. At Halloween, I wanted to go trick or treating, but I wanted to participate in the older activities that were available. Donnie and I went trick or treating, and then we thought we would try some of the other activities. A lot of the kids would go to businesses and trick or treat them. If they didn't have a treat for them, they would throw eggs at their building. After that, they would begin egging cars and other people too. Donnie and I stood in the woods and threw eggs at a car that was traveling by. I timed the movement of the car perfectly, and the egg landed on the top of the car. The car came to a screeching halt, and two guys came running at us through the woods. They were big, mean, and mad about what we had done. As one of the guys lifted his fist to hit me, the other

guy grabbed his arm and said, "Hey, it's Jerry's brother, don't hit him." I was grateful to have an older brother with a reputation that would protect me. The guy pushed me down, and they ran back to their car and sped off. Donnie and I decided we wouldn't egg anymore after that.

The following year they finished the new junior high school but only sent the 7th graders there. I was still in the youngest class at the school. The following year they sent the 7th and 8th graders to the junior high school, and I was still the youngest one at the high school. We did practice basketball at the middle school that year, though. I never became the oldest class in elementary, junior high, or high school.

I really enjoyed the 7th grade and became really involved in sports. It was what I lived for. That fall, Donnie and I tried out for the cross-country team. We didn't know what we were doing; we just knew we had to run. I thought it was kind of fun running around the area, down a trail here, over the hill there, and winding all around the countryside. I hated running up the hills, though, but we had made the Junior high cross-country team, although they took anybody who would run. We often ran with the older athletes, and we watched them in awe. The longer we ran in the season, the less we seemed to like it. It became difficult to run and then have to walk home from school. When I'd get home, it was difficult to be motivated to do homework because I'd be so tired from

sports and the walk home. Donnie and I were pretty competitive in baseball, and then we continued our rivalry in cross country. I could usually run faster than him in practice, but he usually beat me at the cross-country meets. I would sometimes beat him, but we didn't have many cross country meets. We only competed against a few schools and then had the final meet.

When cross-country was over, I tried out for the basketball team. There were fifteen players that were kept on the junior high team, and I barely made the team and might have been the last one to be kept, probably number fifteen. I couldn't dribble, pass, shoot, know, or understand the game of basketball. I think the coach kept me because he thought I might develop into a good player. Basketball was really exciting for me, I was at practice early, and I was often the last player to leave. I worked hard and did my best to watch the best players and tried to copy what they were doing. I often had to get a ride from someone or walk home from practice in the winter if I wanted to play winter sports. Chugiak was three and a half miles from Eagle River and another three and a half miles from where my house was located. Sometimes Mom would come to get us at school or in Eagle River. Sometimes I would get a ride part of the way home, and other times, I had to walk all the way home. I really loved playing basketball and was willing to find a way home. My hard work and resilience paid off, and I eventually

worked my way up to being a starter on the basketball team. Toward the end of the basketball season, the coach called a time-out.

He said to the players on the court,

"If you don't know what to do, give the ball to Goedel; he's not afraid to shoot."

Several years later, Durstin and other players became High School State Basketball Champions playing for the Chugiak Mustangs.

Donnie and I would walk home together almost every day. We lived across the street from one another, and it made it convenient for both of us. After practice, we'd change and take a shower in the locker room. It was especially helpful to be able to take a shower before we walked home. One day somebody took a white towel and snapped it at me. It didn't really hurt because they didn't know what they were doing. Somebody had just done it to him, and he was trying to do it to me. When he showed me what he was trying to do, I took my towel and did it to him instead. You had to be careful walking around in the locker room, or somebody could snap you with a wet towel. If it was done correctly, it felt like you were being hit with a whip. We had lockers in there because we were on a sports team. The lockers were to keep our workout clothes, equipment, uniforms, and shoes or cleats. We also had lockers in the halls as well. The lockers in the

halls were smaller and meant to keep our books and belongings in during the day. If it was possible, we'd go to the locker between classes. We could leave our lunch, coats or other things there. After showering, we'd go wait near the office in the hall by the phone.

It was a rotary payphone by the office that everyone used to call home. It cost 10 cents to make a call. We'd wait by the phone as others called, hoping to catch a ride for at least a part of our journey. Some students would call home and then hang up, thereby sending a message to their families that they were ready to be picked up and they wouldn't have to pay for the call. We had party lines back then. That meant there were several people who would have their phone ring when a call would come in. If it rang once, it was for one person; if it rang twice, it would be for someone else. It was like sending their family a message that they were ready to be picked up.

At home occasionally I would pick up the phone and hear other people talking to one another. They could usually hear that you were on the line. If they didn't hear you hang up, they'd tell you to get off the line. All calls wouldn't necessarily be private. A person could quietly pick up the phone and listen in on any party line.

When there was no hope of a ride, we'd begin our walk into the cold winter night. Sometimes we'd get a ride as far

111

as Bill's house, the Bullock's house, Fire Lake, Eagle River, or sometimes all the way home. It would be so cold that it felt like our wet bangs would freeze. I was always curious to see if the hair would break, but I was always afraid it might break and then my bangs would look funny, so I never chanced it. As we walked, it was always dark. We could see the stars at night and always pick out the big dipper. It's the symbol used on the Alaska State flag. They stars reminded me of the fireflies that I had seen when we lived in Florida. It was so cold and could see our breath and would make up games as we walked. We would see who could slide the farthest on the different ice patches we encountered. We would try to kick rocks or ice chips between the other person's feet as we walked. If the ice went through the other person's legs, it was counted as a goal or a point. If the person moved their foot to stop it, it was considered a save. It was our own version of hockey. It helped, but it was still a long walk home. We were bundled in our parkas, wearing our boots, and prepared for the cold. Occasionally we would see a moose, a deer, or any other animal. Sometimes we would see the aurora borealis dancing in the skies and admire their beauty. They looked like colored waves moving in the sky. There were other nights when we would have to walk all the way home as the snow would fall, making it more difficult to travel. We'd usually rest halfway home at a store in Eagle

River. There were a few times when we'd see somebody in the store that would ask us if we wanted a ride.

Mom would give me a dollar or two to buy lunch and then purchase something from, Carr's the store in Eagle River, on my walk home. I would usually buy something for Donnie and me to share. There were a few times when he didn't have money of his own. He got in trouble one night when we were in the store. I don't know what happened, but I wound up having to walk home on that cold winter night by myself from Eagle River. Somebody from the store drove him home. I do remember he got a good spanking from his dad. We lived in the middle of two and a half acres of land, and he lived in the middle of another five acres, and I could hear him getting a spanking that night. I could hear his dad yelling at him and him screaming and crying. The next day at the bus stop and on the way to school, he didn't say much. Eventually, he told me that he had taken something, and neither one of us brought it up again.

After basketball season, wrestling season began, somehow it all worked out for us to participate in every sport at the school. I tried out for the wrestling team and made it. We had about twenty guys on the Junior High wrestling team. Many times we had to wrestle off to secure a certain spot at a meet for a particular weight. I usually wrestled at about 125 pounds. During wrestling practice, I had to wrestle against Donnie. He was bigger than me and wrestled at a

heavier weight than me, but we were the most closely matched against each other. Wrestling practice was difficult, a strenuous workout. We usually had to run every day to maintain or lose weight. We had a long workout practicing our moves on the wrestling mats. We each had a wrestling partner that we'd practice against. It was usually the same person, but sometimes we'd wrestle against other opponents. I had to learn what a takedown was and how to obtain one for points. There was an escape, a reversal, a near pin, and a pin. Each person on the team wrestled for their particular weight but could earn teams points depending upon how they did. After the team was selected, the coach set a rule. He said that we'd all have to shave our heads before the first meet, which was about a week away. Several of the guys went home and shaved their heads that night. I was surprised when they came to school the next day with their new haircuts. They had wrestled before and found it natural. I, along with a few others, didn't like the idea. Each day a few more teammates came with their hair cut. A couple of other guys and I didn't want to shave our heads. We didn't mind getting a haircut, but we didn't want a buzz. Then the day before the meet, the coach told us that the final wrestlers would need to get a short haircut, not a buzz. The other wrestlers didn't think it was fair, but those who hadn't cut their hair thought it was fair. I went home that night and told Mom to cut my hair short, but I didn't want a buzz. She left

my hair about an inch and a half long. When I went to school the next day, the other guys didn't think it was right that my hair was that long, but everyone accepted it. We were a good team, and I learned how to wrestle well by copying the other athletes. Several of those wrestlers eventually went on to win State Wrestling titles for themselves and our high school, including my good friends Don Zimmerman and Bill Watkins.

One day on one of our walks home from wrestling, we stopped in Eagle River to get a snack at the store. There was an older wrestler that said something to Donnie, and he talked back to the guy. Donnie was a big guy and didn't back down from anybody. The guy kept saying things to Donnie, and he kept talking back to him. The guy came up to Donnie and started arguing, and before I knew it, he had thrown Donnie down on the Ice in the middle of the icy parking lot and was beating his face into the ice. It all happened in a matter of seconds. Before I knew it, the guy was walking away, and Donnie had a bloody nose and cuts on his face. The whole time I stood silently because I knew the kid was much older and bigger than either of us. I reached down and helped Donnie pick up his stuff and helped him get up off the ground. His nose was bleeding, and his face was all bloody too. His face was swollen by the time we arrived home, even though it was so cold outside.

We usually had to run every day to lose or maintain our weight for wrestling. We'd wrestle for the school team at meets with all the local teams and would also go to AAU wrestling meets in the area. Those meets were usually held in Anchorage. I usually bought lunch each day at school and ate the things that probably weren't the best for me. We carried our lunches on trays that had a picture of a teal and black colored Chugiak Mustang on it. One day a guy by the name of Joey Cathers came to school on the day of the meet and was eating everything in sight. We reminded him that we had a wrestling meet that day, and he'd have trouble making weight. He told us that he had taken an ex-lax pill the night before, and he was currently ten pounds underweight, and he wouldn't need to worry about it. He ate as much as he wanted and then had a milkshake when he was finished. I really thought it wasn't fair when the rest of us had to watch everything we ate to try and make weight for the meet. At his weigh-in, he was right about that; he was way underweight. After our weigh in we would eat something for the strength and energy we'd need for the meet. On the day of the next wrestling meet, he came to school but looked sad. We asked him what was up, and he said he had taken another ex-lax, but he was still overweight. He never was able to get back to that weight and had to move up to a heavier division.

We'd often practiced in the gym or in the multipurpose room. The multipurpose room was used for everything. We would eat breakfast and lunch there too. We'd practice wrestling and had our school dances there as well. Donnie and I joined the gun club at school because we figured we were shooting our guns and hunting all the time anyways, so why not. When we joined the gun club, we first had to read and study about guns in Mr. James' classroom. One day the teacher invited us to go to the multipurpose room. When we got in there, there were about five or six shooting targets set up. We had to shoot our guns at a target that was set up on a large box that was made with lead. Seems strange to have shooting target practice in school where you eat lunch, but that's what we did.

Just about the only thing we didn't do in there was our woodshop class. That's because we had to use the machinery in the woodshop classroom. I enjoyed the hands-on part of the class. I was familiar with most of the tools because I was used to seeing dad use them around the house. We had to be trained on the big machinery that we'd use. Learning to plane the wood, cut it, sand it, and lacquer it was fun. We had to draw out our plans on paper, choose, cut our wood, and then begin assembling it. Later in the year, we would make our gun racks for Father's Day. Advanced, older students would make large gun cases. Our first project was to make a small magazine holder we made for our mothers

as a Christmas present. It was a project that each of us proudly presented to our mothers that year.

Chapter 13: The Test

I was in my 7th-grade year, and things began happening for me in so many ways. While living in Alaska, we learned to love the outdoors. My younger brother, Oscar, and I loved to play outside. We started playing army outside and building traps all over the yard, which was two and a half acres of land. We had trails that we would follow all through the woods. Building the traps started slowly and developed into a complex game. At first, all we did was dig a small hole in the ground and cover the hole with leaves and sticks. The holes were only about a foot deep or so. Dad always had us digging holes in the yard anyways, and I guess it was a takeoff from that. Whenever we didn't have enough to do, Dad would have us dig a hole somewhere. I guess he wanted his children to understand the meaning of hard work.

We would go separate ways on the property and dig holes and try to camouflage them. Then the other person had to follow the trail and try not to fall into the hole. We found creative ways of hiding the holes so that they couldn't be seen. Sometimes we would put a log in front of them, and other times we would put the log behind the trap. We would dig a pretend hole to help hide the real one. We got more creative with building our traps to try and fool the other person.

Our love for playing army and building traps continued. We even built a fort that had once been a hole that Dad wanted us to dig for a well, and he never used it for anything. We put logs on top of it and dug an entrance so that it became our secret hiding place. One of the neighbor's kids decided to use it for his smoking pit. It wasn't what we wanted, and we told him he couldn't smoke there. He tried to get us to smoke, but Oscar and I didn't go for it, and we told him that we wouldn't allow it. Dad eventually took it all apart and filled the hole.

As the traps became more extensive, it became harder and harder to fool each other because we knew where everything was. We had built the traps, and we knew where all the pitfalls were. We started working together to build one long row of traps, and we let our friends go down the trail. We wanted to see if they could see what was ahead. We had a great time laughing at them as they fell into holes all over the place. They would think there was a trap here or there when in reality, they were fake traps that made them go one way or another into the real trap. One day we got the wonderful idea to send our little sister, Lorna, who was five years old, down the trail of entrapments. She was little and helpless and wouldn't know what a trap was. We told her she needed to run down the trail as fast as she could. As she began running down the trail, she first fell into a shallow trap that left her laughing from the surprise. As she proceeded

down the trail, each trap became deeper and harder to see. She finally fell into a deep trap and wound up getting hurt severely by some broken glass close to one of our traps. She began crying and calling for Mom. We tried to calm her and tell her that everything was o.k., but she knew that she had been hurt and continued to cry. When Mom came out and found out what had happened, she was furious. She said that it was o.k. if we wanted to hurt each other, but we shouldn't let our little sister be fooled by the things that we were doing. Mom made us go out that day and fill in all the traps that we had made. That ended that.

In the winter, we would go tobogganing and sledding. There was a steep hill close to our home. Donnie got me to go over and ride down the hill on a toboggan once. I knew how to steer a sled because you could control it with the steering mechanism on the front. As I would lay on the sled, I could see where I was going, and the metal skis on the bottom would hold well in the snow or ice. Before getting on the toboggan, he told me the way that we could steer it was by leaning one way or the other. As I climbed on behind Donnie, I let him steer; we began going down the hill. We were only on the sled for a few seconds when I felt like it was out of control, so I kind of slid off the side. Donnie continued down the hill to the bottom and into the trees and bushes. It didn't look like it was fun to me, so I didn't try it again.

Later on, when we got a snow machine, we would ride out in the snow all day on Saturdays. I wasn't too big at the time, and those machines were heavy. It was like learning to drive a car but on ice. Once on a Saturday after fresh snow, I asked Oscar, my little brother, if he wanted to go with me. We both got ready and took off into the fresh snow. There was a small jump we would take after it snowed all the time. When we took the jump in the new snow, we would have the softest landing. I asked Oscar to hold on tight and be ready to go fast. I went over it fast, and when we landed, I turned to ask him what he thought. He wasn't sitting on the snowmachine behind me. He had been thrown off and was sitting there crying in the sled behind us that we were pulling. On another occasion I went speeding around an icy corner and turned the snow machine over. I went sliding on the icy road and eventually came to a stop. I hopped up uninjured and lifted the snow mobile to its correct position and continued. There was a little scratch on the side that dad asked me about. I told him that I hit a patch of ice and turned it over. He told me to be careful driving in icy conditions because I could get hurt.

As I began accelerating in sports, I found school to be a little better because I had several friends. One day in 7th grade, the math teacher said they were going to give everyone a special math test for a new math program they were going to implement. They took a couple of days to

explain what would be tested on. Then they gave the test to all the 7th-grade students. I wound up getting one of the highest scores in the class. The math teacher was amazed and suggested to the administration that they place me in the honors math class. Up to that point, I had continued to struggle in school, and it wasn't easy for me. I found a new love for school because I could understand this new math so easily. The other classes were still difficult, and I struggled, but I had hope. They rearranged classes, and I was placed in the class with all the honor math students in the grade. I would have some of the smartest kids in the class asking me how to find the answer to a problem. I could usually figure out the math problems without writing anything down. It wasn't long before the smart kids were all working with me and getting my help. One day, I was asking one of the smarter kids in another honors class for help. The individual said that the answer was in the book. All I had to do was go read to find it. After that, I did the same thing to the kids that were mean to me. I suggested they look in the math book for the answer. I would still help all my friends, and they were amazed that I could figure out the math so easily. My brain had begun to think of math from the time I was young. I just couldn't stop thinking about numbers. Now when I would see numbers on license plates, I could do so many more things. Like square a number, use a factorial. find the square root or cube root of a number. It gave me so many more

options for finding and counting numbers. Thinking of numbers and using them in my mind in my youth helped me to be prepared for the math test. I could often work the problems out in my mind because I had been doing it for so long. Finding the percent of a number or the discount on the price of something became fun to me. I would figure out my batting average after every time I batted by calculating it in my head. Soon other players were asking me to calculate their batting averages as well.

I still struggled in other subjects but did the best I could and made slow improvements with the help of my friends. I was advancing but still having difficulties but feeling like I fit in. One day, I had to give a book report in the advanced Language Arts class. I wasn't used to having to speak in class. I was okay when I had to speak during any of my sports practices but pretty uncomfortable in school. I had become comfortable performing in front of others, but the idea of giving a report was kind of daunting. The teacher had a podium in front of her desk that each person stood behind while giving their report. Each student stood tall and spoke with what seemed such ease. When it was my turn, the teacher called my name. I had to give my report. It felt uncomfortable to be standing, so I moved or kind of pushed and slid a few things on her desk and then sat down. The class began to laugh, but it made me feel better, so I gave my report sitting on the edge of the teacher's desk. I think the

teacher was surprised but didn't say anything to me and let me give my report sitting down on her desk, and I used the podium to put my notes on.

As I gained new friends and developed new skills in math and other subjects, I became more and more confident in my ability to learn. I still struggled with reading, grammar, and spelling. Spelling was the worst. I hated having spelling bees in school because I was usually one of the first ones out. With my newfound educational confidence, I started to play around a little too much. I did take a German class. I figured my last name was German, and it wouldn't hurt to learn the language. Donnie and I took the class together and practiced our German with one another. Dad said that his parents spoke the language fluently, but he had never learned the language. One day I walked up to my German teacher. I stopped and brought my right hand to a square with my palm out and said, "Wie!" which means how. He started laughing because he knew that I was an Indian, and that's the word for how in German. I had heard somebody say "how" in a German movie and knew that's what Indians would say in the movies I watched.

One day in Mr. James's Science class, I was making what we called a spit wad shooter. We would take a Bic pen and remove the middle pen part. Then we would jam one end with a spit wad, and the other end would be stuffed with a paper wad too. We would use the middle of the pen to push

the inserted spit wad, and it would use pressure to pop the other spit wad out with a loud pop. I was making one in class when all of a sudden, I created too much pressure on the pen, and it made a loud pop while the teacher was writing on the board with his back to us.

He slowly turned around and looked at the class and said,

"I know everyone in the class will look at the person that just did that."

I was sitting in the second to the last chair in the row. Everyone began looking at me, so I slowly turned around and looked at the last kid in the row, who was sitting right behind me. He was an Eskimo. As everyone was looking at him, he looked up, puzzled, then shrugged his shoulders and raised his hands in disbelief. The teacher asked to speak with him after class, and he wound up getting in trouble for me that day.

Martin Luther King Junior was assassinated in the spring of that year. In many areas of the country, there were problems with his death and the Civil Rights Movement. We lived in an area where we didn't seem to feel the repercussions of it too harshly. Occasionally somebody would say something to somebody else about being different. We only had a few kids in the community that were Hispanic, Eskimo, Native, Asian, or any other nationality. I think we were protected by our friends and weren't seen as

126

any less than those around us. It was a good safe area to grow up in.

Chapter 14: Winning and Losing

In the spring, I began participating in track which was also new to me. There were so many things to try. I ran the mile, 880 yds, 440 yds, 220 yds. Each of the races was difficult in its own way. Running the mile was difficult because it was hard to keep a steady pace for a longer amount of time. As a 7th grader, the fastest time I can remember was 5 minutes and 14 seconds. I had to run the 220 only a couple of times. I had to try and run as fast as I could, and I found out I wasn't as fast as the quicker athletes. The shot put and discus were similar events in that we were trying to heave a heavy object as far as possible. The shot was a round metal ball, and the discus was like a small plate made of hard rubber. When done correctly, either one could be heaved a good distance. I became above average in the discus but didn't weigh enough to heave the shot very far. The long jump, high jump, and pole vault were similar as well. The long jump required speed and the ability to jump. The high jump required that I be able to run up to the bar and go over the bar without knocking it down. The scissors were the style that most jumpers used at the time. A new style called the Fosbury flop was the style that I learned and used. I had to learn where to begin my approach, run with enough speed, and time my jump just right to make it successfully over the bar. I became pretty good as a high jumper. Donnie and I would often contend for 1st place in that event at every meet.

I didn't win all the time in everything, but I won every one of them at least once while participating in a track meet. It was like the world of sports had opened up to me, almost like it had been made for me. I had lots of energy and was always excited to be participating in something new. During the course of the year, I played baseball, ran cross country, played basketball, wrestled, and participated in track. Each helped me be better prepared for the other sports that I participated in. Now that the school year was over I was finished with the track season, it was time to start all over again.

That following spring, baseball came around, and I practiced every chance I got. Don and I still had to find a way to the baseball field every day. Dad had placed a large cement sewer pipe in our yard. I think it was left from the sewer we put in our yard. I would go out and throw the ball against the pipe whenever I was alone. I would throw it as hard as I could against the pipe. It would come back to me in many different ways. Sometimes as a grounder, other times as a line drive, and sometimes it would be as a pop fly. It helped me with my throwing and with catching flies and grounders. It was a method that I could practice by myself if I needed to.

Donnie and I continued to go to the baseball field and play ball all summer long. He moved up into Babe Ruth League because of his age, but I continued to participate in

the little league program. He would show me how they would pitch differently at that stage. In the little league program, we couldn't steal bases, but now, in his Babe Ruth league, they were allowed to. They would pitch from what was called the stretch. I began learning more about the next level from him. We would either walk or ride our bikes to town almost every day and play baseball. We both were older and had improved quite a bit at baseball that year. By the time the season actually started, I had played baseball hundreds of times. We would go and play all day on Saturday and all day long during the summer months. Alaska was the land of the midnight sun. In the summer, you never really knew what time it was because the sun never went down. It wasn't anything strange for us to come home at 10 o'clock at night because we never knew what time it was. There were probably a couple of the players that wore watches, but we never paid attention to them. Mom would usually give me a dollar or two to buy something to eat while I was in town. We would buy soda and candy or chips and other snacks to eat. We'd always buy those baseball cards that had bubble gum in them. We'd attach the baseball cards to the spokes of our bikes too. I loved the Cincinnati Reds baseball team because my team was called the Reds. My favorite player was Johnny Bench because he was a homerun hitter, and I had developed into a homerun hitter as well. I was out of the house for the day, and Mom was happy that I

was content participating in sports with my friends. Our houses were several miles farther into the country, so when we finished, we had to find a way home. We either walked, rode our bikes, got a ride from a friend, or we hitchhiked home.

We still practiced at the field next to the elementary school. There were usually about 10-12 of us that would practice regularly. Patty Johnson and Roxy Knecht were the only girls that practiced with us regularly. Roxy was the only girl who could hit a home run over the fence, and not even all the guys could hit a homerun. We all got used to each other, and it wasn't uncommon to have any of the players hit a homerun on any particular day. There would occasionally be others that would come and play, but the main 10-12 players played on a daily basis. If one of us wasn't there, then there was probably something wrong, or they had to go somewhere with our family.

One day Don Zimmerman and I were playing football on the baseball field after we finished practicing. Somebody threw me the football, and he tried to tackle me, but I wouldn't go down. So he started spinning me in a circle until I finally fell down on my hand. I fell on it kind of strangely, and when I got up, it hurt really bad. I looked down at my thumb, and it was crooked and broken. It hurt really bad. My demeanor became solemn, and I was ready to go home. I walked home that night holding my hand because it hurt so

bad. When I got home and showed Mom, she looked at my thumb and said it looked broken. She took me to the hospital at the Fort Richardson (Army) instead of the Elmendorf Base (Air Force). One was an army base, and one was an air force base. It was the closest hospital for her to take me to. Mom asked the doctor if he was going to set it. The doctor said he wouldn't need to and thought it would grow correctly because I was still young and growing. I didn't get to play baseball for a couple of weeks, but I didn't have a cast on it either. I started trying to play with it wrapped. I played first base and was a pitcher on our team as well. When I began to throw the ball, I had to throw the ball side arm because my thumb was wrapped. I was what you'd call a junk pitcher. That meant that I could throw a curveball, a drop ball, and a screwball and throw it from three different angles. Now I could only throw the ball from the side. Then something miraculous happened. Holding my thumb extended when I held the ball, creating a new pitch for me. Now my curve ball was curving a couple of feet instead of a couple of inches. When I would throw it during warmups with my friends, they were amazed at what had happened. I had to hold and throw the ball differently, so it wouldn't hurt my thumb. My thumb is still crooked to this day, but my curveball was always good because of my broken thumb.

In the first game of my last year in Little League, I was the number four hitter. The first three players got on base.

On the first pitch, I hit a grand slam to open the little league season. A grand slam is when a home run is hit, and there is a player on every base. It's the best home run that a person can hit. I was one of the leaders in hitting home runs that year for the team and league and eventually made the all-star team again. We had another year of practice under our belt, and as an all-star team, we thought we were pretty good.

It was my second time playing on the all-star team, and it was 1968. Mom attended all my games and cheered me on. I was used to Her, Gloria, Oscar, and Lorna attending as well. Jerry wasn't there; he had graduated from high school and joined the Navy right after that. He had already left for basic training. Cherie wasn't either; she had gotten married to Bob. He was in the Air Force, and they moved away after they got married. It was much different than that first year. I was again chosen to play on the all-star team, but this year Mom made sure I had the right kind of birth certificate. Our all-star team looked pretty good, although our appearance made us appear as a second-rate team. The first game, we played the Anchorage team and won 5-1. Then we played the Kodiak team and won 8-0. It was single elimination, so one loss and a team would have to play in the consolation bracket.

We had made it to the championship game. We were to play the team from the prestigious Elmendorf Air Force Base. They were like a machine, and they demolished the

opposing teams they had played as well. The day of the game came, and upon our arrival, we found that the Elmendorf team had wonderful-looking uniforms. They matched perfectly from one player to the next. They looked pristine in appearance matching from head to toe. Their warm-up jackets completed their uniforms. Our team, on the other hand, went through our warm-up routines with precision, but our uniforms were far from team-like. We didn't even all have the same uniforms. Some of our uniforms were gray, and some were white. I wore a gray baseball shirt with gray pants, blue and white striped baseball socks with white socks underneath, and black low-top converse shoes. We weren't allowed to wear cleats in Little League. They had been put together from different all-star uniform sets. All the players had chosen their own baseball shirts that were worn under our uniforms, so they didn't match. We were close to looking like a complete team. As we approached the time to play, we noticed their side of the bleachers began to be filled up with a band. They had brought the U.S. Air Force band from the base to play at the game. We went through our warm-ups, but I think we were frightened to death. The other team looked intimidating to us! We were the home team, meaning we had to play defense on the field first. Their first batter got on base with a hit, then the second got on base with a walk, then their tall, African American pitcher got up to bat. He hit the first pitch over the center field fence on a line drive. We

all watched in awe as the ball flew over the outfield fence. He ran around the bases, and they were now ahead 3-0. We began to wonder how we would ever defeat a team that was so good. There were no other runs scored on us that inning, and they were ahead 3-0. We then retired the side by getting the last two outs. The same guy that had just hit the homerun was now their pitcher. He started warming up on the pitcher's mound, and we continued to watch in awe. When he threw the ball, it was hard and fast. Now all of a sudden, we didn't feel like we could do anything. We felt as though there was now no chance of winning. We played the best we could, but we felt as though there was no chance of winning. Up to this point, we had believed in ourselves and worked together. We played and practiced and always believed in ourselves and each other. Now we were experiencing something we weren't familiar with. How could we defeat a team that was as good as they were? It was our turn to bat, and we went down one, two, and three. We hadn't scored; we had barely hit the ball. They didn't score again in the second inning, either. Then in the bottom of the second inning, when we came up to bat, there was another strike out, then another out, then one of our players got hit by a pitch and went to first base. The next batter Kenny Deloscher, got up and hit a towering home run shot over the centerfield fence, and the game was now in overdrive. Our bench and our fans began to cheer, and we again had some of our

confidence restored. The score was 3-2, and we were behind, but we felt like we had a chance. It was a grueling six innings of baseball, and we went back and forth, but we could never gain the lead.

It was the bottom of the sixth inning we found ourselves down by a score of 5-4. We were the home team, and so we would have the last at-bat. The pitcher got the first batter out. Then the next player got up and got on base. The coach had selected one of the smallest players in the league to be on our all-star team. He wasn't amazingly fast, he couldn't field very well, and he couldn't hit very well, Mike Terry. The coach called for a substitution in the game, and he was up to bat. Before he got up to bat, the coach told him to go up to the plate and crouch as low as he could, and try to get a walk. He said, "Don't even swing at a pitch." He was probably only four feet, five inches tall, or smaller. He did as he was told and crouched low, making his particular strike zone difficult for the pitcher to strike him out. The tall pitcher did his best to throw the ball right down the middle of the plate, but it was too small an area for him to hit. Low and behold, Mike walked on four pitches. Next, the coach made a substitution pinch runner for him at first base, and Mike Stewart was now the runner at first base. There was a passed ball, and the runners ran to second and third base. The next batter struck out, and all of our players were standing next to the dugout fence. The anticipation of what would happen

kept us standing there, watching and hoping for a miracle. It was the bottom of the sixth with two outs. We were behind 5-4, runners on second and third when the next batter came up. The pitch was made, and our player hit the ball over the shortstop's head, and the runners ran to home and third. The outfielder reached down for the ball but bobbled it for a moment, and the runner from second base, Mike, was being waved home by the coach. By the time the outfielder had gathered the ball and thrown it home, it was too late, and Mike Stewart had scored the winning score.

Our team raced out to the field, and we started jumping around, celebrating. We threw our hats and gloves up in the air and began dog-piling on each other near the pitcher's mound. We were the most unlikely team to win the area tournament. The players on the other team were hanging their heads and crying, and I remember feeling bad for them, but it was a wonderful feeling for us. The Air Force band became silent and began putting their instruments away. The parents, family, and friends began consoling the team members that had just lost. They had been a sure bet to win the tournament and become State Champions. The tournament organizers gathered us together on the field to take a team picture. It wasn't very clear, and I'm not sure who took the picture. It would be sent to be printed in the state tournament guide. Our parents, family members, and fans were jumping and cheering in the bleacher seats and all

around the stadium, waiting to congratulate us. Then we met our fans and continued to celebrate. We would all go to the local Dari Delight in Eagle River to get our favorite ice cream as a part of our celebration. It would usually be a cherry or chocolate-dipped cone, a sundae, or a banana split. I think it was a banana split for everybody that night. I had grown up with ice cream from Dairy Queen around the country and loved chocolate, butterscotch, or, my favorite, cherry-dipped cones. Our family would often get a box of Dilly Bars to eat. Our team sat together, celebrating with our friends and family and sharing our thoughts and feelings about the improbable win. We all went home on cloud nine, wondering what was in store for us next.

We had just won a trip to Juneau to play in the State Championship games, which we didn't know anything about. We had a few days to prepare and practice and upgraded our uniforms slightly to look like we belonged. Our team photographs from that tournament will always make us look like the bad news bears. We rode the train to Juneau and had a great time seeing the countryside of Alaska. It was fun traveling on the train and we'd walk from car to car, especially with the excitement of the wind blowing and watching the tracks zoom by under our feet. We played cards and enjoyed the countryside as we traveled. We saw pheasants and other wild animals on our trip.

When we arrived in Juneau, we again were seen as the underdogs. We had never represented our region in the tournament. Our league was only about four years old, and there were only four teams to choose our all-star team from. The Juneau team was favored to win the state tournament. There were only 4 teams playing for the state title. On the first day of the tournament, we won our game, and Juneau won their game as well. On day two, we were to play Juneau for the state championship. It was an all-dirt field. The infield of a baseball field is usually part grass, and part dirt, and the entire outfield is usually all grass. This field was entirely dirt. We played for the Alaska State Little League Championship, and our team was good enough to win. All the practice that we participated in over the last couple of years paid off. We were the 1968 Alaska State Little League Champions!

By winning the state championship, we were now the state representatives and received new matching state uniforms and a trip to the western regionals held in Vancouver, Washington. We were to be housed in a nearby hotel and went out to play our first game. We wound up losing the first game and needed to play another game the next day. We won our second game and were set to play the third game on the following day. I met a cousin, Daniel Frye, on my Dad's side while we were there. We ate lunch together and took pictures with Larry Ryan, one of our main pitchers.

He asked me if I had ever hit a home run, and I told him that I had. I told him I would hit a homerun for him the next day. We wound up playing against a team that had the biggest player in the tournament. When he would throw the ball, it went by us so fast that we would swing our bats too late to hit the ball. The first time he struck me out, the second time I got up, I decided I was going to swing earlier than I was used to because the ball was coming at me too fast. I began my swing before he had even pitched the ball. I timed the ball perfectly and hit the ball out of the park for a homerun. I had honored my promise to my cousin and hit a homerun that day. We had won two games and lost two games in the tournament. We weren't the regional champs that would go on to play at the Little League World Series in Williamsport, Pennsylvania, but we were content with having played our best. A Team from Japan eventually won the world series that year, where there were only eight teams that played. Most of the guys on our team were tired of playing baseball, and I think we were all ready to go home and relax.

Chapter 15: A Helping Hand

Now that we were finished playing baseball, we had a night to play and relax. All the players on the team got along pretty well. There was a player named Durston on our team who some of the guys weren't good friends with. He was one of the younger players on the team. Sometime in his young elementary days, something happened at school, and he was given a bad reputation by some of his peers. Most everybody played with each other except Durston, and so it was on our trip to Washington. Our leaders had checked us into a hotel with a pool. Being from Alaska, where we lived, we weren't used to having a pool to swim and play in. It was usually a cold lake that we were used to swimming in. It was our last night there, and the whole team was outside playing in the pool, for the most part in the shallow end. We were playing football or some form of volleyball in the water. We weren't used to swimming in warm water, so we enjoyed our time there. It was night, and our team was the only group of people swimming out there. The coaches were sitting in the chairs, watching us. The pool lights gave us the light we needed to see. As we jumped and splashed, the waves of the pool continuously struck the sides of the pool, making shimmering lights all around us. Everybody was playing together except for Durston. Durston was in the deep end all by himself. Occasionally I would watch to see what he was doing over in the deep end. He would step out of the pool

and drop his body into the water right along the edge of the pool. Then he would get out of the water and jump into the pool over and over again. Durston was kind of tall and lanky, and the pool was only about seven feet deep in the deep end, and Durston was only about five foot six or so. Durston continued his lonely escapades of jumping into and crawling out of the water. After a short time, I noticed that Durston decided to change his routine a bit, and rather than jumping from the side of the pool, he would just lift himself up from the edge. Then he would kind of push himself, using the edge, down into the water to the bottom of the pool. I watched and wondered how he could keep himself occupied for such a long time without really doing anything. Those of us playing catch with the football would often get out of the water to chase a ball or to go jumping into the air to try and intercept or catch a pass from a teammate. We would throw, then catch the ball, then tackle one another by trying to dunk each other as a form of tackling. The ball was thrown over my head towards the deep end of the pool. I crawled out of the pool to retrieve an errant pass. As I hopped out of the pool, I looked over to see what Durston was doing. I watched as he was neither at the top of the water nor the bottom of the pool. He seemed to be stuck between the bottom and the top. His arms were going every which way, and it appeared that Durston was struggling to get out of the pool. I looked and thought to myself that Durston was drowning. I took

another quick look, and yes, indeed, he was drowning. I thought for a moment, should I jump in and save him? Then I said to myself, what will everybody think if I save Durston? I took a step to walk away when something inside told me that I must save him no matter who he was. I had been taught from my youth that we were all Children of God. We had been created in the image of God and every life was worthwhile. I had a conscience and it was talking to me and I was listening. I jumped into the pool and grabbed him by the arm, and he grabbed on to me and began pulling me down. I pushed him up so he could grab the edge, then helped him safely out of the water. He came up gasping for air, thanking me for saving his life. Durston had been playing in the deep end of the pool and didn't know how to swim, which nobody knew or realized. After he got out of the pool, he ran and told the coaches what had happened. They were kind of puzzled and came to ask me what had happened. I acted like it was nothing and said I had only given him a hand when I had really jumped in and saved him. In the meantime, Durston ran into his motel room, with one of the coaches following right behind, yelling to everybody that I had saved his life. We all kind of stopped what we were doing, and we all just stood there in the pool. He called home immediately and told his father of the events that had transpired. His father talked with the coach, and soon, the coach and Durston came back to the pool and thanked me

for saving his life. I shrugged it off and said that I had just helped him out, not really saved his life when indeed I had saved his life. When the coach returned to the pool, he and the other coach decided that it was time for us to retire for the evening. The next day we flew back home. The week after we returned, there was a banquet that was held for us. All the players and their families and friends were in attendance. Some of the players that didn't play on the team also attended with us. All the players wore their State team uniforms, including our hats and blue windbreakers. Our State Championship banner was presented to us, and each of the players received a small five to six-inch individual trophy as well. Durston's Dad was the head of the little league commission in our area, and he passed out our trophies at the awards ceremony. As he gave me my trophy and shook my hand, he pulled me close and thanked me for saving his son.

Mr. Wilson said,

"I know what really happened that night in the pool, and I want to thank you for saving my son's life."

I think my mom knew what was going on, and she took a picture of him whispering in my ear. After the season was over and we had returned home to Eagle River, we were like celebrities. Nobody thought in their wildest dreams that we could win the state championship. After the ceremony, they

took a team picture with our three-foot team trophy and our team mascot, Roxy Knecht.

I would now be entering eighth grade, and I participated in every sport I could. I first ran cross-country, then wrestled, played basketball, and finished off the year by participating in track. Donnie and I had become rivals even though we were best friends. We did everything together. We got used to walking to and from school together. Although at least half of the time, we got rides part or most of the way home. We would make up games to play as we walked home. One thing we would do is climb up into these skinny birch trees and climb up as far as we could. Then we would hold on for dear life as we descended to the ground. We called it parachuting out of the trees. The tree would give way without breaking and slowly let us down to the ground.

Every spring, the snow would begin melting, and there were often small rivers of water draining in the ditches on both sides of the road. There was water everywhere. One day we found some large branches as we were walking to town, and we began using them to help us jump over the running water and puddles we encountered. As we continued daily traveling to town, we began to challenge each other to be able to vault our bodies over larger puddles and over bigger objects using those branches. Before long, we found that we were trying to jump over walls and fences. It became more and more difficult to get over some of the taller, higher

objects, and sometimes, we couldn't make it. Occasionally we would have our branch break, and we would find ourselves falling into a puddle or landing on the ground.

We became pretty good at it and found it to be very helpful when we learned to pole vault at school during the track season. It was in 8th grade that we were introduced to official pole vaulting because we attended school at high school. Either Donnie or I would win something at almost every track meet, including now our newest event, the pole vaulting event. It was really fun unless the pole broke underneath us, which had happened with our homemade sticks many times. The whole puddle vaulting experience helped us get ready to learn to be better high jumpers and pole vaulters too. It was the same in everything we did; it was always a competition to see who would win.

After we learned to high jump, we decided to make our own high jump pit at my house. We got some poles and a branch and took some sawdust, and placed it in a landing pit. In track, there was either a pit full of deep sawdust or a big foam pad we would jump into. After it was finished, I can remember how excited I was to jump over it. I went first. We both did the Fosbury Flop when we high jumped. This means you go over with your back first and land on your back. When I jumped and landed on the ground, I had the wind knocked out of me. Donnie looked at me and asked me how it was. I told him we needed more sawdust, but it was fun.

He jumped once, and that was the end of our home high jump pit. He got the wind knocked out of him too.

In the summer months, Donnie and I would do everything together. We would often go fishing in the Eagle River. It was probably a mile from our homes. We'd grab our fishing poles, and tackle box and use whatever bait we could use. Sometimes we would try small marshmallows, worms, salmon eggs, or corn. We would walk out to the main road, head towards the glacier in the valley, then follow a trail to a place we called our fishing hole. We would often stay out fishing all day; we sure had fun. The water in the river was all milky looking, though, because it was glacier water from the canyon. We'd catch a fish called a Dolly Vardin or a Salmon if we were lucky.

There were some small clear lakes or pools along the river that we'd fish and swim in. We were at mirror lake to go swimming one day. I think I was a better swimmer than he was. There was usually a deck out in the deep part of the lake that we could swim out to. The water was cold, so we would usually swim as fast as we could. Donnie jumped in first, and I jumped in after him. He got about half way there when I could see that he seemed to be sinking. So I caught up to him and grabbed him to help him. Luckily there was a 50-gallon barrel in the water that I could feel with the tip of my toes, and I tried to help him. He was much bigger than I was, and so I lifted him slightly and told him there was a

147

barrel he could step on. He stepped on the barrel and waited to catch his breath in the cold water. We waited for a few moments, and then we continued, and we both made it safely to the deck.

We would go hunting occasionally too. We used to go out and shoot rabbits, squirrels, and little birds. It was so much fun to shoot the little birds and just watch them drop straight to the ground. Then I heard a talk at church once about shooting the little birds. The speaker said that we should leave the little birds alone; the little birds were made by the Lord for us to enjoy. The scriptures tell us that God even took care of the little birds. I felt like the Lord was talking to me, and I felt really guilty. I never shot another little bird after that.

Chapter 16: An avalanche

During the winter of my 8th-grade year, dad had this gun that he had bought at a gun shop. It was a special gun called an over and under. There were three or four of them, and he decided to buy them all. He then sold the extras to his friends, that wanted them as well. An over-and-under rifle shoots two kinds of bullets. It shoots a shotgun from one barrel and a slug or bullet from the other barrel. It's similar to a double-gage shotgun, but instead of the barrels being side by side, there's one barrel above the other barrel. It was a gun that my dad cherished. One cold winter day my friend Don Zimmerman and I decided we wanted to go hunting up on the mountainside. I approached my Dad and asked him if I could use his gun to go hunting. Of course, he was hesitant. I was about 13 or 14 years old at the time. People don't usually just give their favorite gun to a 13-14-year-old boy, even if he is your son. Well, for some reason, he gave me the gun to go hunting, and Donny and I went up on the mountain to hunt. He told me to be very careful and not lose it. We were at a place on the mountain that was called the saddle or lower part of the mountain. We rode our snow machine up the mountain on that cold winter day to see if we could find anything to hunt. We were at the lower part of the mountain and couldn't really see all around, so we decided to hike up to the higher part of the mountain. We thought it would be a good idea to leave the snowmobile there. When we got to the

top, all we could see was white for miles. There wasn't a trace of an animal anywhere. The wind was blowing snow, and it was cold. As we got up to the top, we noticed that the snow had become hardened, and we were able to walk on top of the snow. Usually, we would sink into the snow, which made it hard to walk through. We pounded on the snow with our boots. We stomped and jumped on the snow, but it was as hard as concrete. So, Donny and I had a wonderful idea. We were going to go over the sloped side of the mountain and look around. As we peered over the mountainside, we found that the winds had caused the snow to get hard and crusty everywhere. We did some more stomping with our boots and found that we could make holes in the snow with our boots in certain areas. We also found that some of the snow was not hard at all and that it was very deep. Soon we discovered that only over the sloped edge was the snow hard and crusty continuously where the wind hit it. Before long, Donny and I were sliding across it just a little way and using our heels to stop us. We decided that we could have a contest to see who could go the farthest down the slope without sliding down into the valley. First, I went to see what it was like; then he went, then I went, then he went. Each time the person beat the previous record. In the winter there isn't daylight for many hours of the day, and we could already tell it was starting to get dark. There were only a few hours of sunlight in the winter each day. Realizing we

couldn't do this all day, we decided to make one last attempt to try and win our newest competition. Winning against each other was everything to us. We had competed against each other for years in baseball, basketball, track, wrestling, cross-country, and everything else we could find. It was final. We would have one last attempt, and we would both go at the same time. We were both determined not to lose. We counted one, two, three, go. As we slid down the slope, we watched each other to ensure that each was going to be the winner. The heels of our shoes were scraping into the hard snow as we grabbed the snow with our gloves to try and stop ourselves from going down too far. When suddenly, the pressure from our heels made the whole side of the crusty snow give way. Inadvertently we had caused the entire mountainside of snow to slide, and we were in the middle of it. Before I knew what had happened, Donny and I found ourselves sliding down the mountainside in the middle of a snow slide. I can remember as we were sliding down the mountainside, looking over and seeing Donny sink into the snow, and then he'd pop back out. Each time he did, I saw him gripping his rifle as tightly as he could. I can't remember if I was going through the snow or under the snow, but I knew that I was scared. After about 15-20 seconds of sliding down the side of the mountain within the avalanche we had created, we came to a rest at the bottom of the saddle part of the mountain close to where we had started. I remember

Donny popping up out of the snow, and he was covered with snow.

Donny had a big smile on his face and said, "Do you still have your rifle?"

I wasn't even sure where I was, let alone able to tell if I had my rifle or not. I looked down, and my rifle was nowhere to be found. Donny and I started immediately looking for the over and under and continued looking for the rifle for as long as there was sunlight. We got too cold, and too tired, and it became too dark to look any longer. We hopped on the snow mobile with the headlight on and started for home. The trip down the mountain was a cold, quiet one that day.

We had determined that we would have to go back home, and I would have to report the results to my dad. It was one of the hardest things that I had ever had to do. My Dad had been a Chief in the Navy. Sometimes I wasn't his little boy; I was one of the sailors that worked for him. I didn't know what to do or what to say. I was hoping that I was his little boy and not one of his former sailors that day. We had visitors in the house that day, so I went in and told Mom, hoping that she would tell Dad what had happened. She told me it was something that I'd have to tell him. After walking around outside for a little while, and letting the visitors leave, I mustered up all the courage I could and went into the house. He asked me if we had success on our hunting trip. I hung

my head low and told him that we had not. Then I proceeded to tell him and my mother that we had been in an avalanche and I had lost the gun. Thank goodness for Mom, she expressed how glad she was that I was alive, but that didn't stop Dad from inquiring about his prized rifle. I told him that I had lost his gun during the avalanche. I told him that Donny and I had looked for it as long as we could, without success. He told me I would have to work it off somehow. It was one of the worst things in the world for me to disappoint my father. Especially when it felt like he really trusted me. I had a difficult time knowing that I had let my Dad down that day, and I was determined to make it up to him in some way.

I'll never forget the impact that an individual left on me one day when he said, "You can replace furniture, cars, or any material possession, but you can't replace your kids."

Chapter 17: The Find

Spring in Alaska can be murder, with melting snow happening around everywhere. It didn't seem to come fast enough for me that year. I was looking forward to baseball, but even that wasn't at the forefront of my mind. When the snow melts, it creates mud and water running everywhere. I watched the mountain each day and wondered when the snow would be gone from the top. One day it looked like most of the snow had melted on the top of the mountain, and I decided to go and look for my father's gun. I had worried about that gun for the entire winter. I was determined to find that gun. It was a Saturday, and I told my Dad that I was going to go up to the top of the mountain. It took a lot more time and energy to walk up the mountain because I didn't have a snow machine. As I approached the saddle area, I looked and looked without much success. Plants had begun to grow, and I couldn't quite remember where it was that I had landed. I hiked to the top of the mountain to see if I could recall where it had all started. I walked my way down from the top of the mountain, and I tried to imagine where it was that I had landed. I tried to recall where Donny was, where the snow machine was, and what my surroundings looked like. It looked so much different without all the snow everywhere. Then I saw something shining in the tundra. It was the gun, and I ran to retrieve and pick it up. It no longer looked as it did when I took it hunting in the winter. It used

154

to be new and shiny looking. It had rusted, was worn, and looked like an antique. The important thing was that I had found my Dad's missing rifle, his prized possession. I quickly started my descent down the mountainside with a rifle in hand. I studied it, looked at it, and gave it the once over about twenty times. I was happy but sad. Would my dad want this old gun? It was not the same. I was still proud of myself for finding the gun. I don't think that I understood then as I do now. I later realized that the gun was not his prized possession; I was. On that cold winter day, I'm sure my Dad was disappointed in me, but I was sure he knew that he could replace the gun, but he could never replace me. When I returned home, I showed him the rifle, and he was proud that I had found it. Then he told me to wait there for a few minutes. He came back and handed me some chemicals and asked me if I could try and polish it up a little bit. I worked on it for quite a while, but it would never look new again. I think that was my punishment for losing the gun.

Later that year, Donnie and I went back up on the same mountain to go hunting. When we got up to the top of the mountain, we searched the area for deer, moose, sheep, or anything we could see. Then we spotted a black bear coming down from the mountain behind our mountain. We quietly got up and ran back down the mountain to the house and told Dad. He told us to hop in the truck and take him up to see where the bear was. He brought my sister's husband, Bob,

up with us. We drove as far as we could up the mountain in the truck and then walked the rest of the way. When we got to the top, we all slowly started walking down toward where the bear was. When we got close enough, both Bob and Dad prepared their rifles. They had scopes on their rifles and decided they would shoot at the same time. One of them counted one, two, three, and then they shot at the bear, and it went down. It was quite a ways away, probably 50 yards away, and so we went back to the truck and drove the truck back down the mountain. There was a road between the two mountains that would take us closer to the bear. The truck stopped, and Dad and Bob got out of the front of the truck, and Donnie and I hopped out of the back. We had to walk about 30 yards to the bear. When we approached the bear, it looked like their shots had killed it. We approached the bear then Dad shot the bear one more time to make sure it was dead. Then Bob took his rifle and tried to move the bear with the end and kicked it to make sure it was dead. Bob reached over and lifted the bear's head, and suddenly it growled. We all jumped back, and Dad and Bob shot the bear several more times. The bear had air in its windpipe, and when he lifted the bear's head, it came out as a growl. After they shot the bear, we all carried the bear down and put the bear in the back of the truck. Don and I sat in the back of the truck with the bear, and we took the bear home, skinned it and kept the bear meat to eat. The only person that got a picture with the

bear was my younger brother, Oscar, who wasn't even with us on any part of the hunt.

In the winter, we would sometimes go hunting with Dad. Mom and Dad loved the taste of wild meat, although I didn't particularly care for it. I loved good old ground beef from the grocery store. On one trip, Dad took us up north to Lake Louise with him to go hunting. By now, I had my own rifle. It was a 30/30 Winchester. He rented a small cabin for us to sleep in. It was a little bigger than size of a large tent; it had an outhouse and a potbelly stove too. Dad, Jerry, and I went out and hunted for, and we shot and killed a couple of Caribou. The Caribou would travel in large groups during their migration, with many times thousands in a herd. After we took them back to the cabin, Gloria and I went out to ride the snow machines on the lake. We hadn't gotten too far before we were freezing, so we returned to the cabin. When we went into the cabin, we were so cold, and I told Dad that he needed to put more wood in the stove. He told me it was burning as hot as it could get. I lightly placed my hands on the stove and could barely feel any heat from the stove. Then I opened the stove and could almost touch the fire and could hardly feel any heat. We had already gotten our things ready to leave, and Dad was getting the car and trailer ready to leave. About then, Dad opened the door and said the car wouldn't start. He said the oil was freezing, because it was 70 below zero outside. He actually took some of the wood

out of the stove and built a small fire under the engine to warm it up. When it warmed up enough, he started the engine. He told us to get our things; we were leaving right then. It took us a few hours to get back home. When we arrived home, it was dark and snowing, so it was about 32 degrees at home. We had experienced 70 below zero, and now it felt so warm outside at 32 degrees. I was running around outside in the snow without a coat because it felt so warm. It was a change of 102 degrees in one day. Mom kept telling me to get in the house or to put on a coat.

We had traveled from Corpus Christi, Texas, to Anchorage, Alaska, and finally landed in Eagle River, Alaska. There had been so many changes, and I had attended three different schools and lived in three different places. The only thing that didn't change was we still had our faithful dog, Prince. He was the best dog a person could ever have. He was very obedient and was always so playful with all of the kids. We often took him hunting, and he went with us when we went fishing too. Jerry was kind of the one assigned to take care of him. Sometimes he and his friend would try and get our black Labrador and his friend's German shepherd to fight. Dad found out and told him he better never have that happen again. He had traveled with us up the Alcan highway and been there for us on our journey. After a few days of illness and care, he would return to his rambunctiousness. One day we could tell Prince started

feeling a little ill and had some kind of growth around his nose. Each day the growth got a little worse until it covered his nose, mouth, and all around his ears. I'll never forget the day Dad came out to visit Jerry and me as we sat near Prince. He came out with his rifle and told Jerry he'd have to go and put Prince down. There was nothing else that we could do for him. So Jerry untied Prince and asked him to follow him out into the woods. I think the whole family was crying as Jerry walked away with the dog. We stood there watching as he walked over a small hill and into the woods with Prince. Then after a few minutes, we all heard one shot from Jerry's gun, and Prince was gone. We all cried. I'm sure it was more difficult for Jerry; he had to shoot, and bury Prince.

About that time, Dad bought us a horse. I think he felt that it would replace the loss of Prince. He taught us how to take care of the horse by feeding it, housing it, and riding it. One day I took the horse out to ride it around the block. There was a telephone line trail that I would ride the horse on. As we were approaching our property, I gave the horse a nudge to gitty up or go faster. At about the same time, we were approaching a telephone pole. The horse began to trot next to the telephone pole, almost like it was trying to rub me off his back. I lifted my left leg so I wouldn't get scraped against the pole when the horse instantly bucked me off. I wasn't sure what had happened, but I knew I had been bucked off and was lying on the ground. I picked myself up

and limped over to the house. Dad was outside and asked me why the horse was trotting around the yard without supervision. I told him that the horse had bucked me off. He wasn't happy about what had happened. He returned the horse to the former owner that day and said he had changed his mind about owning a horse.

One day in the middle of the summer, I don't know if it was because Prince was now gone if he couldn't find somebody else, or if Jerry just wanted me to go with him. He asked Mom if we could go fishing and cross the Eagle River. He only told me we were going fishing. So, we walked a couple of miles down to the fishing hole that we always used. When we got down there, we fished for a short while, and then, Jerry said,

"Okay, let's see if we can cross the river somewhere close to here."

I looked at him, puzzled because it was already late, even though it was light outside. We walked downstream a short distance, and he said,

"Okay, we'll cross here."

 The Eagle River is an ice-cold river that is created from a glacier that is up in the canyon. The water is kind of gray and murky. So when he said we were going to cross, I knew that it was going to be cold. I think Mom didn't want him to

be alone. So we started crossing the river in our clothes, with nothing to change into. It was deep enough that we had to start swimming about a third of the way across. When we got about halfway across and were treading water, we spotted a beaver that started to swim towards us and began slapping its tail at us. Jerry said, we better not cross here, and so we went back to shore, and he decided we'd cross elsewhere. After ten to fifteen minutes of walking farther downstream, Jerry found a place to cross the cold river. When we finally got to the other side of the river, I didn't know where we were going, but we walked for a long time on a dirt road. I know it was early in the morning, like 3 or 4 o'clock in the morning. I got so tired but had dried off somewhat until I couldn't walk any longer. Then we found a large tree next to the road. There was an area under the tree, like a cave, where I could lie down. About the time I crawled in to lie down, Mom came driving up in the car. I was so glad to see her. She asked where we had been, and Jerry explained what had happened. She told us that she had been up and down the road several times looking for us and had become worried that something had happened to us. She was happy that we were safe.

There were things that we had to get used to in Alaska. There was always an adventure around the corner. Donnie and I would go swimming in a small pond near the Eagle River, where the water would run into. We'd stand on large

rocks and look into the crystal-clear water. We'd jump into that little pond when the water was so calm and clear. We'd feel the top of the water, and it wouldn't feel too cold. Then when we'd jump in, it would be ice cold and would take our breath away. The sun had warmed the upper part of the water but underneath the water was still very cold.

One day Donnie and his Dad asked me if I wanted to go fishing on the other side of the Eagle River with them. I told them I wanted to go, so I gathered my things, and we drove to the south side of the river. When we got out of the car, his dad had a rope with three sixteen-penny nails welded together and bent like a large fishing triple hook, and the ends were sharpened too. At the top, there was a metal hole for a rope to go through. In the middle, there was a weight welded to the bottom of it. When we approached the river, we could see the Red Salmon swimming upstream. There was Red Salmon everywhere. They were so big you could see a large part of their body sticking out of the water as they swam. I could see their top fin, and they were a bright red color. It was a stream where they were laying their eggs, and there were so many of them. Donny and I went one way, and his Dad went another way.

Then Donnie said,

"Let me show you how to do this."

He threw the hook and rope out and tried to hook a salmon. He tried several times but wasn't able to catch a fish. One time he snagged a fish with the rope, and one of the nails bent, so we had to fix it. I kept telling him that I'd be able to do it, so he gave me the rope and hook. I had to throw the hook upstream and time the moment when the hook would be over the fish, then pull the rope. It was on the third try that I hooked a salmon. It was so strong and powerful that it began swimming away from me, so Donnie grabbed the rope, and we pulled the fish in together. Right, when we landed the fish, Donnie yelled, "run!"

I watched the fish flopping around on the ground in front of me with the hook in its side and the rope next to it, and Donnie was running away from me, fast. When he took off, I didn't know what was going on, but I dropped everything and began running with him through the woods as fast as I could. After we had run for several minutes, we stopped, and I asked him what was happening. He told me that it was illegal to poach salmon.

I said, "I thought we were fishing!"

To which Donnie replied, "Yeah, we were poaching, and that was a forest ranger walking towards us!"

His Dad had already seen the ranger and was in the car waiting for us to leave. Luckily,

I found out it was illegal and wasn't caught. It only happened once. I had learned my lesson.

Chapter 18: Feeling Good

I had become comfortable in Alaska. I had won a state championship, experienced and excelled in other sports, and made lots of friends. It was 1969 now. It was in July of that year that Apollo 11 landed the first man on the moon. We watched on television as Neil Armstrong walked on the moon. It was also the summer of Woodstock. Music and life were changing quickly. I remember seeing a few people return from college, and they had changed; the guys had long hair and dressed so differently. There were protests around the country with the flower child or hippie that began to emerge in our lives. It was an exciting time in my life. One of my friends from church, Johnny Womack, had learned to play the guitar. It would be really cool if you could play the guitar at that time period. We had our opening prayer and pledge of allegiance and did all of our opening exercises for scouts. Afterwards Johhny showed me his guitar and how he could play it, he let me try it. I went home and asked my parents if I could get a guitar. After some time, they bought me a guitar. I remember Mom taking me to Anchorage to learn to play it correctly. In my first lesson, the guy was teaching me how to play each note. He talked about the frets of the guitar and explained to me how to hold each string. He tried to teach me how to read the notes in a music book. He presented me with a learn how to play the guitar music book. I looked at the notes on the paper, and they didn't

make sense to me. I held the neck of the guitar with my left hand and held the rest of the guitar against my torso and in my lap. I did my best to hold down the strings between the frets like I was told to do. Then with my right hand, I used the guitar pick to pluck each note. It didn't sound the way that I thought it would sound. Most of the notes were not sounding very good, and my fingertips were hurting from pressing against the metal strings. As I tried to change the fingers on my left hand from fret to fret on the guitar, I found it difficult to hold the guitar string against the neck completely. I plucked the guitar strings, and I realized it didn't sound the way that it should. I didn't want to play the notes; I wanted to play the guitar like Johnny. It was a painful hour to practice something that I wasn't interested in doing. I told Mom and Dad I didn't want lessons from the guy at the music store anymore. I wanted to learn to play the guitar like Johnny, so I took my guitar to him. He taught me a few chords, D, C, G, and F, and I began playing my first song, House of the Rising Sun. I knew the words and soon began singing along as I played the song. I learned to strum the strings and began picking the notes with my right hand as I held the chords. I practiced playing the chords every chance I could and began getting the hang of it. Once I learned a few more chords, I could play several songs. Before long, I could play just about any song that I had chord music for and sometimes could figure out how to play a song without any

music. The single note on a page didn't make sense to me, but the chords, I understood. It was probably that I wanted to be able to master playing more quickly and didn't want to read the notes. Then I asked Mom if she would buy me a record. The first album I ever had was Glen Campbell's Gentle On My Mind. I would listen to it and try to pick out the tune and play chords as the songs would play. In the winter time, when there wasn't much to do, I would play my guitar for hours on end while listening to music on our record player. I loved playing records that Jerry, Cherie, and Gloria had as well.

I was beginning to feel like I was a little bit different from the other kids that had become my close friends. Nobody ever said anything to me about being different. Mom would occasionally say things about me being so good at sports because of my Indian Heritage. That was the term we used back then. I didn't really understand what she was talking about. I didn't think I was an Indian, but I was. It was only myself, and our family that were Native in the community; the Knecht family were Japanese, and there were a few Eskimos in our community too. Besides that, the community that we lived in was pretty much non-Native.

By 9th grade my life seemed to be coming together. There were a few obstacles here and there, but I had grown a lot and was about five feet nine inches tall. I had lots of friends, got along with my parents, and loved life. Mom had

opened a beauty salon at one end of our trailer. There were always different women from the community coming and going out of her shop. Occasionally she'd wash and cut my hair too. She would always wash my hair first. She'd have me sit in her swivel chair; then she put a brown plastic cape around my neck and secure it. I'd have to lay back in the chair, and she'd turn on the water and begin testing the temperature with her hand. Then she'd wet my hair, get the shampoo and begin washing my hair. It always felt so good to have her massage my head for a minute or two. Then she'd add conditioner, rinse and dry my hair slightly; then I'd have to sit up. She'd put my hair up with hair clips. I would sit in her swivel chair and watch in the mirror as she would cut my hair. I would make different sounds and question everything she did. She'd tell me to relax and reassure me that she knew what she was doing. Then she would adjust the angle of the chair so I wouldn't be able to see her in the mirror. She would cut my hair in layers. She would have my hair clipped with about twenty clips; then she would undo one clip at a time and begin styling my hair. It was much different than when dad would cut it. He'd put me in a chair, cover me with a cape, then buzz the sides and cut the top. His preference was to buzz the whole thing because it was easier for him that way. I stopped having him cut my hair because I didn't like wearing my hair short. There were a couple of times when Donnie or others came by, and I had my hair up with

clips which was a little embarrassing, but it was still better than a buzz. He'd laugh, but it was much better than his father's bowl cut that he'd receive.

There were times when she would be busy doing somebody's hair, and we'd want or need something from her. Mom always had a way of making us feel special. I knew that I could always talk with her and ask for her help. If we ever needed anything, she was there to help. She didn't really want to work away from her children. Working at home was a way to make sure she was around if we needed her. Mom would have cases of TAB (soda) in her shop that she would give to her customers when they came to get their hair done. Tab was a diet soda back then, before we had diet Coke or Coke Zero. From the time we were young, she used to give us a drink or a soda and hide us somewhere in the house so nobody could find us. Over the years, we called it soda, pop, soda pop, or a Coke, especially after living in so many different parts of the country. She would open a bottle of soda or give us a treat of some kind and take us to a place in the house where we wouldn't be seen or heard. She told us we had to be really quiet and not tell anybody what we were doing or where we had been. She would often put us in a closet somewhere and tell us to sit quietly while we finished our drinks. I think she did it so she could keep her sanity. She would tell us how special we were, and she would then tell us that she loved us so much but didn't want

to make the other kids jealous. So we weren't supposed to say anything to anybody.

One day while she was busy doing somebody's hair, she asked me to be really quiet and take a drink and sit in the closet. I went to the closet, and to my surprise, there was my sister sitting in the closet, drinking a drink just like me. Before the door closed all the way, I looked at her, and she looked at me, and then we both showed each other the drink that Mom had given us. I didn't care if she had a drink, and she didn't care that I had a drink, either. We still both felt special. We sat quietly, whispering, and laughing in the dark about how special we felt and finished our drink. When we finished our drink, we took the bottle and put it where it belonged, and went our own way, knowing that we were loved.

I was happy with my new life even though there were some ups and downs. Later that year, Gloria had her appendix burst during the school year and had to stay in the hospital for several weeks. We attended church, and I felt comfortable and at home attending there. I enjoyed my responsibilities in the church. I remember Mom being so proud of me when I prepared or passed the sacrament. I attended church on Wednesday evenings and did a little bit of scouting with them, but I was usually too busy playing baseball or another sport. I did become a tenderfoot in scouts. We would go on hikes and do some camping too.

When we went camping, Dad would usually have me take some of his K-rations to eat. They were foods that military personnel would pack with them when they were out in the wilderness. They usually came in a box and had in a can some kind of main dish, a fruit, and some bread or crackers. It was much better if you were really hungry, but It wasn't something that I really enjoyed. Dad was used to having them because they used them in the Navy.

One day at our young men's activity, Johnny rode his new motorcycle to church. He was so excited and was letting everyone ride it. He finally let me try to ride it, and I stalled it about 3 times when he said that's enough. I was so disappointed and couldn't forget about it. My mind kept thinking about how to use a clutch. I didn't know or understand what a clutch was supposed to do. Then one night, in a dream, I could see myself riding a motorcycle. In the dream, I knew how the clutch worked and was riding all around on the roads and in the hills. When I woke up, I was so excited to go back to see Johnny. The next week, sure enough, Johnny brought his motorcycle to church, and I asked him if I could ride it.

Johnny said, "No, I better not let you try again."

I said, "No, I know how to ride a motorcycle now."

With a little persuasion, he let me try again. I hopped up on the bike and adjusted the kickstart, stood up on it, and pushed it down with the weight of my body.

The engine started, and I looked over at him and said, "One up and three down?"

He just nodded his head yes. That's how the gears on a motorcycle are used. I pulled the clutch in and revved the engine a little. Slowly I released the clutch and gave it a little gas; then, I drove away on the motorcycle. I went from first gear to third gear without a hitch and drove down the dirt road. I could feel the power of the motorcycle as I drove down the road. After about a mile, I slowed down and then turned around. Again, I went through the gears, first, second, third, and then fourth gear. It was exhilarating to drive the motorcycle down the dirt road. He was amazed that I had learned how to ride the motorcycle and asked if I had practiced on someone else's motorcycle. I told him I had learned in my dreams. He looked at me, puzzled, and I looked at him with a kind of look that made him think I was kidding, then we both laughed.

Chapter 19: Life Changes

It must have been in the late spring or early summer, I think in May, June, or July. My younger brother, Oscar, had gotten a new twenty-two rifle from Mom and Dad for his birthday. Living in Alaska was wonderful as a young man. We would go out and go hunting at the drop of a hat. Oscar was outside shooting his new rifle, although he was only about nine or ten years old. I was in the house with Mom. Jerry had joined the Navy, and Cherie was married and living in Pennsylvania. I can't remember where everybody else was. All of a sudden from the house, we heard a gunshot go off, and immediately after, almost simultaneously, we heard a loud scream. Mom was standing in the living room and I was sitting on the couch when she stopped in her tracks, and I knew what had happened. She and I both thought that somebody had been shot. She put her hands to her chest and then slowly fell to her knees and was struggling to stand up. Then she went from her knees to lying on the floor. I ran to her aid, then immediately, Lorna came in and was crying. She said he had been stung by a bee. Both Mom and I thought that one of her children had been shot. Because of that thought, it had caused her to suffer a heart attack. Gloria came, and together, we tried to assist her. I can't remember who, but someone called the doctor. It was 1969, and 911 had been established as an emergency number across the United States in 1967. I think either Gloria or myself had

called the number. An ambulance arrived. The paramedics took out the gurney and rushed to the house. We escorted them to the place where Mom was laying on the floor. After a quick examination and a few questions, they placed her on the gurney, rolled her to the ambulance, and took her to the hospital in Anchorage. There were four of us children that stood there in the house as they drove mom away. We had tears in our eyes and didn't know what to do. It wasn't long before Dad came home from work. He had heard that something had happened but wasn't sure what was going on. We explained what had occurred, and he quickly showered, changed, and then went into town to visit her there. I had to stay home with Gloria, Oscar, and Lorna. When Dad arrived at the hospital, he received bad news from the doctors. Mom, indeed, had suffered a heart attack. The doctors needed his permission to get started right away. Dad gave his consent, and they operated immediately. They needed to perform quadruple heart bypass surgery on Mom. There were some tense moments and a few difficult days that followed. After Mom made it through the operation successfully, the doctors notified Dad that She would only have five years to live at the most. Maybe ten if she would move to warmer weather. After Dad heard the news, he went home and began selling the land and trailer that we lived in. He told us to begin packing; we were going to be moving. We questioned what he was talking about, and he told us we would be moving to

the lower forty-eight. That's a reference the people in Alaska use to talk about the United States below Alaska, but excluding Hawaii. We began packing but didn't know exactly what we were doing. We packed our things the best we could. He had almost everything packed and ready to move by the time Mom was out of the hospital.

Mom and mostly Dad decided we'd move to Washington, where Mom was from. This time we weren't asked, and they didn't try to persuade us to leave. We were told that we would be leaving as quickly as possible. There were only the 6 of us at home now. The climate in Washington was warmer, and Mom knew people there, including family that could help. They also thought that Dad could get a job there easily. Within a matter of weeks, my family was moving to Washington. I begged Mom and Dad to please let me stay in Alaska to finish the baseball season. I had made the all-star baseball team again for the fourth time in a row, and we had another good team. The all-star team was made up of some of the teams from Anchorage from the Babe Ruth division. Other community members heard the news of Mom's medical situation and offered to help. A family by the name of the Bullocks offered to let me live with them until the end of the season. Mom and Dad agreed about the decision that I would stay with the Bullock family for the rest of the summer to finish out the season and compete on the all-star team. I think it made it easier for them

to go with five people rather than six people. Although I would be able to help them physically, I wasn't even close to ready to move mentally. I was fighting against it.

That summer Donnie and I made the all-star team along with Bill Watkins. In one of our practices, the coach decided that he would try me out at shortstop and Donnie out at center field. There are rules for who can catch the ball when it is hit to certain places on the baseball field. I had always played first base, and Donnie always played left field. We knew the rules at those positions, but we were new to these positions. The coach explained everything to us and then began hitting practice fly balls between us. Then he hit one between Donnie and me. I directed the infield and Donnie was in charge of the outfield. If the ball was hit between us, the first one to call would catch the ball, but the outfielder was to call off the infielder. As I started running back to catch the ball, I yelled, "mine!" In the meantime, Donnie began running forward towards the ball and yelled mine at the same time. Then we both yelled mine one more time at the same time. Maybe it was our competitive nature that we had achieved over the years that had set in. I was going to catch the ball, and he knew he was going to get it as well. Then I turned to catch the ball, and Donnie leaned in to catch the ball, and we collided. My head hit him, and he came down on me. We both went down, I was passed out for a couple of seconds, and I think he might have as well. Then

the coach came running to assist us and asked us if we were both okay. With both being a little dazed, we looked at each other. Donnie slowly looked up at me and was holding his hand over his mouth. There was blood all over, and when he moved his hand from in front of his mouth, he was missing his top four teeth. I looked at him and started laughing; I think I was still a little dazed; it felt kind of like a dream. He looked so different to me. One of the coaches escorted him to a car, and he was taken to the dentist, where he was fitted for his new front teeth. The other coach decided that we'd end the practice for the day. I had a headache but felt bad for having an accident with him.

One summer evening, after the school year was over and I was staying with the Bullocks, they had a party at their house for all their children. I was with Steve and all of our friends in their house. We played card games and spin-the-bottle. A bottle is placed between the group that is sitting in a circle. A person spins the bottle, and whoever the bottle points to has to kiss the person that it points to. It was finally my turn to spin the bottle, and when it stopped, It landed on Roxy. She was the first girl that I ever kissed, and I had a crush on her. We continued to play other games for a while including twister and eventually we all decided to go outside. The oldest family member had graduated from high school, and it was easier to have a party for all their children at once. Most of my friends were there with us that night. The older

graduates began partying a little more than us and began drinking alcohol. We watched as they began doing things that weren't made with good judgment. My friends and I went outside and gathered together as a group. We huddled together, and everyone put their hands in the middle. Then one of the members of the group said let's make a pact with each other. Let's promise each other that we'll never smoke or drink.

Then the group, in unison, said,

"Yeah."

It was a Moment in my life that I'll always remember. I had already made a promise to God that I would never smoke, drink or do drugs in my life. Now I was making a covenant with Him and myself out loud. I had made the covenant with him at church, called the word of wisdom, which promised me physical strength and stamina, with increased spiritual blessings as well, if I would omit smoking, drinking alcohol, and drugs from my life.

I stayed with the Bullocks, and I enjoyed living with them, but I felt out of place. The younger son, Mark Bullock, and I became good friends. He and Bill Watkins, and I started doing things together that summer. I was in the graduating class one year ahead of them but was really the same age as them. I lived farther away from Donnie now and didn't get to see him as much. One day Mark and Bill, and I

hitchhiked to Anchorage just to have something to do. That was about 10-12 miles away. It's hard to believe we would have done that, but many people did it back then. As we were walking along the road, we saw a policeman that had pulled over somebody. One of the three of us had the idea that we should pretend to be running away from the officer. When the officer looked at us, we all ran into the woods. After we had run about twenty yards, Bill ran into and was stopped by a barbed wire fence. I ran into him, and then Mark ran into me. He tried to stop us, but we had been running too fast. His hands and legs were a little cut from the barbed wire but were, for the most part, okay. We continued to walk in the woods for another ten to fifteen minutes and then came back out onto the main road. It was about another ten minutes that the same officer pulled up next to us. He asked us our names and what we were doing. We told him our names and that we had just walked into Anchorage. He then told us that he was looking for three runaways that fit our description, and he wanted to see if it was us. We told him that we lived in Eagle River and that we were on our way home. He told us to be careful and then let us continue our walking, or hitchhiking back home.

Our all-star Babe Ruth baseball team wound up winning the state championship again that year and got a trip to Centralia, Washington, to play in the western regionals. As winners, they would fly us to Washington. It was the second

time that I had flown. I thought it was the greatest thing in the world. There were several of my friends that saw us off at the airport. They knew that I was leaving and might not come back. I didn't know if I'd ever see them again, either. I was traveling with my baseball friends and was happy, but leaving my other friends behind at the airport. I was happy but sad. I can still remember arriving in Washington and seeing all the evergreen trees. It was so beautiful there and much warmer to us too. It was so much different than Alaska.

We were greeted in Washington by a group of young ladies that were to be our hostesses for the time while we were there. They would show us around and take us to places and have gatherings and parties for us. They were all about our same age, and being young men, we enjoyed that. Then one day, we were in a house with about 20 people. There were only a few people left upstairs, and we kind of looked around and wondered where everybody had gone. We looked upstairs and then looked downstairs and found that everybody had gone downstairs. They were playing a game, and we questioned what they were playing. I asked if the new people could also play. They said that we could. They dealt the cards and then told us that they were playing a game of poker. I learned to play the game of poker while riding the train to the state tournament in Little League. Dad was in the navy and had taught us how to play the game as well. We sat

down with the group, and the cards were passed out to everyone. There was no money in front of us, so I didn't think they were gambling. Then when we found out who the loser was, he took off his shirt and was told that it was a game of strip poker. I was totally surprised and told them that I didn't want to play that game, so I got up and left. I don't know what they said, but I knew that I didn't want to be a part of that. A couple of the young ladies followed me upstairs, and we just hung out there for a while. One of the girls I thought was cute. She had blonde hair, and her name was Debbie Buzzard. She said she liked my long brown hair and thought I was cute.

It was during that same tournament that I was at a pool party. I think they had the hostesses for us to get us off task and make us lose our concentration. The girls provided us with a pool party. We were from Alaska; we didn't have pool parties there. I jumped off the diving board at one point and dove out too far into the shallow part of the pool and hit my mouth on the bottom of the shallow end. It wasn't as deep as I thought it was. Of all the people to see as I came up out of the pool, it was Donnie, the person whose teeth I had knocked out only a few weeks before. I was holding my mouth, my lips were bleeding, and I told him I had hit bottom. He shook his head in disbelief and escorted me to the house where I was cared for. The coaches took me to a local dentist who examined me, and I found out that I had

cracked three of my front teeth that day. They took me to the dentist, who said he couldn't do anything at this point. He told me that I had cracked three teeth and they would have to be cared for by my regular dentist when I got home.

We had made it to play in the semi-final game. We were to play the host team that was from Centralia, Washington. Our hostesses knew the entire team but had come to know us as well. They cheered for us somewhat but cheered for their friends more. Mom and Dad, along with my sisters Gloria and Lorna, my brother Oscar and a cousin, came to see the last day of the tournament. When they arrived, they waved me down, and they were wearing clothes that I wasn't accustomed to seeing them wear. They looked different and odd to me. They were wearing clothes that had what looked like Native designs with hats, cowboy boots, and headbands. It looked so peculiar to me, and I didn't know what to think. I was happy to see them, but they looked so different to me. Eventually, we wound up taking third place in the tournament. We lost to the host team from Centralia, who played for the championship. We had the awards ceremony for our team, and the team gathered around, took pictures, handed out awards, and then the team got on the bus for their flight home. It was then that I had to say goodbye to Don Zimmerman, Bill Watkins, and Mike Stratton, who were on the team with me. I didn't know if I'd ever see them again. It was a sad day for me to have to say goodbye to the good

friends that I had made over the past several years. We had been through so many events together, school, baseball, sports, and good friendships.

Dad was driving a bright red with white trim 1957 Dodge wing-swept automobile. There were six of us that got in the car to go to my new home in Washington with my family. It felt odd sitting in the car with them. We talked, and they told me about what life was like there and asked me how things were in Alaska. We stopped at my aunt's house in Tacoma, and everywhere I looked, and everyone that I talked to was related to me. I kept meeting people, and for the first time in my life, I looked like everyone else. We were all Natives. It felt different, and I felt out of place. After we dropped our cousin off in Tacoma, Washington, we all climbed back into our red wing-tipped car and began traveling to our home.

Chapter 20: The Reservation

When we arrived at our new home in Tulalip, Washington, I was not ready for the change. The family explained to me that we now lived on the Tulalip Indian reservation. Tulalip means small-mouthed bay; that's where the Tulalip Reservation located on the Puget Sound Bay. They began telling me all about what Natives were like and that we were Natives. We got off the interstate and went west toward the reservation. We passed a drive-in theater; there were trees everywhere, drove over Quilceda Creek, then turned up a driveway to a white house on a hill. We lived in the first house on the reservation. It was a small, white two-bedroom house. It did have a short basketball hoop that I loved to play on. It was only eight feet high, where a regular basketball hoop would be ten feet high. I practiced dunking and tried different moves on that basket. We had living there Mom, Dad, me, Gloria, Oscar and Lorna. I had to sleep on the living room couch, to begin with. There was only one bathroom, and we were renting it from our Aunt Katie, whom we had stopped to visit in Tacoma. From day one, the family began to teach me about reservation life. Gloria was playing softball with the native team, and Oscar was playing on the young Native baseball team as well. I had never seen Gloria play softball before, so I didn't think she knew anything about the sport. I had played catch with her a few times over the years, but she had never played on any

organized sports teams. It wasn't just sports; it was in everything we did. I wasn't ready for this new reservation life. They had a couple of months to acclimate to their new living conditions, but I wasn't ready to give up what I had in Alaska. In early U.S. History, reservations were land sections created by the United States Government to place the Native Americans away from the land being settled by Europeans arriving here in America. Oftentimes it was the land that the settlers didn't want, the land that was considered useless. That was after the government found that it couldn't completely destroy or remove them. Different treaties were signed with each Native group to ensure they could always live on the land assigned. The government, in turn, promised to provide all necessities of life for the Natives. Some of the Native families had been living on the reservation for many generations. I was just arriving and seeing it for the first time.

Mom took me to experience Native American pow-wows for the first time in my life. She wasn't up often or for very long because of her heart bypass surgery, but she wanted to introduce it to me. I had no idea what it was or what to expect. She did wear a few different Native Looking clothes and took a shawl with her. I had never seen her take a Native shawl with her to anything before. A Native Shawl is used by the women like a blanket that is wrapped around their shoulders. They sometimes wear it when they dance.

185

As we arrived, I could hear the beating of a drum in the distance. As we approached the venue, the sounds got louder. I could hear bells and some kind of strange singing. When we entered the facility, there were Natives everywhere. Many were dressed in their Native Regalia. Regalia is the term that is used to identify the clothing that is used when the Natives dance. They don't call it a costume because a costume is used when a person is trying to become someone else. It was the clothing they wore when they participated in their Native dances. There were many more that were not in Regalia, and they were the spectators. I followed Mom and the family around everywhere, wondering what was going on. I didn't feel like I fit in, but I looked like many of the people attending the event. When we found a place to sit, Mom began explaining the Native culture, songs, and dances to me. The singers at the drum can be either Northern or Southern singers. They have different songs that they sing. Often times you can tell the northern singers because they sing in a high falsetto. The southern singers sing in a lower tone. The Northern singers usually sing on the outside of the arena or circle, while the Southern singers might sing in the middle of the arena. With over 570 Native groups around in the United States, it's not always easy to identify the group or song. Most of the singers that were there were from the tribes in Washington. Then a song

began playing, and she took her shawl and put it over her shoulders and said,

"Let's go out and dance!"

I said, "No, I don't want to!

Soon Gloria, Lorna, and Oscar followed. Then Dad joined them, dancing around in a circle while the intertribal song played. With an intertribal song, anybody is allowed to dance. She then went out and began dancing out on the floor with many other Natives that didn't have Regalia on, along with those that did. She didn't stay out very long because she still wasn't very strong. I had no idea what was going on. I sat silently, listened, watched, and wondered how this related to me. I wasn't familiar with this part of the world, even though it was my Native culture. I had a couple of Native girls follow me around during the evening, and Mom told me to go and talk with them. I wasn't interested in participating in any of the events there. Most of the time, Mom sat; I followed Her around as she looked at what vendors were selling, and she did buy a few things. She also met several Natives she knew from Tulalip and other places. She would introduce me whenever she had a chance. I knew she fit in, and the rest of the family was enjoying the event, but I couldn't figure out how I was supposed to fit in.

The summer was ending, and there wasn't much left of the baseball season. I had just played for my age group in the

main tournament that everyone my age wanted to play in, and at a pretty high level. Mom asked a man to come over and recruit me to play with the native baseball team, so I agreed to go play. The fields on the Reservation weren't very good, and they tried me out at every position that there was. Then they had me hit and found out that I could hit really well and that I could pitch too. It wasn't the same for me. Playing with a bunch of people I didn't know wasn't fun for me.

There were only a few weeks left before school was to begin, so we went to the beach. The water was cold and salty too. I just continually wanted to go back home to Alaska. We visited different Native and non-native sites in the area. I was impressed when we visited the Seattle Space Needle, and the fact that the Seattle Supersonics played there was amazing. I did have the opportunity to attend a couple of their games. I followed pro sports on a daily basis by reading the newspaper, but besides that, it just didn't feel the same. I didn't know where anything was, and I didn't know any of the people either. We attended activities on the reservation, and I did meet several natives that were my age, but I was feeling pretty sad and lonely. I really missed my friends in Alaska. A lot of it had to do with my age. It was a terrible time for me to have to leave all my friends behind.

On Sundays we met at church in town with a Marysville congregation. I knew a few kids at church, but we went to

two different schools, Marysville and Lake Stevens High School. There was only one girl that I knew that was my age and went to school with me. When school began, I got up early and prepared for school as I usually did every year. Dad dropped me off before he went to work at the oil refineries in Anacortes. An hour before regular school, I attended an early morning seminary for Scripture study. It was kids from our various congregations that met together who were non-native. The church was only a few blocks from school, so I'd walk to school from there. I was used to dressing my best, not Sunday best, but I would always dress nice on the first day of school. So I dressed nicely, and my sister, Gloria, and I got dropped off at school. Mom was still slow and low on energy, and she didn't get out of bed much because of it. When I got to school, it felt like I was the only student in the whole school that was dressed up at all. All the other students were dressed in clothes I would identify as grungy. Mostly jeans and t-shirts. Everyone was looking at me like I was from another planet. After I entered the first class, I couldn't wait to get home. I wanted to hide all day, wishing that I could go back and change.

The next day I wore a pair of jeans, waffle stompers, and a t-shirt which became my daily school outfit till I graduated. It seemed that people looked at me differently than before. I tried to blend in and make friends, but no matter how hard I tried, it didn't seem to work. It seemed easy to make friends

when I lived in Alaska, but now I felt completely out of place. I tried to make friends, but everybody already knew each other, and I didn't seem to matter to anyone. There were a couple of Natives that said hi to me whom I had met during the summer, but that was all the acknowledgment that I received. I don't remember anybody really talking to me for that entire first week of school. I went to class by myself, ate by myself, and just kept all my feelings and thoughts inside. How I wished that I could be back in Alaska, where I knew everybody in my class and they knew me too.

That first Friday, there was a football game, so I decided I would attend and see how things went. I was now a part of the Marysville Tomahawks; my mascot was a tomahawk? The cheerleaders had a tomahawk logo on their uniforms. Others had the tomahawk symbol on their warmups or uniforms. Throughout the game, there were sounds and noises made by the crowd that referred to Native Americans. similar to what is called "The Tomahawk Chop" done in many large arenas at sporting events today. I had never heard anybody make reference to Indians in that way. I had heard similar sounds on television or in movies. It was common to hear people make a reference to the Natives as crazy Indians, wild Indians, wearing war paint, or on the warpath. People would hold their mouths to their lips and make a woo, woo, woo, sound. I sat watching, trying to evaluate the entire situation. Every student attending was either playing

football, in the band or cheering for them as a cheerleader. I pretty much just sat there with my family, which only made matters worse. We arrived a little early and watched the end of the Junior Varsity game. My cousin was playing, but I couldn't tell which one he was. Mom and Dad pointed out that he was easy to spot. He was the only player on the team with long black hair that came out of the back of his helmet. His name was Chuck and he lived in Tacoma but came to live with us for the school year. He was a year older than me. Gloria seemed to fit in and had several Native friends she was sitting with, but something just wasn't the same for me. Music seemed to always play an important part in my life. On the way home, I heard a song that always made me homesick for Alaska. It was Carol King's song, "So Far Away". I wondered why my friends had to be so far away from me.

Each passing day seemed to be a little more difficult for me. The teachers didn't know who I was because I was new. The students didn't know who I was, and I wasn't on any of the sports teams. I had missed tryouts for cross country and football, so I didn't participate in anything for the first time since I was eleven years old. I was used to running, jumping, or doing something. The longer I was there, the more I could see there was a division between the Natives on the Tulalip Reservation and the people of Marysville. I would often hear one group put the other group down in the hallways or hear

them argue with each other. There were fights between the whites and the Indians that would occur in the hallways and on the school grounds. It was meant to intimidate the natives and quiet them. There were some Natives, both guys and girls, that would be ready to fight anybody for saying negative things to them at any time. They had become accustomed to being bullied and wouldn't put up with it anymore. Fights would require the students to be expelled from school for a few days. It wasn't uncommon for the Natives to quit going to school; they had grown tired of the misery. They were mean, and harsh and fought for their pride. I also began to see how many of the Natives on the reservation had problems with smoking and drinking. There were many non-natives in the community that participated in the same things, but it didn't seem to be exposed. Some of them were my own relatives. I couldn't find a place to fit in. I did the best I could in each of my classes and began to accelerate in my math class. Mom took me to watch a few football games at the University of Washington. At the time, the quarterback was a Cherokee Indian by the name of Sonny Sixkiller. She tried to help me understand my Native heritage, but I didn't see how that made any difference. He was a good quarterback, and I enjoyed watching the team. I did become a fan of the University of Washington, and especially Sonny Sixkiller. I would hear the catcalls towards Sonny during his games as well. People made reference to

him going back to the reservation or being a person lesser than others because he was Indian. It quieted me, and I never made reference to my Native origins. I didn't need to be ridiculed or made fun of; I had a difficult enough time as it was.

I did the best I could but continued to struggle throughout the first part of the school year. During back-to-school night, Mom and Dad escorted me to each of my classes to meet my teachers. My last class was out in a portable trailer. It was hard enough to have them follow me around to each class, but I was doing okay. When we finished my math class, everyone began exiting the classroom. As we began to exit, the wind blew the door open. We all braced ourselves to go out in the wind and rain. We were in the middle of the group leaving the portable. A huge gust of wind came and hit Mom, Dad, and me. That's when Mom's wig blew off. I was just grateful it was the last class we had to visit for the night. It was still humiliating to have it happen. I'm sure she was embarrassed as well. Dad quickly ran and grabbed the wig, and she hurriedly put it back on. When we got in the car, they laughed about what had occurred but I knew that I'd hear about it. I did hear about it at school for the next few days.

When basketball season arrived, I was ready for the basketball season. I knew it was a chance for me to show everyone what I could do. The coaches ran us up and down

193

the court as usual. The tryouts were intense, but I worked through them. The coach would call the names of individuals that he knew and ask them to perform a skill, then all the others would follow. I knew how to complete all the skills, but they didn't know who I was. The problem I encountered when I began playing with the non-native guys from town, especially when playing basketball, is they would never pass me the ball. I was the only Native that was trying out for the sophomore basketball team. There were no Natives playing on the Varsity or Junior Varsity team, and only one other Native player was trying out for the freshman team. It wasn't only that I was Native; they knew each other and had played basketball together over the years. They were friends and were familiar with each other. I was the new guy, was Native, and I didn't fit in. It would often feel like the team I was on was playing four players against the other five players.

Despite not getting a real chance to show the coaches or players what I could do, I made the basketball team. I ran hard, worked hard, and practiced on my own before and after our regular practices. I had been through tryouts before and knew that I had to work hard and do my best. I had to learn the new system and prove myself. That was probably the hardest part. Many of the players on the team had played together the year before and knew the system. It was all new to me. It didn't seem to matter what I did; I always seemed

to come up short. Finally, after a few weeks of games, I had earned a spot in the starting lineup. We were playing in Oak Harbor, WA. When the game began, our team grabbed the tipped ball, and we went quickly down the court. The ball was passed around a few times. When it was passed to me, I pulled up and hit a jumper, we were ahead 2-0. The other team took the ball to our end of the court and scored to make it 2-2. Our team quickly passed the ball in bounds, and we went down to the other end of the court. The ball was moved around the court again and eventually passed to me. I pulled up and scored again to make the score 4-2; we were ahead. The other team quickly came down the court and tied the score 4-4. Before we could inbound the ball again, our coach called a time-out and asked why we weren't playing defense. He called the name of another player and told him to check into the game for me. I was pulled from the game with no reason given to me; I didn't play again till the game had been decided and almost over. I don't think I got to start another game that season. Occasionally one of our players would tell me to go back to the reservation and play ball with the Indians. There were others that just saw me as another athlete, but I wasn't used to feeling like this. It was an odd feeling to have somebody attack my nationality. I had never been treated that way, and I didn't think I was an Indian. I did have a couple of players that would talk to me occasionally and tell me they felt like the coach didn't like

them either. I understood what it was like to play any sport. I felt like I knew who the best players on any team were. I didn't think I was the best player, but I felt like I deserved a chance to get more playing time. I was getting very little to no playing time on the court. We'd ride the bus to our different games as a team. Usually, the Sophomore and Freshman teams would ride together along with the cheerleaders for those teams. I would find a seat by myself somewhere on the bus. All the coolest guys and most popular cheerleaders would be gathered at the back of the bus. Almost everybody on the bus knew each other from attending school together over the years. Occasionally someone would sit next to me on the bus and get to know me. I did get to know the guys on the team a little, but I still felt like an outsider.

During the week, I would go with my uncle Dave. He was my mother's half-brother who was also Tulalip Indian. We would go play basketball out on the reservation a couple of nights a week. Sometimes we'd also go to town and play with the old guys at the YMCA. He was my Mom's half-brother on her mom's side, the only Uncle that I knew, and he loved sports as much as I did. These guys on the rez played so differently than I had ever played before. They ran up and down the court with what seemed like little or no defense. When somebody got open, they would shoot the ball, and with the rebound, they took off in a fast break in

the other direction almost immediately. They knew that I played on the school team. It was almost like playing in a pickup game. The Natives called it run and gun. There was more running up and down the court than I had ever done in any practice or games before. I was in good shape, but all the running made me tired. Teams from each reservation had their own teams. Some were really good, and others, not so good. They would have Indian basketball tournaments. Teams would travel from place to place with their teams to compete in each other's tournaments. We had a fairly good team for our age group. We were competitive, and I could help them win, and they could help me understand who I was. I was told by my school team's coach that I wasn't allowed to play in their tournaments if I was playing with the school team. I continued to play basketball for the school team and only played with the Reservation team occasionally after the season was over. I received the same treatment from them that I received from the non-natives in town. They didn't want to pass me the ball, and I was usually the last one to be picked on a team. Occasionally somebody would tell me that I was an apple (red on the outside, white on the inside) and that I should go back to town and play. I had no idea what they were talking about. I had no idea what an apple was, but I heard it a lot in my life after that. I wasn't enjoying my new surroundings.

I became quiet and a loner. I would only answer questions from the teachers in school if I was asked specifically to answer. I would rarely volunteer to answer any question on my own. Occasionally Mr. Ibea my math teacher would challenge us with questions. He would say that a correct answer would earn five extra credit points but subtract two points from our grade with an incorrect answer. There were only a couple of people either in a class or on any of the sports teams that I would talk with. I didn't want to be there; I wanted to go back to the way things used to be in Alaska. Mom and Dad, especially Mom, tried to get me to fit in with the kids on the reservation.

I began attending a Wednesday night Native seminary called Lamanite Seminary. There was a bus that would pick up the natives to go to church activities one night a week. It wasn't fun for me, and I didn't really want to attend. Then Mom and Dad began to drive and supervise the bus. Mom tried to help me fit in, but it didn't work for me. I found myself going home, doing my homework, playing my guitar, and playing my records over and over. There were three albums that I listened to continuously, Glen Campbell's, Gentle on my mind, Guess Who's, American Woman, and The Beatles, Let It Be albums. I began writing ballads about my life's situation to sing while I played my guitar. Here are the words to a poem that I wrote for a song;

The two worlds that I live in, trying to make them one,

Where the one world meets the other, that is where I am

I was in a world of my own. I didn't belong to one world or the other, but I did belong to both. I continued to wonder where I fit in. I'm sure there are other people who feel the same. How do we fit in different worlds in a comfortable way?

When I wasn't playing my guitar, I was listening to music or playing basketball by myself outside. I would play basketball for hours on end, especially after watching an NBA basketball game on television. Dad and I put up a basketball hoop on a wooden pole in the backyard. I would play into the nighttime. It was in the backyard, and there was nothing but dirt. It rained most days in Washington, but I would play every day anyways. There were some days when it would be so wet and soggy outside that I would shoot the ball, then get the ball as soon as it went through the net so it wouldn't splash in the puddles that were underneath the basket. I would make my older sister Gloria and my younger brother, Oscar play a game against me any chance I could. We would play to a hundred. I would give them ninety points, and then we'd play to one hundred. I would always easily win. I would hustle, run, jump, shoot, block shots, and steal the ball from them relentlessly. Gloria had never played basketball, and I was five years older than Oscar, so I had a huge advantage. We'd go out, and I'd let them warm up by shooting a few shots; I'd take several shots too. For every

shot they missed, I would rebound the ball and shoot so I was getting additional practice in. After a few minutes of practice, we'd begin. I'd always get the ball first because I was so far behind. We'd played that if you made a basket, you'd get the ball back. I could usually score twenty or thirty points before they would even get the ball on a shot that I had missed. If I missed a shot, they could shoot the ball right back into the basket. If they missed, I had to clear the ball about ten feet back from the basket. As the game progressed, I would let them make a basket here and there. When I'd get close to ninety points, I'd usually let them make a basket to encourage them to continue. Every now and then, they'd score a basket without my help which made me work even harder to win. They hated playing against me, but I'd wait until they needed something from me and then I'd challenge them. I would coax them into play each time by giving them more points, to begin with. I'd give them 90, 92, 94, 95, and eventually a 96-point lead. The score would begin 96-0, and I would win almost every time. One day they beat me 100-99, and they jumped around and celebrated for the rest of the day and evening. I had scored ninety-eight points to their four points but had lost the game.

Dad eventually put a light outside for me. That made me only want to play longer. I would make up games, and I would pretend to be two different teams playing each other. I would shoot free throws and play till one team scored a

hundred points. I practiced layups, free throws, bank shots, long-range shots, baseline shots, and jump shots from anywhere. I would stand under the basket and shoot the ball with my right hand and then my left hand on both sides of the basket. I learned to spin the ball or twist it and use the backboard to get the ball to spin into the basket from either side. I watched basketball on television any chance I could see it. I loved watching Pistol Pete Maravich play. He was a famous professional basketball player back then and played college ball for LSU. Some people thought he was too flashy, while others thought he was the best. I didn't get to see him play too many times, but he would show up on highlights occasionally. We didn't have ESPN back then and would only see a few minutes of sports on the news on any given night. I began wearing floppy socks like him and trying to imitate the things he would do when he played. He dressed kind of sloppy and had long hair. I began to dress the same and let my hair grow too. I learned to spin a basketball on my finger as he would do. He had a creative way of passing and shooting the ball, and I began trying to do those same things on our local church team. I began passing and dribbling differently. He would pass the basketball to someone without looking, and I tried the same thing. Soon the players learned to always be prepared for a crazy pass from me. Most of the players weren't particularly

good, and I had a good time just practicing different skills. I didn't care if I won or lost; I just wanted to play.

Our church team eventually participated in an area church basketball tournament/sports day. We had a really good team and made it to the championship game. Throughout the day, each participant had to sign up for track events as well. I high jumped, long jumped, and participated in the mile run. We had to have at least one person on the team in every event to qualify to play in the finals. We also had to have one of the best records in our short tournament. We had made it to the championship basketball game. There was only one problem for me. I had to compete in the mile run prior to the game beginning. It was the last event of the track portion. After the first three of the four laps, I had a large lead and slowly jogged the final 200 yards. I was tired but still had to participate in the final basketball game. The team had been warming up while I was running. They told me to hurry back because the game was going to begin. I was tired but hustled as quickly as I could. I made it to the start as our team took the court. I slowly walked out to take my position on the court. We had a good player at the center position. He tipped me the ball; I passed the ball to Dave, who was running towards the basket. He scored the first basket, and we were ahead 2-0. I continued to play for most of the game. I took a couple of breaks to try and recover from my run. We easily won the championship game and

dominated the track events as well. Most of the guys on the team were from different parts of the area, and I didn't really see them at school. We occasionally got together after that, but I didn't see them too much after that.

I was really struggling to pick myself up, but now there was nothing that I could do to help myself feel like I fit in at school. Most of the guys that were athletes drank, and many of the Natives did as well. It wasn't the environment that I wanted to be around. I looked at my Dad, and he was white. For most of my life, when I looked at him, I could see myself looking the same color as he was. When I looked at my mother, I saw myself in her as well. Now when I looked at Dad, he was white, and my Mom was Indian. There was a real difference for the first time in my life. I saw television shows and movies differently as well. It seemed like the Indians were always the bad guy and always got the short end of the deal. The Natives on the reservation knew it and so did I, and we were bitter about what the white society had done to us.

Mom and Dad entered my sister, Gloria, and me in a church talent youth conference for Natives in the State of Washington. There was a song that we had heard called "Go, My Son." A song by Carnes Burson and Arlene Nofchissey Williams, who were both Natives. We decided that we would try and perform that song together. I was the guitarist, Gloria was the drummer, and then we sang together. It was

a song written by and for Natives. The words included, "Go my son, go and climb the ladder, go my son go and earn your feather, go my son, make your people proud of you." I wasn't sure what earning a feather was all about and how I could make my people proud of me. Although we performed well enough to earn a trip to the finals in Salt Lake City, Utah, I still didn't understand how it helped me fit in or identify my culture. Gloria and I were still in high school, and we still did a few things together. She was going to graduate after the school year, and then I would be alone. All alone! I had a younger brother, but he was 5 years younger, and a younger sister who was 8 years younger than me. I did meet other Natives at the events held in Seattle and Salt Lake City, but it didn't help me identify who I was. I just kept wishing that things could just go back to the way they were.

Gloria had found a friend on the trip to Salt Lake. She and her friend sat together on the bus ride. I still didn't have anybody besides Gloria that I felt comfortable with. When we arrived, we were placed in host family homes, and Gloria, her friend, and I were all placed in the same home. They had a Polynesian family that had several children who invited us to stay with them. When we performed, there was a large audience which we weren't really ready for, but we did our best. I wore a nice outfit that included a white blazer. We didn't win the competition but did earn an honorable mention. There were several classes and workshops for us to

attend throughout the day and dance at the end of the program. I did hear some good messages from the speakers that helped me begin to see things a little differently. I found that there were other people out there like me, but I still felt alone.

Chapter 21: A New Language

I seemed to be doing okay academically in school and had caught up a lot in all subjects in Alaska. I felt like I was at or above grade level in all subjects. As a matter of fact, I seem to be really excelling in math. I had a really difficult math teacher, Mr. Ibea, who was my math teacher for most of the time I attended Marysville high school. I think he taught all the advanced math classes. One of the first weeks that I attended his class, there was a day when I didn't do my homework, and he made a big deal about it in front of the whole class. He said it better not happen again if I was going to continue to be in his advanced class. After that, I was sure to complete my math homework every night. He would often try to catch me not paying attention. If he was reteaching a concept and I understood it the first time, I would have a tendency to zone out. He would explain a second time to the class how to do something, but I had already learned it the first time he had taught us.

Mr. Ibea would ask, "Terry, do you know the answer?"

I would rattle off the complicated answer, and the whole class would look at me in disbelief. It was the one good thing that had happened to me since moving to Washington.

Each day after school was over, there was a school bus that would take all students, Native or non-native students,

home to the reservation. We lived in what was called a border town. The reservation was adjacent to or next to the town. Although it was the reservation, there were pockets of non-natives living on the reservation. There was one bus that took all the kids home who lived there. The first stop let off many of the Native students near my home. We lived about a mile from the high school. Mom and Dad wanted me to ride the bus so I could get to know the other students. I didn't feel comfortable around them, so I decided to walk home every day. I had walked several miles home with Donnie on a regular basis, and a mile in temperate weather was nothing for me. One day the bus drove by, and the kids were yelling things out the window at me. I decided that I didn't want that to happen again. After that day, as soon as the bell would ring, I would begin running home as fast as I could go. I would usually make it about three-fourths of the way home before I would see the bus. Then I'd begin walking like it was no big deal. They never did figure out how I always beat the bus home. It was a good workout for me too. I was getting better at running home on a regular basis.

Between school and home, there was only one way to get home. It was necessary to make a few turns and then go under the freeway to get home. The freeway was Interstate 5, which connects San Diego, CA, all the way to Vancouver, Canada. Between Marysville and Tulalip, they had built a bridge that let the locals drive under the freeway to go from

town to the reservation or the reservation to town. When I lived in Alaska we didn't have a big interstate; it wasn't something that I was used to. One day I was a little late leaving school, and I thought I might try a quicker route home. So I took a route that went straight across from the school to home. The problem was there was an interstate there. I ran straight towards home as quickly as I could. When I got to the end of the road, there was the freeway. I hopped over the freeway railing and looked up and down the freeway, and thought,

"I can do this!"

So, I approached the freeway and waited for an opening. When I saw an opening and began to cross, I quickly realized the cars were moving much faster than I had imagined. I ran as fast as I could and made it to the median, and hopped over the median metal guard railing onto the grass on the other side. Then it looked like there were more cars, and they seemed to be going faster than before. I think the speed limit for the freeway at the time was 70 mph. There were a few cars honking their horns at me. I don't know exactly what they were thinking, but I know they thought I was crazy. I looked back and wondered if I might retreat, but there were too many cars. Finally, after waiting for a short while, I saw an opening and dashed across the freeway to the other side. When I made it to the other side of the freeway, I promised myself I would never do that again. I did beat the bus home

that day, but more importantly, I had learned a valuable lesson to never try running across a freeway.

One day, during the fall, I think it was at a thanksgiving gathering on the reservation. On Holidays it was not uncommon for all the Natives on the reservation to celebrate Thanksgiving and Christmas with a gathering. It was a time for everyone to socialize, and usually, the food was provided by the tribe. Sometimes they would provide gifts for the families of the young children as well. They'd set up long tables, and usually, family and friends would gather together in groups. The young kids would be running around playing chase or tag. The older kids would be outside playing football or basketball, and the adults would be visiting with one another. It was on that day that something really strange occurred. Our family was eating at one end of the large room. Mom was walking around talking with friends and family. She was standing near one end of the building, and a person I didn't notice arrived at the other end of the building. Mom put her fingers to her mouth and whistled. Then she yelled out in a loud voice, Hach, Hach Moses. I looked up at her in dismay. I had no idea what she was yelling. Then she yelled again, saying, Hach, Hach Moses. A short, older Native gentleman smiled and walked towards her. They hugged one another and began talking. After they had talked for what seemed like 5 or 10 minutes, Mom motioned for me to come and stand by her. As I approached, I could hear her talking

but could not understand a word that she was saying. She and Hach, Hach (which was a Lushootseed word that means Holy) Moses were speaking my mother's native Lushootseed language. I wondered how in the world she knew that language. I had lived with her all my life and had never heard her speak a word of that language. She introduced me to him and then continued speaking to him in her Native language. They talked and laughed and made the funniest sounds that I had ever heard.

She eventually taught me little bits of the language and also later started teaching the language on the reservation. At first, she began teaching my Uncle Dave and my sister, Cherie. Dave had forgotten the language after going to school and later college. Later She began teaching classes on the reservation to individuals that wanted to learn. Next, she began teaching classes at Everett Community College. Prior to her death, she was offered the opportunity to teach the language at the University of Washington even though she only had very little formal education. Here's a song that she later wrote and taught me:

She told me that in the Lushootseed language, "Little"-Refers to something little or little children.

TEN LITTLE INDIAN BOYS

one little, two little, three little Indians

C'I'O', SI'SALI', ~XIX Ah Ah Seat Sil Bich

Cheet' Oh, Seat Sali Shleat Slich whooh ah ah seat sil bich

 four little, five little, six little Indians

BI'BOOS, E'LATS, TSI'LATS Ah Seat Sil Bich

Beat ah Boohs, Eat Lahts, Steat Lats ah ah seat sil bich

 seven little, eight little, nine little Indians

E'SOS, TIT'QACI, QWIL'QWIL Ah Seat Sil Bich

Eat ah sauce, Teat tah Clachee, Qwheat Qwill ah ah seat sil bich

 ten little Indian Boys

O' LUB ah ah seat sil bich

O' LUB ah ah seat sil bich

She began from that Moment on to teach us words and phrases from the Lushootseed language. We had a dog, and we called him Skullbite, which was the word that meant dog. We would say oh, that's too bad by saying oosh a baba tu. If something was over there, we would say too da dee eee.

Now I really knew that I was different. I wasn't like all the other non-native kids at school. I was indeed an American Indian, and there was nothing I could do to change that. When we got home, I asked my mother why she never

let us know that she could speak that language and how she remembered it so well. She then proceeded to tell us how she was punished when she was a little girl and never wanted that to happen to her children. As we traveled to Minnesota, Alaska, California, Rhode Island, Texas, Virginia, and all of the other places, she simply translated all the words she encountered into her language. She had continued to speak her language in her mind to herself. So when she met Moses that day, she could still remember the language that they had grown up with.

I was doing my best to understand my native roots, but I couldn't understand them. It didn't feel right. I couldn't be something different yesterday and a Native today. By springtime, I had had enough of the drama that reservation life offered me. I still didn't belong in either place. I was still a loner and did my best to fit in anywhere. To compound the problem, there was nobody that understood my religious connection either. I often had people offer me the chance to drink, but I wasn't willing to change that part of my life. I had made a promise to myself, and I was going to keep it no matter what anyone else did.

Chapter 22: Going Home

I tried out for and made the junior varsity baseball team and again I was the only native on the team. One day, after practice, I mustered up the courage to ask Mom and Dad if I could go back to Alaska and play baseball for the summer. My older brother, Jerry, had returned from serving in the Navy. He had served in Vietnam and, for serving there, received a one year early release. He was married and lived in Eagle River. Mom and Dad called him and discussed the possibility. One day when I came home from school, they told me that they were going to let me return to live with Jerry and play baseball for the summer. I was so excited for the school year to end. I wrote a letter to my friends and told them I would be coming back to Alaska for the summer. They wrote back to me and asked me about the date that I would arrive. They would get me signed up to play on the baseball team.

After the school year was over, the day arrived, Mom and Dad took me to the Seattle airport, and I was returning to Alaska. It was a plane ride that took forever. I couldn't get there fast enough. I looked out the window and watched as the terrain changed from moment to moment. We flew over snow-capped mountains. As we prepared to land in Anchorage, I could see the mountain range and the rivers and bay that looked familiar. When the plane landed in

Anchorage, Jerry and his wife, Laurel, greeted me. I was so happy to be back in a place that felt like home. I hugged Jerry and Laurel and went to retrieve my luggage. I was happy to see them, but couldn't wait to see my friends. Laurel told me that they had received several phone calls from my friends inquiring about the time and date of my arrival. When we arrived at their home, it only took a few minutes before there was a knock at the door. One of my good friends, Bill Watkins, was there to greet me. I was so happy to see him, and we gave each other a hug. He told me that everyone was gathered up a couple of blocks away at Roxy's house, and they were all waiting to see me. I gathered my things, and we began walking up to her house. On the way, Bill looked at me and said man, you look so much taller. I was wearing cowboy boots, and it seemed like I was taller. Then in our conversation, he asked me if I had been drunk yet. I looked at him surprised and said, "of course not". He said then there's only three of you left that haven't been drunk. I looked at him in amazement as we continued walking to her house. For a Moment, I thought about the Natives at home on the reservation that drank and the other athletes as well. He continued talking with me about all that had happened over the past year until we arrived a few minutes later. There were about eight or nine of my friends there, and they were all giving me hugs, and they said they were so glad to see me. Little did they know that I was more glad to see them

then they were to see me. They had all gathered for me to come and see them, but they had all gathered to celebrate two of our birthdays. A couple of the girls gave Mark Bullock and me a little 45 record for our birthday. The song was "Close To You" by the Carpenters. I felt so loved and appreciated and immediately returned to the person that I was prior to moving to Washington.

After our gathering, the guys told me that the baseball season was close to halfway over already. Their season began earlier than ours did in Washington. The team that I had played on for so many years did not have any roster places for me to play. They didn't know that I was going to be returning and had filled all the places on the roster. The father of one of the players, Mike Stratton, had found a spot for me on a roster of a team in Anchorage. I knew the team and knew that they weren't very good, but they were willing to let me finish the second half of the season with them. It was the minimum amount of playing time that would be needed if I was to be picked for the all-star team. The very first game that I played with them, we had to play my old Eagle River team mates. I began the game by pitching, and every time the team got a hit, they would harass me in kind of a fun way. I was a good pitcher, but all the players on the team knew how I pitched from playing baseball for so many years with me. It wasn't fun to me, but it was meant to be fun. Even when there should have been an out, the players

on my new team would make an error, and the players would be safe. It was one of the longest games that I had to play. It made for a rough baseball season for me that summer. When the game was over, we all rode back to Eagle River in the same car. They teased me and gave me a hard time for being on such a lousy team, but eventually, we all began to laugh at how bad my team was. At least I was with people I considered friends.

Having lived on the reservation for a year, I began to see things a little differently. When I arrived, I was wearing cowboy boots, which I would never have done if I was living there. However, there was a group of guys and gals that wore cowboy boots and cowboy hats in Eagle River. All my friends usually wore tennis shoes. I only wore those boots the first day I arrived; after that, I wore strictly tennis shoes.

As the summer continued, we would play ball, hike, go swimming, fish, and enjoy each other's company. My group of friends all went on a hike one day, and we were all in our shorts and tank tops. There were a few girls but more boys on the hike. Then as we were walking and talking, one of the girls asked me how I got such a good tan.

I blurted out, "It's an old Indian trick!"

They all just kind of looked at me strangely for a second, and then all started to laugh. I didn't know where that had even come from, but something felt different. I now knew

that I was different from the others, having lived on the reservation for a year. Roxy tripped and twisted her ankle when we were at a good distance from our car . Nobody really knew what to do in that particular situation. I remembered learning about what to do in that situation in one of my scouting classes. We wrapped her foot, and then I asked Don to help me carry her to the car. We had her put her arms around our shoulders, and then we crossed our arms underneath her, and Don and I held onto each other. Roxy sat on our arms like a chair, and we carried her back to the car. I didn't mind because I thought she was good-looking, and I had a crush on her too.

Mom and Dad called and asked me how things were going. I told them I was having a good time and loved being back in Alaska. I told them all the adventures we were having and that I had been placed on a different team. I think we were the worst team in the league that summer. Then they asked me if I had seen all of our friends at church. I told them we hadn't been to church. Jerry and Laurel didn't go to church, and so I didn't go either. They weren't happy about it, and called them later to ask if they would please take me to church, but we never did go that summer. After Jerry returned from serving in the Navy in Vietnam, he didn't really talk about religion or go to church anymore.

In one of our games, we played on a new field in Alaska that year. It had just been built, and this was the first season

that it was used. It was right next to the ocean. The field was a little bigger than most. Left and right field were usually about 300 ft, and center was about 350 ft. This field was about 320 ft all around. There would be a cash prize of $50 for the first person that could hit a homerun over the fence. I didn't know about the reward at the time. When I got up to bat, the pitch was thrown, and I hit the ball perfectly. The crowd watched the ball sail through the air and over the chain-link fence. The left fielder backed up and chased after the ball as it sailed over his head, and we all watched the ball bounce on the other side of the fence. It was a homerun! The umpire motioned that it was a homerun, and I trotted around the bases. Then the left fielder yelled and motioned to the umpire that it had bounced over the fence. The coach called the umpire, and they gathered in a meeting at the pitcher's mound. Then the umpire looked at me and said it was a ground-rule double, saying it had bounced over the fence. Then he motioned for me to return to second base. I wondered for the first time if I was being cheated because I was brown, because I was Native. I didn't say anything but thought about it for the first time. Even though everyone saw the ball go over the fence, I was denied the $50. My coach told me he was sorry that it had happened that way.

He said, "You should have received the $50, and I'm sorry."

On the night before my 16th birthday, I had a strange dream. I thought I could see myself putting on my floppy socks. I was sitting on the porch at home in our little two-bedroom white house. I could feel the heat of the sun warming my body. Then I looked over my shoulder and saw what looked like three spirit personages floating across the swamp area by the Quilceda Creek next to our house. They were 100 yards away, and as I looked at them, they did not look at me but floated away from me. Then I realized that they were spirits, and I began to cry uncontrollably. I could feel the goodness in their spirits and couldn't stop crying. When I woke up, I found myself with real tears. Jerry came in to check on me because he had heard me crying, but I told him that I was just dreaming.

The next day I couldn't get it out of my mind. It was a strange but very real dream. Mom called me because it was my birthday. She wished me a happy birthday and asked me about my friends and the people there and everything else. She noticed in my voice that something was wrong and asked if there was something that I wanted to talk about. I told her that I had a strange dream the night before. I told her the dream that I had dreamed, and then there was a pause on her part.

I said, "Mom, did you hear me?"

Then she said, there was a wreck outside of our house where you described in your dream. There were three Native people that were killed there last night. I didn't know what to say to her, and she didn't know what to say to me.

Then she said,

"I think you were blessed to see those three Native spirits as they went to the next life. It's in your blood", she told me.

"That's one of the blessings of being who you are. You'll know things by dreams, I have the same gift."

I continue to know things in my life through dreams.

Chapter 23: Bye Chief

When the season ended, I had made the all-star team for the 5th year in a row. I didn't even get to try out when I was thirteen because the coach wouldn't take 13-year-olds on the team. I only found out I had made the team because my teammate, Mike Stratton's Dad, was a coach for the all-star team and took Mike with him to the tryouts. Mike told me that he and I had made the team as 13-year-olds, but the head coach wouldn't let us play. Well, I made the team again this year too.

When we prepared for the state tournament, the coach told us that we would be the host team and wouldn't be going to the state tournament. The Host team was the team that kind of welcomed all the other teams to the tournament, like down in Centralia, Washington. There weren't really any responsibilities that we were given, and It didn't really do anything for us being the host team. I think there were seven regional teams, and we would be the eighth team which would make it easier to fill out the brackets. The tournament organizers also thought we had a good record over the past several years as well. We still had to play in the region tournament against all the other State winners, including the State representative from Alaska. We practiced for a couple of weeks, as usual, as we prepared to play in the tournament.

We won our first game of the tournament. We found out that the second team we had to play in the tournament was the all-star team from Washington State. The team was from Everett, which is about five miles south of my home in Tulalip. It was a much larger city than where I lived. I knew where it was, but didn't know anyone from there. I was the lead-off batter and fouled off like 12 or 13 pitches and eventually earned a walk to first base. Fouling off one or two foul balls during an at-bat is a big deal, and I was at-bat for a long time. I then stole second base on the next pitch and scored on a hit from a teammate right after that. I hit four for five in the game. That means I got up to bat five times, and four of those times, I got a hit. I was grateful that I was playing with all my friends in Alaska and wondered what it would have been like if I had stayed in Washington.

We had beaten all the other teams, including the Alaska State Champion team, which was one of our rivals from Elemendorf, the air force base. There was only one team that hadn't been beaten, and we had to play them in the championship game. We were up 2-1, and it was like the 4th inning. We played seven innings. Our second baseman was at bat, and he was hit by the pitcher. The ball hit his left hand, which was holding the bat, but the umpire said it hit his bat. The player went down in pain and held onto his hand in pain. Our coach came out and had him take his batting glove off, and you could easily see that there was a big red spot on his

hand. The umpire called that he was hit by the pitcher but required that he would have to continue to play in the game. We didn't score any more runs that inning, and we all went to play our defensive positions. We got the first two batters out. Then the next hitter got a double, and they now had a runner on second base. The following batter hit the ball to our second baseman, who had been hit in the hand by the pitcher in his previous at-bat. It was a routine grounder hit to him. When it hit his glove, he grimaced in pain and immediately dropped the ball. After it bounced off his baseball mitt he picked it up with his bare hand and threw it erratically to me at first base. It was out of my reach, I couldn't get the ball, and it went all the way to the fence. That let the runner from the second base score, and the runner at first went to second base. The score was now tied 2-2. The next batter came up, and the exact same thing happened again. The ball was hit by second base man, and again, he bobbled the ball and then threw the ball wildly passed me at first base. The runner on second scored, and the batter ran to second base. Our coach called timeout and went to talk to our second baseman. He had him take his glove off, and he looked at his hand. It was red and swollen. The coach touched it slightly, and he grimaced in pain. Then he tried to move his fingers, and he quickly pulled his hand away from the coach. He told the coach he was sorry for the errors and that the hand that was hit was hurting. The coach motioned

for a replacement at second base, and he escorted him to the bench. We got the next batter out, and there were no more runs scored that inning. If we were to win this game, we would still have to play them one more time, but we'd have Mike Stratton, our best pitcher, on the mound. He had been a pitcher on my Red's baseball team the first year I began playing. We were the home team and got to bat last. It was the bottom of the 7th and our last chance to win. I would be the fourth batter to hit in the inning. The first batter flew out; there was one out. The next batter got a hit and was now at first base. The third batter was up, and I was on deck. I watched the pitcher, trying to figure out how I could get a hit off of him. I studied his movements and his pitches, trying to figure out how to get a hit if I got a turn. The third batter hit the ball slowly to the infield, and the ball was thrown to second base. The runner was out. Then it was relayed to first base to try for a double play, but the runner was safe at first. I took a couple of practice swings and walked out towards home plate. I looked around the stadium. I needed to get a hit and keep us in the game. We were playing this game in the stadium where the semi-pro team called the Anchorage Pilots played. I had attended many of their games over the years. Our head coach was a pitcher on that team and played in that stadium. Our assistant coach was Mike Stratton's father. We had one runner on first base and could tie the game up if I Could Somehow get a double or triple. I grabbed

my bat tight and prepared to stand in the batter's box. Coach Stratton was our third base coach, and I looked to him to see if there were any signs. The base coaches often relay hidden signs to their players to do certain things while at bat. It could be a steal by the player on first, or a hit and run, or a bunt, I was looking to see if there was anything on. He didn't give me any signs as to what I should do during my at-bat. He just stood there and looked at me; then he called time out. He motioned for me to come to him, and he began walking towards me. I hustled down towards third base to meet him.

With his back towards the left field fence, he asked me,

"What is the number on the left field fence?"

I said, "It says 375 ft!"

Then the coach said to me,

"You are one of the few players on this team that can hit the ball over that fence. Now go and make contact."

So I went back up to the home plate, and I stood in the batter's box and prepared for the pitch. I looked again for a sign, and the coach just clapped his hands and then kneeled over slightly and grabbed his knees. I held the bat tight and dug my cleats into the dirt. I looked at the pitcher as he looked at his catcher for a sign. The catcher will relay a sign for the pitcher to throw a certain pitch. That way, the catcher won't be fooled by the pitch. Oftentimes the coach in the

dugout will relay a sign to the catcher as to which pitch the pitcher should throw. The first pitch came, and I swung at it with all my might and missed; it was now strike one. I stepped out of the box, took a deep breath, and looked down at the coach, then took a couple of practice swings. He just clapped his hands again, then nodded his head yes to me. I stepped back into the batter's box and prepared for the pitch. The pitcher looked at the catcher, checked the runner on first, and then the second pitch was thrown. Again I swung and missed, strike two. I stepped out of the batter's box once again, and I looked down at the coach, he just smiled and nodded his head yes to me once again. Took a couple more practice swings, called time out to get my feet set as I got back in the batter's box, and prepared for the pitch. The pitch was thrown, I swung and missed again. Strike three, and I was out. The game was over. We had lost. We were so close. How'd we lose, I wondered.

All the players on our team hung their heads as the other team stormed the mound to celebrate. They were the regional champs and would continue playing for the national title. I knew what it felt like to win, and I knew what it felt like to lose as well. Coach Stratton came to me and gave me a hug, and praised my efforts in the game and the tournament.

Then he said, "Thanks Smiley (that was the nickname he had given me), You played a great tournament!"

As we began to gather our things from the dugout, our second baseman appeared with his parents, and he was wearing a cast. During the game, he had been taken to the emergency, which was down the street. X Rays were taken, and his hand had been broken. If only he had been pulled after he got hit with the ball. We might have won the game 2-1.

The players began walking away with their parents and family. Each went his own way after saying goodbye to all of our teammates. It had been another great season. As we parted ways, Coach Stratton yelled, "Good job Chief!"

I looked to see if he was talking to me or someone else. He was talking to me. I raised my hand, waved goodbye, and wondered why he had said that. I said goodbye to my friends that had come to watch our game. Then I got in the car with Jerry and Laurel, and we quietly took the thirty-minute ride to their house.

Chapter 24: Back to the Reservation

I went home to Jerry and Laurel's house. I didn't know what I was going to do. It would be a couple of days before I had to leave to fly back home to Washington. I had already begun to miss the place, and I wasn't even gone. I met with friends over the next couple of days. I was sad that we had lost the championship game, but I was even more sad that I would soon be leaving all my friends. I had already begun to dread the thought of leaving. When I began packing my things, I looked at the cowboy boots that I had worn on the trip to Alaska. I had no desire to wear them and began to wonder what it would be like to return home. There were a couple of carloads of friends that decided to see me off at the airport. A couple of them wouldn't be able to go to the airport with me, and I began saying goodbye to my friends in Eagle River. With each passing minute and every goodbye, I could feel sadness, and loneliness that began to creep into my soul. I didn't want to go home to my family; I wanted to stay with the people who had become my family over the past several years. As I got into the car with my brother and his wife, I had a couple of friends in the car with me. I wanted to cry but didn't. It seemed like we didn't have much to talk about. We made small talk, and they suggested that it would be fun when I returned again. After we arrived at the airport, I went and checked in my luggage and received my boarding pass. Everyone in the group followed me to my

gate. Some of my friends walked next to me and talked with me all the way to the gate. Others stood back, not knowing what to say. People were talking and trying to hold a conversation with me, but I wasn't talking much. They could look at my countenance and tell I was sad to be leaving. My brother and sister-in-law said goodbye first, and then just kind of stood out of the way. Then one by one, each of my friends hugged me and said goodbye. Finally, a couple of the girls in the group hugged me and gave me a kiss on the cheek. I could tell that they had been crying. Their eyes were red and puffy. Then I could hear one of them sniffling as she walked away. They told me they would miss me. It was time; I walked to the gate and showed the gate attendant my boarding pass. The agent greeted me with a smile and wished me a good flight. I boarded the plane and looked to find my seat. It was a window seat, and I looked out to watch. I could see many of my friends as the plane began to move, waving goodbye from the large window in the waiting area. I could see others wiping away their tears, waving to me, turning around, and walking away. They were holding each other and waving goodbye. They could see me through my small window, and I could see them, and we waved goodbye for the last time. They were the best friends a person could ever ask for. They helped me gain a confidence that I would never have gained on my own. We had taxied and were ready for takeoff. I watched the airport zoom past before my eyes, and

then they were gone. I would never see any of them again. I sat in my seat quietly, crying. Wondering why this had to happen to me. Why did I have to go back to the reservation? I didn't want to go, I didn't belong there, but there was nothing I could do to change it.

The two-hour flight seemed to go by quickly. I reminisced about my life in Alaska. Before I knew it, we were preparing to land at the SeaTac airport in Seattle. I had thought and cried off and on until we had almost arrived. What could I do? What would I do? The walk from the plane to the gate seemed unbearable. Mom and Dad were anxiously waiting for me with open arms; they were so glad to see me. Oscar and Lorna were with them as well. Gloria had graduated from high school and was now in college. She was no longer around for me. We were good friends and talked with each other about life and lifted each other up when it was needed. They hugged and kissed me, along with my brother and sister. I tried to be happy but wore my feelings on my sleeves, and I'm sure they could tell I wasn't really happy. I was once again surrounded by my family and community, but I just didn't feel like I belonged there.

I returned home in time to have a couple of days to prepare for school. We went out and bought the things I needed. Then it was time for school. I had become used to wearing my waffle stompers, and we looked everywhere, trying to find the perfect pair. I also needed a few new t-

shirts and jeans. I had grown a little bit more and was now five foot eleven, so many of my old clothes didn't fit me well anymore. I wasn't excited to be home and didn't have anybody that I was excited to meet at school. Mornings in Washington were often foggy, cool, or rainy, but it didn't matter. Dad took me to early morning seminary, and it was no different. I didn't really fit in with the other kids. I didn't want to ride the bus, and I didn't want Mom or Dad to take me. I just wanted to be alone. When I arrived at school, I looked at my schedule and approached my first class. My first class would be with Mr. Ibea, my math teacher. I would be taking honors, pre-calculus math. He was one of the few people in the school who actually knew who I was. I entered his class and found a seat three or four seats from the front, over by the side of the room, where I could gaze out into the world. The class filled with students. I knew a few of them but wasn't really friends with any of them. The ones who knew me said hi, and I returned the comment. There was no excitement in the air about seeing anybody. I wondered what it would be like if I was going to school at Chugiak High School for the first day again. I would be looking for all my friends, and we would be comparing our schedules to see if we had any classes together. I wasn't in Alaska; I was in Marysville. I went to each class one by one, realizing I didn't have anybody to talk to. I knew some of the other kids in my classes but just found a place to be alone. Occasionally

231

somebody would tell me they were saving a seat for their friend. I would just move father to the back of the room. I wasn't excited to see anyone or talk to anyone. I would just kind of walk around alone all day. As I walked through the hallways, people were hugging and calling for one another. They gathered in groups and talked about their summers. They would continue to talk until the bell would ring and then run off to class. I walked through each group and made my way from class to class. It didn't help that one of the popular songs during that time was Indian Reservation by Paul Revere and the Raiders. Words that kept coming back to me from the song were, "Locked them on the reservation." That's what it felt like I was locked in; I was trapped with nowhere to go.

Finally, the lunch bell rang, and the students quickly went to the lunchroom. The jukebox that we had in the cafeteria was already playing songs. A student would pay .25 cents to play two songs. Students would line up to select to play their favorite songs. There was no way to tell what song was selected by the former person. I remember listening to Rod Stewart's song "Maggie Mae," over and over. I stood in the lunch line and waited to order my lunch. I wasn't really talking with anybody and could hear the song playing in the background. I could hear others talking about what they had done for the summer. Occasionally individuals would look at me as if I was eavesdropping. I listened or could hear them

talking because I didn't have anybody to talk to. They would turn away from me, then talk a little softer. I picked out the things I wanted and went to the checkout. I would save a quarter for later to purchase an apple from a vending machine. I went and sat near where all the other Junior athletes in the cafeteria were sitting. They were the only ones that I knew at all.

Then to my surprise, one of the guys said,

"Hey, did you guys hear Terry played on the Alaska team that beat our Everett team? That was you, wasn't it?"

I said, "Yeah, it was me."

Then somebody else said, "We kept on hearing your name. That's the team you would have been on if you had played here in Washington."

Someone else said, "They broadcast it on the local radio station."

Then another person said, "Yeah, they kept calling your name. I think you were like 4 for 5, and they couldn't strike you out the first time, right?"

I said, "Yeah, that's right."

I wasn't expecting them to notice that I had been gone, and they even noticed that I had beaten the local Washington

team. After that, they just started talking amongst themselves again, and I was just kind of left in the background.

I took a photography class that year as well. It became a true lifetime love of mine. We would take pictures with an old box camera. When I'd look in the lens from above, it would display the picture upside down. It was kind of weird but amazing at the same time. In the class, we had to learn how to develop the film as well. Developing the negatives and watching the pictures become exposed was so much fun. It gave me something new to think about. I learned that taking good pictures included more than snapping the button. There was the setting, color, surrounding, light, and so many different elements. It wasn't much different than before, but it was different.

I continued to try to figure out a way to get back to Alaska. Then I thought of a way to get back to all my friends. When I went home that day, I asked Mom and Dad if I could go to Alaska and finish my senior year and graduate with all my friends. I can remember asking with such enthusiasm, and I thought it was a great idea. They said they would talk about it, but the next morning they said they had discussed the idea and wouldn't let me go back to live. I'd have to finish school in Marysville. I didn't have another plan. I'd have to learn to live here on the reservation. This was my home, but I didn't want to be here.

A few days later, I came home from school and saw a large mound of salmon in the front yard. A tribal member who was a fisherman brought a truckload of salmon and dumped them out in the middle of our yard. I can remember walking into the house and

I asked, "What are all the fish doing out on the front lawn?"

Dad answered, "Waiting for you to clean them."

Dad wanted me to clean all the fish. Then he handed me a knife and told me I needed to go out and clean all the fish. I dreaded the idea of having to clean all those fish. I pulled the hose close to the fish and began cleaning the Salmon. I was there for several hours cleaning all the fish. My life was miserable. I didn't care for fish as it was, and after cleaning several hundred fish that day, I still can't eat fish to this day. I often have people say they can't believe I'm a real Indian because I don't like fish. This wasn't helping me feel like I fit in, and I didn't know what it had to do with being a Native American.

Chapter 25: A New Home

On my first Sunday back to church, I sat in the back. We used to meet for church in town at a remodeled morgue. I always felt uneasy meeting for a church there. There was only one of a couple Native families that met there. Most everyone else was non-native. I was typically happy to go to church and then go home. We were now meeting at the granger hall on the reservation. It was a small building with a small congregation. Most of them were Native, but it included some non-natives as well. Before the church meeting began, my mother stood up and beckoned for me to come to her. I went and stood next to her, and she was holding a man's hand and drawing letters in his hand. Then she took my hand, and placed my hand in his and said,

"Write your name in his hand. Do it slowly and use all capital letters."

So I introduced myself, and he tried speaking to me. It was difficult for me to understand him. His voice went from extremely loud to really soft and continued back and forth like that. Then Mom asked me to escort him to the front so he could bless the sacrament. I was a Priest in the Aaronic priesthood now and would be one of the individuals to bless the sacrament. From the age of fourteen to sixteen, I was a teacher and would prepare the sacrament. I was to escort and help him? I was to assist him? I wondered how he would be

able to bless the sacrament. When it came time, I stood next to him and let him know when it was time to stand, and then helped him stand up. He was both deaf and blind. He was still doing his part. I did feel strange, but at the same time, I felt like I was doing something really worthwhile. I wondered how he could say what he needed to, but he had memorized the words he needed to speak. When I look back, I'm embarrassed that I didn't take more time to help him. I know when a person is feeling down, or their life isn't going the way they think it should, that person needs a helping hand. It was my responsibility to help him on a weekly basis. It did make me realize that my life wasn't what I thought it was; I was doing much better than I thought in comparison to others.

I did have a couple of non-native friends that I started hanging around with as a Junior in high school. I'd go to their house, and we'd play basketball just about every day. They weren't on the school basketball team; they just loved playing basketball. Then one day, one of the guys just quit hanging around with us. The other friend told me that he was running around with the wrong crowd and didn't have time for us anymore. In another week or two, the other friend quit hanging around with me as well. I tried to contact both of them, but neither of them had time for me any longer. I began to see them hanging around together here and there. I wasn't sure if it was because I was Native or not. Most of the friends

that I had made in Alaska were my friends all the time and included me in whatever they were doing. Now it seemed like I would make a friend, and then, in a few weeks, we didn't hang around anymore.

I had two uncles that were Mom's half-brothers. Uncle Butch and Uncle Dave. One of them, Uncle Dave continued to stop by and pick me up to go and play basketball or tennis with him at the local YMCA. He had graduated from college and had an excellent job. He would arrive in his 1965 light blue convertible mustang, which was one of my favorite cars. The other one, Uncle Butch, was a Native American woodcarver. He would carve Northwest Native American art all the time. I was fascinated by his ability. One time he asked me to fetch a piece of wood that was on the ground between the two of us.

Then he said, "Watch this."

He began to whittle a small Northwest Native American thunderbird out of that piece of wood. He did it in just a few minutes too. Then he handed it to me. I don't know what happened to it, but I wish I had it today. I do have an awesome Native American paddle that he made and signed the back of in 1970. I was amazed but still thought, how does that help me? I don't carve. I can't do that. As I continued to try and understand my native roots, it only seemed to become more complicated for me.

Mom began telling me legends and stories about the Native people in the Northwest. There were gatherings for only natives. There were special ceremonies that they participated in. There were customs and art that were unique to the Tulalip Natives. I noticed differences between the rest of the world and the Native Customs. Mom owned native land on the Tulalip and on other native reservations as well. She decided that she would trade some of her Tulalip lands for land across the street from where we were living. After they purchased the land, they decided to build us a house on that property. Many of the local natives told us that we shouldn't build on that site because it was called the old Indian trail. Mom and Dad decided that we would build a house there anyways. As we began to clear the area, it looked like a place where bums would hang out. There were beer cans and bottles scattered throughout the entire area as we continued to clear the area, we found old bottles and would often sell them to an old antique shop that was next to the white house. There was a young guy that lived there. He heard me playing my electric guitar and came over to meet me. He invited me to come over to his house and jam with him. One day I went over to visit and he took me to his room. He had been burning incense, said he did it all the time. As we talked about music he told me he was a Jimmy Hendrix fan. Then he began playing his electric guitar like he was a pro. I listened in amazement. Then he asked me if I ever did

drugs. I told him I didn't. He said he'd be willing to let me try some if I was interested. I told him I wasn't interested. He told me that was fine. I stayed for only a few minutes and then went home. He was a year older than me. I didn't really hear from him much after that. Mom told us Native stories about when she was growing up as a little girl. There were Natives called the Stick Indians or steet-tots, who would come and take away the bad children. She told us other stories as well that made me curious. We started to experience strange things that made me wonder again about myself and my native culture. Probably best not to divulge too much of the mysterious happenings. Occasionally we'd have one of those strange happenings in the house, and Mom would speak Lushootseed to relatives that had passed on. I'd ask her what she was saying, and she would say she was telling them to stop bothering us and go back.

As we built the new house, I would often have dreams about a person with black hair that was walking around upstairs. I told Mom, and she told me that our ancestors were coming to check on us and see how we were doing. One night I had a dream about a man with black hair and told Mom about him.

Mom said, "Oh, that's Ambrose; he must be checking up on us."

240

I didn't know who Ambrose was and didn't want him checking up on me. I couldn't figure out what it was all about. He was mom's grandfather who raised her.

We lived next to a small creek called the Quilceda which flowed into Puget Sound. The water from the ocean's tides would come in and go out daily. The actual creek was low, but the high tides made it seem like it was deep. The tides would float large logs next to our new home. The logs were supposed to be going to the local Weyerhaeuser plant. In the mornings, you could often smell the chemicals that were used at the plant. Oftentimes logs would be separated and would drift to different locations, eventually landing on our property. There would be many Saturday mornings when Dad would wake me up to go out and cut logs for the day. We would spend many hours, he would cut the logs with a chainsaw, and I would carry and stack the wood. I would eventually have to chop the logs for our firewood too. I became pretty good at chopping and stacking firewood. Some of the logs would be 24 to 36 inches in diameter. I made a game of it. I would try to chop the log in half with one swing. If you hit the wood just right, it would crack in half. Occasionally I would get the ax stuck in the wood and have to take the time to get it out. Sometimes I would just pull it out, and other times, I would have to use a sledgehammer and chisel to remove the ax.

Chapter 26: The Middle of The Night

One night before we had moved into our new house, I was awakened in the middle of the night by the sound of native drums. I could hear drums beating, Gloria was gone, and I had the bedroom to myself. I slowly peeked out my window and could see five or six people singing Native songs as they sat in a circle around their large drums. There was a fire in a large barrel that was close to them. They were drumming and singing songs in unison. I peered out my window the best I could and tried to watch them. Then they stopped, and one of the individuals looked up at our house. When they did, I quickly closed the shade and ducked so I wouldn't be seen. What in the world was happening, I wondered? I slowly crawled to Mom and Dad's room. I got as low as I could because I didn't want to be seen. From the floor, I began to whisper as I entered their room,

"Mom, Dad, there's.."

and then I heard a sharp, quick, but strong "shhhh!" from both of them.

They told me to be very quiet and to stay out of sight. I asked them what the heck was going on. They told me that there were a few Natives who were angry that we were building our new house on that property. They had come to

cast a spell on our home. Then they showed me a toy that was hanging on the wall.

Mom said, "Those people gave it to us to give to you kids to play with. They have cast a spell on it and are now trying to curse us for building the home across the street."

Okay, I didn't even want to be a part of this native life. It was so far from what I wanted to be. They said, "Make sure you don't ever touch this."

To which I replied, "Don't worry, I won't!"

Then they knelt in prayer and asked the Lord to please watch over and protect us as we slept. Mom knew who those people were but didn't tell me. Then she said everything would be all right.

She began speaking in her Lushootseed language to someone, somewhere. Then I realized she was saying a prayer in her Native language.

Then she said, "Go to bed and try to get some sleep."

I was tired and went back to bed, but it was difficult to sleep, especially when I could hear that music. I eventually got to sleep but woke up a little later. I sat up, and looked out the window, and the music, the drum, and the people were all gone. The next morning when I arose, I remembered what I had experienced the night before and quickly lifted the shade again. Yes, the people were gone, and there were no

reminders of them sitting there singing the night before. I got up, got dressed, and was ready for school. As I walked to school, I kind of looked both ways wondering if there was going to be something else I would need to worry about. It was a rough day at school, and it was difficult to concentrate. I didn't have anyone to talk to, nobody to share my feelings with; I had to just keep it bottled up inside. When I returned back home, I couldn't help but think about what had happened the night before. When I got home, I asked Mom,

"Anything new about all that singing last night?

She said yes.

"I heard from various news sources that all of the people from last night have had some kind of accident. A couple of them got in car accidents, and one of the ladies with long black hair had to have an operation. They shaved her long beautiful hair."

I was learning about the Native ways but wasn't sure this was what I expected.

It wasn't long after that occurrence that we moved into the new house. It wasn't completely finished but it was finished enough for us to move in. I had the upstairs room. I didn't want it at first because I had had dreams of a man with black hair walking around up there. But I took it because it was out of the way and I had my own room. All the drywall

wasn't up yet, and you could see the studs and the framing, but we completed things here and there almost every day. I had basically helped Dad build a house from scratch. I helped with the foundation. When they poured the foundation, one of the walls gave way, and there was cement everywhere. We had to reinforce it halfway through the pour but managed to get it under control. I had laid the flooring with tongue and groove boards and assisted in the electrical, plumbing, hammering, and nailing of the wood in almost every part of the house. I didn't help when they put up the rafters, though because Dad didn't want me to get hurt, but we now had a new place to call home. We somehow had an old standing radio that stood by the window. It was to be my project to learn how to fix a radio with tubes.

Chapter 27: Proving Myself

I had made progress in sports at school, but it just never got any easier to prove that I was as good as all the other kids. In the fall, the physical education coach asked everyone to go and take a lap around the football/ baseball field and then be ready for our activity. There was a fence that encompassed both areas. When the coach said go, the class bolted out the door and ran the approximate one-mile run. I had run cross country and track and still ran home to beat the bus almost every day. When the class took off, A student by the name of Allen, who was on the school cross-country team, was in front of the pack. He took the lead, and there wasn't anybody else who could stay with him except me. We ran down the first side of the field. He turned the corner, and I was right behind him. After I turned the corner, I looked behind me, and there were a few students that were close to me. I stayed with him, and when he prepared to turn the second corner, he turned to see how far I was behind. He was surprised that I was keeping up with him. I turned the corner, and we had a larger lead on the group behind us. I noticed after the second turn that he had increased his speed, so I quickened my pace as well. The first and third distances around the perimeter were much longer distances. He was running fast, but I was keeping up with him. When he turned to look back at the third turn, I was still right behind him. He was now a little shocked to see me so close. He turned the

corner and sprinted to the finish area. I turned the corner and sprinted right behind him. There was nobody even making the final turn yet. When he got back to the starting point, he stopped and leaned over, holding his knees, trying to catch his breath. I stood standing with my arms up, and my fingers clenched around my neck. We were both breathing hard.

The coach came out of the door and looked at me, and said,

"Goedel, go take a lap."

I said, "I did!"

The coach looked at the other runner as though to ask him. He lifted his head and stood to look at the coach and said, "He did; he came in right behind me."

I still felt like I wasn't getting the respect I deserved. I didn't know if it was because they didn't know me or if they didn't like the fact that I was a Native American, an Indian. It was the first of several times when I wondered if I was getting a fair shake.

Later in the school year we had a wrestling competition in our p.e. class. For wrestling, we were in a rotation where we had changed teachers for part of the semester. Our teacher was now the high school wrestling coach. He took a few days to teach us the basics of wrestling. Then we practiced against each other. He taught us how to do a

takedown, a reversal, an escape, and how to pin our opponents. After a few weeks of practice, he put us in categories to wrestle against one another. The students were arranged in categories from lightest to heaviest by weight. Because he was the wrestling coach, he was used to setting up the brackets. Before the match would begin, he would ask all the students to sit on one side of the mat or the other. Students were to sit on the side of the mat of the student they thought would win. In my first matches, the class was split, with half of the class on one side of the mat and the other on the other side. I easily won and pinned my first and second opponents. There were several matches each day for all weight categories. He had the brackets posted on the wall so everyone could see who would be wrestling each day. The rule was the better you wrestled, the better your grade would be. Next, I had to wrestle against the biggest, meanest native from the reservation that I knew. Everybody was sitting on his side, except maybe one or two students. He had a reputation; they knew he was big and mean too. When the match was over, and I had won, everyone was surprised, including the coach. I made it to the final match. In the final match, I had to wrestle against Jim, a varsity wrestler in school and one of the finest in the area too. We only had three one-minute periods, whereas when you wrestle in the competition you have three, three-minute periods. After the first period, the score was 0-0. After the second period, he

248

was given the upper position, and I got an escape for 1 point. I was up 1-0 after two periods. In the third period, I had the upper position, and he got a reversal on me for two points. I lost 2-1 but gained respect from the coach and the wrestler. He congratulated me and asked if I had ever wrestled; I told him that I had. He invited me to go out for the wrestling team, but I never wrestled again after that.

Later in the school year, we were high jumping in p.e class., and the same thing happened. There was another kid in class that was considered the best high jumper for our grade. His name happened to be Terry as well. We had several guys that could jump pretty well, but only Terry and I used the Fosbury flop method. I knew the first time he jumped that he was a high jumper. The other guys were using odd or different techniques to jump. The bar started at 4 feet to make sure everyone in the class could participate. It moved up by two inches after every round. Each person would be given three tries at each height before they would be disqualified for missing. By four feet 10 inches, there were only a few jumpers left, including Terry and me. At that height, everyone missed the jump except the two of us. The bar moved up to five feet, and we both made the jump. The coach moved the bar up to five feet one inch, and we both missed once and then made it on the second jump. The coach moved the bar up to five feet two inches, and we both made the jump. Then the coach moved it up to 5 feet 3

inches. We both missed the first jump, then we both missed the second jump as well. Terry approached the bar and then changed his mind at the last minute. It didn't count as a jump, and he'd get another chance. The coach asked me if I was ready, so I jumped and made it; I cleared the bar. I was excited but didn't get out of control because there was still a chance we could continue. Then it was Terry's last jump, and all his friends were telling him he could beat me. He was a good guy and had a lot of friends that were athletes and a popular guy at school. He jumped, and his foot hit the bar as he was going over, and the bar fell. I won the high jump competition for our class. Even with all that I had done to prove myself, it felt like I still didn't get any respect. I continued to wonder if it was because I was Native.

Chapter 28: One More Class

It was that winter when I became tired of trying to fit in. I just lived my life day to day. One day the counselor called me in to meet with her. She reviewed my transcripts with me and said,

"Do you know that you only need one more class to graduate?"

Then she said, "If you take this English class at Everett Community College, you can graduate this year."

I looked at her in amazement. In Alaska, we took seven classes every day, but we only took six in Marysville. I found out that I had received extra credits from my 9th-grade year in Alaska. I went home and told Mom and Dad. They contacted the counselor and agreed to have me take the class at the community college. Just the year before, a counselor had told me that it would be okay if I didn't graduate because many of the Natives didn't graduate. So Mom took me to the community college, and I signed up for the class. I began taking the class with the hopes of graduating a year early. It felt odd to attend a class in college when I wasn't even finished with high school. It was different too. College students would come wearing whatever they felt like. Students would arrive or leave throughout the class period. The class was two hours long on Monday and Wednesday.

Students were allowed to smoke in class, bring non-alcoholic drinks and eat too. I felt out of place in a different way now. Although I was now attending a class at college, I didn't feel any older. I still had my regular classes with my junior classmates. When they adjusted my schedule for the next semester, I wasn't put in any classes with seniors.

The school year finally came around to basketball season. Prior to the season, the coaches organized an intramural basketball league for games before school. There was one original tryout for everyone, and then teams were chosen. There weren't any practices after that; the teams just met up and played a game in the morning. I was playing well and loved it, even though it was early in the morning before school. I did make a couple of friends from my team that I began hanging around with during school. We played well enough during the short season to make it to the championship game. I had the opportunity to take the last shot of the game as time was running out, but I missed it, and we lost. The basketball coaches would come and watch the games.

Later that week, the varsity basketball coach asked me if he could talk to me after gym class. He asked me personally if I would try out for the varsity team. He said he had been watching me play in intramurals and thought I could help the team. I was kind of shocked but explained to him that I was taking a night class and wouldn't be able to play. He wished

me good luck in my schooling. Our varsity basketball team did go to state that year and earned third place. The coach had gone and recruited several players for that season. There was one player whose name was Tom Graham. He had long hair, and dressed like a hippy. One day in the hallway, he was talking with the teacher of the senior English classes. The teacher asked him if he'd please cut his hair. She offered him $100 if he'd let her cut his hair. He said he wouldn't do it for money. Not long after that, the basketball coach pulled him aside and asked him if he'd consider trying out for the team. He was six foot, five inches tall, and was a big guy. He tried out and made the varsity team much better. After he made the team, the coach told him, he'd have to cut his hair. He went home that night and cut his hair on his own. It was one of those things in life that I wished I could have participated in. Up to that point, I had felt as though the basketball coach wasn't giving me an equal chance to play because I was an Indian. I didn't feel that way any longer. I think I was still young and developing, and the other players were older and more experienced. I didn't feel like he was being prejudiced against me. Looking back, I don't think I was ready for that level yet, I was only 16 years old, and the other players were seventeen and eighteen years old. There weren't any other Native basketball players except for myself and George Williams, who was a year younger than me. He played on the J.V. team that year. The next year after

I had graduated, I learned that George died in an automobile accident. We had played together on the Native traveling team.

I still didn't seem to fit in either at school or on the reservation. I had made a few friends at both places, but it still was odd. I was native, and I knew it now, but I couldn't admit it to myself. I was continually reminded of both places, and it usually made me have negative thoughts about myself. My mother continued to introduce me to the various Native activities, including pow-wows. She told me she would buy or make me the regalia I needed to dance. So we would attend the pow-wows, but I was always a spectator. She would plead with me to participate in the pow-wows and learn to dance. She always told me that I'd make a good fancy dancer. I didn't understand it; I didn't connect with it; it wasn't me. At Halloween, I would see people dressed up as savage Indians. They would wear so-called war paint, a war bonnet, and a Native Costume. Was I supposed to enjoy that people were making fun of me and my culture? Even though I didn't understand it all, it didn't feel good; it was degrading.

I was just about finished with high school. I still had all the same classes along with my Junior classmates. A couple of adjustments were made to my schedule to ensure I would have all the classes and credits needed. One of the changes that occurred was to work as a teacher's aide. A coach

254

offered me a chance to be an aide for them in a p.e. Class in the last half of the school year. I would be the one to get the equipment set up for the day. I would also lead the daily calisthenics for the class. It was a pretty easy class for me; I only needed the class for credit to graduate. I was grateful to feel like I was getting some of the credit I felt I deserved. It was a p.e. Class that had many of my Junior classmates. They thought I was in the p.e. class with them, but I was the aide. They wondered for most of the semester why I was able to do everything for the teacher. One day one of the students asked me why I was in charge. That's when they found out that I was going to graduate early, and I was the teacher's aide. I didn't really have any friends to share my news with, so I never told anybody about my plans to graduate early. My English class at the community college was over, and I had earned the credits necessary to graduate.

When spring came, I tried out and made the varsity baseball team. One day I twisted my ankle at baseball practice and came home limping. Mom said we were going to attend the Shaker church on the reservation. I told her that I'd hurt my ankle and I didn't want to go.

Mom said, "Oh good, they'll probably heal your injury."

We got in the car and rode off to the church. When we arrived, there were already a lot of cars in the parking lot. When we walked into the place, there was a small seating

area; it was pretty full. There were a few Natives singing, shaking their bells, and walking around the room. We arrived a little late, and I had to walk past everyone limping as I tried to find a seat. As I sat down, all the singers continued to shake their bells and walk towards me. They reached my aisle and began singing, walking towards me and looking at my foot; I didn't know what to do. I slowly moved my foot under the seat, and after a few moments they left my area and continued to go around the room, seeking others to help. It was the one time that I visited the Native Shaker church on the reservation.

I loved playing baseball, and making the varsity team was a big deal for me. I played first base part of the time. We had a really good pitcher on the team. He was 6'4" and could pitch close to 100 miles per hour. He was a senior, his name was Larry Christensen and I only played first base when he was pitching. There were so many scouts at every one of our games, and many more when he was pitching. He wound up being picked in the first round to pitch for the Philadelphia Phillies. I still wasn't where I wanted to be on the team. I batted down towards the bottom of the lineup. I was on the team but still didn't feel like I fit in. I really wanted to wear a letterman's jacket and would earn a Letter for my jacket by playing on the varsity team. I had always hoped it would be a letterman's jacket from Chugiak High School.

Chapter 29: The Light

In the spring of 1972, I would usually come home, complete my homework, then go out and practice basketball in the backyard. When it got too late or too muddy from all the rain, I would come in and watch television. There were only a few stations to watch, and there were no remote controls for them either. If I wanted to change the station, I would have to get up and change the channel manually. I would usually watch sports if possible, but if not, I would watch any of the shows that were on at the time. There were many different kinds of shows to watch. Television shows portrayed the Indians as bad or wrong, and they always lost. The show F-Troop made fun of the Indians. My sister had returned from college with her husband to visit; they took me to a movie called "Billy Jack." The movie displayed the ridicule that Natives felt in their communities. They were made fun of and belittled. Billy Jack was a fighter that would defend them, their ways, and their beliefs. He stood up for his fellow Natives through violence but was eventually captured. The movie ends with Natives standing on both sides of a dusty, dirty road with their fists lifted high above their heads to support Billy as he is taken away. There had to be a place in between for me. A place where I wasn't made fun of or had to fight my way out of.

As a senior at the high school, there weren't many Natives that I attended school with. I was in history class one day when the teacher said, open your textbooks to a page, so and so,

"Today, we're going to study Indians."

That's when the whole class turned around and looked at me. I had a difficult enough time trying to cope with being an Indian as it was. I felt like I was an inch high and wanted to run away and hide. I was sitting in the back of the class and took the book and held it up in front of my face, trying my best to hide. We began to study about Natives of Washington that day, including the Story of Chief Joseph, a Nez Perce Indian of Washington. We also talked about Indians in general, and there were continual looks my way. Most of what the class was learning, I was learning as well. I didn't have a real Native perspective to speak from. I knew that I was Native, but I didn't understand all the history and stories of the Yakama, Tulalip, Nez Perce, or any other tribes. Chief Joseph was hailed as a hero for the Natives of Washington and had led his tribe throughout the Rocky Mountain region on an epic military retreat. It was the first time I could remember learning about a Native in a positive way. He eventually asks the chiefs of other tribes to hear him. He's known for famously saying, "Hear me, my chiefs! I am tired. My heart is sick and sad. From where the sun now stands, I will fight no more forever." Even though there were

some positive things I was learning about Natives, I still felt out of place. I think a lot of it had to do with being the only Native in the class.

Later that night, when I got home from baseball practice, I was sitting in front of the TV. I was tired, and it was too wet to play basketball. I was tired of being alone. I was by myself long enough, and I didn't want to bear this burden any longer. There was nothing I could do. I had already played my guitar; I had listened to my songs on the record player. I just sat in front of the television, watching a basketball game. It wasn't one of my favorite teams; it was just a game, a game I didn't care about. It was just something to do. A few minutes later, my mother walked into the house. She was excited and asked me if I wanted to go see a special show with her. I was relaxing after school or some sports practice and begged her to let me stay home. With excitement in her voice, she asked me over and over again to go to the show with her, and each time, I begged her to let me stay home.

Then Mom went into her bedroom and changed, got her purse and shoes on, came back in the room, and said,

"Please go with me to the show!"

I told her once again that I was too tired and wanted to just stay home and relax.

Then in a demanding voice, she said,

"O.k., get your shoes and socks on, and let's go."

I soon found myself walking outside with my shoes and socks in hand, meeting her in the car. I was sure I had told her I didn't want to go; matter of fact, I was positive I hadn't even given her a hint that I wanted to go. I sat in the car pouting all the way to the program, which was about thirty minutes away, with my arms folded in disgust, the way teenagers do.

We had to drive to the Seattle area, which felt like a long ride for me. When we finally arrived at the venue, there were posters and pictures of the show that were on the walls. I was looking at everything and feeling puzzled. All the pictures were of Natives. After Mom paid for our tickets, we entered the building and found a seat and waited for the show to begin. When the show began, I thought it was all right, but I wasn't overly impressed. The group performed modern numbers; it was like a really good dance recital of some sort. It was a modern show, but all the performers looked like they were native. They began with modern, contemporary songs and dances for about forty minutes and then had an intermission. During the intermission, the members of the group were selling items, but I wasn't interested in what they were selling.

When the second half started, there were contemporary and traditional Native songs and dances. It began with a few songs with Natives in regalia but with modern songs. Then various number, fancy dancers wearing their feathers and bustles, grass dancers with their long flowing ribbons, and both the men and women had groups dancing, exchanging places performing on stage. There would be men dancing and then women dancers. The women came out in their Native Regalia, and they were performing what seemed to be parts of a pow-wow that I had seen before. There were a few explanations here and there telling about the dances. It was colorful and became kind of exciting, and the audience was cheering them on, yelling and applauding their performance. The stage went dark, and all of a sudden, three dancers came onto the stage, and they placed these round rings on the stage. The lights were dimmed, and I could only see their silhouettes and hear the noise of something they were putting on the floor. The items were round, and I had never seen anything like it before. I was awestruck. I wanted to get closer to see what they were doing, but couldn't. I raised up a little to try and figure out what they were doing. The drum began beating, singing followed, the lights came up, and the three dancers began their routine. They were dancing with the hoops they were holding and doing some sort of magic trick at the same time. The hoops seemed to be jumping up into their hands. As the dance progressed, it only

261

got better. They continued to add these round hoops and make different formations with them. With two, they seemed to be connected and then disconnected almost at will. They would wind their bodies in, out, and through the hoops. Then I saw a formation that looked like a small bird. The hoop dancers were unbelievable to me as they continued with four hoops and then five, and it just continued. There were formations of plants and animals that were being created right before my eyes. I began to study regalia (Native clothing) for the first time. I didn't know exactly what they were doing, but I was mesmerized. I could hear the beat of the drum and Native music come together to make everything complete. Then I watched as they made a formation of what looked like a bird, a full-grown eagle. A flower emerged, and I watched as it blossomed. Finally, they held up what looked like a world made up of hoops. When they had finished the dance, I found myself standing up, applauding with much of the crowd in attendance. I wanted to shout to the world that I was an Indian too. I had never felt that proud feeling for being an American Indian, a Native American. It was as if there was a light inside of me that had been lit, it was burning, and I was feeling something that I had never felt with this intensity before. I remembered, as a young boy, the same wonderful feeling while attending church. I wondered if it was that same wonderful light. It had begun to grow inside of me. After the show, the members of

the group came out into the crowd and greeted us. A few were talking with friends and family. One or two came by, and I shook hands with them. I saw them differently than I did at the first of the show. I admired them for what they were doing. I left the show that night walking a little taller and feeling proud of my Indian Heritage for the first time. It felt like my long brown hair, brown eyes, and brown skin identified me as a Native in a positively unique way for the first time. I had found a way to connect with my Native Roots. I felt like I connected with the hoop dancers. Up to this point, I had only felt the negative feelings associated with being Native American. Television, movies, and songs on the radio seemed to highlight the negative, the bad side of Natives. The world and my community spoke of the smoking, drinking, and problems associated with it. I didn't want any part of the negative things that the world was sharing with me. I knew that someday I wanted to hoop dance and share with others the things that I felt on that night.

Chapter 30: A New Friend

The next day I woke up and was finally a little okay with being a Native American for the first time in my life. There was something good and wonderful about my Native heritage. My mind kept thinking back about those hoop dancers. In my math classes, I could often figure out problems. It was how my brain worked. I reveled in the difficulty of solving a problem. I could not figure out how they had performed as they did. I wanted to hoop dance, I didn't know how, but I wanted to learn. I had turned the corner. I was kind of okay with who I was, I was native, and for the first time, I could feel something good. I didn't run to school and share what I had seen with anyone. I kept it inside. I didn't think there would be anyone who would understand what I was going through. How could somebody feel what I had felt?

About that time, I met a girl at school. I don't remember how we met. I think she saw me at school and just came up and began talking to me. Her name was Pamela Rowett. Before I knew it, I was talking to her every day. I would meet her before school, at lunch, and after school. She found out that I was on the varsity baseball team and asked if I would be bothered if she came to watch my games. I told her that I would be fine with it and let her know our schedule. She came to the next game, and after the game, I hurried to

shower and change. We had won the game, and most of the guys were all celebrating, especially the seniors. They would gather in the shower area and plug the drains. Then they would run and slide in the water. There would be water everywhere, and the guys would be yelling and screaming. Although it would flood, there were other drains the water would go down. The coaches would usually let them have fun for a while. Pam began attending my games and brought her friends with her. She was religious like me, and I began liking her more every day. We talked at school and just tried to get to know each other. One day after attending one of my games, she asked me if I would be willing to go watch her dance at the school play that evening. I told her that it would be fun and I would try to attend. I'd have to go home and ask my parents, but I thought they would be okay with it. She gave me a ticket and told me she'd see me after the show if I attended. I went to her program that was held in the multipurpose room at school. She had a small dancing part in the play. After the show, she found me and introduced me to her parents. I hadn't even thought about her parents attending too. I'm sure they were surprised when they met me. I had brown hair, and brown eyes, and my skin was much darker than hers. She was a sophomore; she wasn't native, she had blonde hair and blue eyes. We were complete opposites. Her parents were polite and cordial.

She introduced me to them and said, "This is my friend, Terry."

I was polite and told them I was happy to meet them. I didn't know them and was scared to death to meet them. It was the only thing that I could think of to say. I was happy she didn't tell me they'd be there that evening; or I might not have attended. She then asked her parents if we could go over to the bowling alley, which was a block and a half away from the school. It was a Friday night, and we didn't have school the next day. Oftentimes students would meet at the bowling alley as a hangout place. Her parents said that it was a little late, but she asked them if we could go for a couple of hours and her parents agreed. They told her to call home later, and that they would pick her up. I didn't have a car or any transportation to take her home. They left, and I was surprised when she grabbed my hand as we began walking to the bowling alley. I didn't know what the heck was going on. She wound up meeting her girlfriend there. I think they set it up, but I didn't know what was going on. We played the pinball machines, played pool, bowled, ate snacks, and just sat and talked with each other. Then a guy I knew from church showed up and said that he had just gotten a car and asked us if we wanted a ride home. We agreed, and he took each of us home one at a time, taking me home last.

I began seeing life through a different lens. Maybe It was a good thing that I was Native. My girlfriend started asking

me questions about who I was. She asked me one day if I was an Indian. I told her that I was. Although I didn't know what that meant exactly, I did know that I was Native. Then she asked me if I lived on the reservation, and I told her that I did. She told me that she thought it was cool that I was Indian. Then she told me that she loved the color of my skin. Her skin was light, and she said she would burn quickly from being out in the sun too long. She said she was jealous of my dark skin and told me that she loved my long brown hair. I was beginning to think that maybe it was okay if I was different from her and others. She, I, and our two friends began hanging out together. It wasn't a whole lot of people, but it was more than I was used to. My new friend Dave had a car, went to church with me, and he would pick me, Pam, and Cheryl up. Then we would go and do things together. It was turning to spring, and the weather began to get warmer. There were twin man-made lakes that were near the house, and we'd go swim there. I had friends again. Good friends. Friends that I enjoyed spending time with and friends that valued me the way I was. It was like these people came out of nowhere. They were people I could be with and enjoy life with once again. I didn't have to go home and sit all by myself every night, all night long. I think Mom could finally see a change in me. She was happy that I had found some happiness again.

I would ride my ten-speed bike over to see Pam at her house almost every day. There wasn't a sidewalk all the way to her house, and I had to often ride in the street. Although it was only a couple of miles, the traffic on the street could become dangerous. One day as I was riding to her house, a Marysville police officer turned his lights and siren on and pulled me over. I thought it was kind of weird that I was being pulled over by the police when I was riding a bike. I stopped by the curb and put my foot down to balance myself. The officer got out of his car and approached me.

He said, "You're riding on the wrong side of the road!"

I then said, "I was only riding on the road because there was no sidewalk there."

He said, "It's illegal."

Then he began writing me a ticket. I was a bit confused as to why I was getting a ticket. He asked me if I had any I.D., like a driver's license. I told him I didn't have a driver's license, and that's why I was riding a bike. He thought I was talking back to him and told me I'd better watch what I said. I immediately stopped talking and just sat there on my bike. I pulled out my Marysville High School i.d. from my back pocket and showed it to him. He took it and went back into his car, and started writing something down. There were people passing by me in their cars, wondering what was going on. After a few minutes, he came back and gave me a

ticket. He said he didn't want to catch me doing that again. I was sure he was doing this to me because I was Native. I felt like he could have given me a warning. I wasn't even sure I had done anything wrong. I was scheduled to take driver's Ed from school in the next week or two.

Pam found out that I could play the guitar. I told her I had been playing for a few years. She asked me to bring it over and play it for her. My guitar had a strap on it that helped me to hold the guitar as I played. When playing the guitar, the left hand is kind of holding the neck, and the right arm is kind of squeezing the guitar, but you're not really holding it. The strap helped me hold the guitar so I could play better. Before getting on my bike, I took the guitar and flipped it behind me. The strap came across my chest, and the guitar was now on my back. I then got on my bike and rode to Pam's house. When I arrived she was surprised that I had brought it and even more surprised that I could play it. I played several songs that I had learned, and then we watched television for a while. She had somewhere to go, and so I decided that I would leave. I hopped on my bike and put the guitar around me again, and started home. There was one way home that had more sidewalks than the other, but I usually rode the route with fewer sidewalks because it was quicker. When I approached the fork in the road to make that decision, I instinctively went towards the quicker route. Then in my head, I remembered what the officer had warned

me about. At the last minute, I changed my mind, but I had made the change too late and tried to make the turn anyway. There was a hole in the road next to the ditch, and as I turned, the wheel didn't quite grab the road. I was moving at a pretty good pace, and the hole made my tire stop. I wasn't going in either direction now. I was headed down into the ditch in front of me. My front tire went into the ditch and stopped, and I began flying over my handlebars. I tried to do a gymnastic front roll going forward. I had performed the move pretty well but had forgotten for the moment that my guitar was on my back. As I landed on my back, I heard the guitar strings make an awful sound and then heard a cracking sound as well. I had avoided any injury, but hurriedly, I jumped to my feet. I quickly turned the guitar around and could see that the neck had cracked at the base and one of the strings had broken. I kind of dropped my shoulders in disbelief. I wondered how I had let this happen. I played my guitar almost every day, and now it was broken. I wondered if it could be fixed and then picked up my bike to continue home. I lifted the bike and prepared to get on it, but then I noticed that my front wheel was completely bent. I wouldn't be able to ride the bike home, I would have to walk it home.

One day Pam and I decided to go and get something to eat off campus for lunch. We were allowed to leave campus to buy our lunch. It was usually Juniors or Seniors that would do that. There were a couple of different fast-food

restaurants adjacent to the school that students would go to. We only had thirty minutes, so we had to get out early and return as quickly as we could. She suggested we go to the Deli, like a 7-11 store. I agreed, and we quickly walked over to the store. Then on the return to school, she kind of slowed down. We were outside of the school grounds, and we heard the bell ring,

I said, "We have to run."

Pam grabbed my hand and said, "Let's just skip the last part of the school."

I had never skipped school before, and I wasn't okay with that. I was a senior now.

Then she said, "We'll be in trouble already because we're late."

So, I agreed, and we began walking back towards the deli. We just walked around the area by the school. We couldn't go to any stores because we didn't want to be caught skipping school. After a couple of hours, we began walking back on the adjacent street.

As we walked towards the school, she grabbed my hand and exclaimed,

"Don't turn around!"

Then she said,

"Do you hear that car coming up behind us?"

I said, "Yes."

She said, "That's my Mom's car; I can tell by the sound of it. We'll just tell her that we got out of pe class early and decided to go to the deli."

I agreed, and sure enough, when the car pulled up next to us, it was her mother. When her mother rolled down her window, Pam told her mom what was going on and said she'd see her at home later, and everything was good. When school was over, I raced over to the gym to get ready for our baseball game that day.

When I got into the locker room, I heard coach DeGross yell out,

"Everybody at the same positions except Goedel. You're not playing today; you can't skip school and play ball."

Even though we were coming to the end of the school year, that was the last and only time I skipped school. She later told me she was sorry for asking me to skip school with her. She said she would make it up to me. I didn't know it, but she was a pretty good seamstress. The next day she brought me a tank top that she had made.

Chapter 31: The Challenge

Pam and I continued to see each other and occasionally went out on double dates with Cheryl and Dave. I saw her just about every day after that. One day she invited her two friends and me to attend the cast party of the school play that she had been in. It was for all the students that had participated in the play. I wasn't really excited to go but told her I would go anyway. She, her friend, as well as my friend and I, were religious, but I still worried about attending the party. Most of the students that I knew in the school went to parties where there was drinking. I would often hear them talk about the parties while there. I was a little apprehensive about the whole thing. Dave had said that he would drive since he had just recently gotten his driver's license and a new little black Valiant. He picked me up; then we picked Pam and Cheryl up at their homes. As we approached the party, I could hear that there was extremely loud music coming from the house. When we drove up, I could see the window panes vibrating from the sound of the music. I asked them one more time if they were sure they wanted to go. They were all excited and insisted that it would be fun and coaxed me out of the car and on my way to the party. We walked up the sidewalk to the house. I could hear the music blasting, and it was getting louder with each step. I could smell smoke coming from the house, and I asked them again if they were sure they wanted to attend the party. They all

insisted that it would be fun. When we entered the house, the four of us found a seat in the living room and just began talking with each other. The three of us, with the exception of Pam, didn't really know anybody, and we wanted to stay together. The people in the crowd knew Pam but didn't really know any of the rest of us. She knew most of the people at the party because it was the cast from the play she had been in. Suddenly the host of the party came into the room, welcomed the four of us, and placed a can of beer on the table in front of us to share. He reached down and grabbed the drink, and then he popped the top and handed the beer to the second person on my right. That happened to be Dave. Without batting an eye, he handed it to Cheryl, who without hesitation handed it to me, and I quickly handed it to my girlfriend Pam, who looked shocked, then handed it back to me. I then handed it to Cheryl, who handed it to Dave. When Dave received the beer, he noticed that there were several people now standing there watching us pass the beer between ourselves. He looked up at the crowd, then took a sip. Afterwards, he again handed the beer to Cheryl, who then handed it to me. I again handed it to Pam. When she received the beer, she looked up and saw the crowd had grown in size and, to my surprise, took a small sip and handed it back to me. I was now kind of in shock and handed it to Cheryl, who quickly handed it to Dave. Dave again took a sip of the beer and handed it back to Cheryl. She now

noticed how many people were watching us and also took a sip of beer and then handed the can of beer to me. I noticed that the gathering of people had continued to grow in the room during our exchange, and I placed the can of beer on the table and said, "No thanks."

I remember feeling quite uneasy by now and didn't know what to do. After a couple of minutes, the crowd had dispersed, and I asked Dave to go to an adjacent room that sounded like there were people playing pool. When we entered the room, there were indeed people playing pool. Pam, in the meantime, went to the kitchen, and Cheryl went with her. She said she went to tell the host that I didn't drink and would appreciate it if he wouldn't ask me anymore. I just stood there with Dave, and we watched the others play for a few minutes. Then those that were playing pool finished their game and put up their pool sticks. Dave and I began playing a game of pool against one another. Neither one of us was particularly good. He racked the balls, and I made the break. I hit the cue ball as hard as I could, and the balls went here and there, but none of them went into any of the pockets. We didn't really know what we were doing; we were just having fun. We had played before but were just beginners. It was easy to get into playing the game and forget about what had occurred earlier. Before long, without me knowing, the room had filled with people watching us play. At first, there was plenty of room to use the pool sticks, but

now we were surrounded by many people. It had become difficult to use our pool sticks any longer. As a matter of fact, the room seemed more filled than it should be. It was lined from wall to wall with people. My girlfriend had returned and was watching us along with all the others. I could feel that all eyes were on us, and it felt very strange. Everybody seemed to be smiling, kind of snickering at us. Then the Host slowly entered the room. He was carrying a large glass of beer as he entered and stopped and surveyed the crowd for a second. Then with a smile on his face, he took another look around the room and then said to me,

"Here's a large glass of beer for you since it's your first one."

I could sense the humor of the Moment for all that had gathered to witness the occasion. I just stood there and didn't say anything. Everyone in the crowd waited for me to do something. I just put my head down, put the pool stick back in the rack, and just leaned up against the wall. I stood there for a few seconds, then put the pool stick back in the rack. After a few moments, I decided to go back to the other room where it had all started. It was difficult to have them challenge me that way. I had already been through the challenges of being Native; now I had a new challenge. I went and sat down in the same place on the couch where I had sat when we entered the house.

My girlfriend, Pam, could tell I was not happy and feeling uncomfortable. She came and sat next to me, put her arm through my arm and in a whispering voice said she was going to tell the host to leave me alone and left the room to talk to him. I was still sitting on the couch when Dave and Cheryl joined me. Then Pam came back and joined us as well. We began talking and visiting when I noticed once again that the room began to be filling with people. I looked around and noticed that most people were looking in my direction and seemed to be smiling. The kitchen doors swung open, and once again, the host of the party entered. He was smiling and holding a pitcher of beer this time. As he entered, he looked around the room, kind of toasting different individuals. As he approached the couch where I was sitting. He stopped and placed the pitcher of beer in front of me on the coffee table, and said,

"Terry, we all know you have never had any alcohol to drink before, so we're going to give you this large pitcher of beer free tonight. Everybody else here has to pay except you; this one is on the house."

I sat there and stared at him for a second, took a deep breath, then said,

"No thanks. Sorry, I don't drink".

The group as a whole began to laugh and kind of whisper and point. I sat for a few more minutes with my friends, and

then slowly, the crowd dispersed. The party wasn't fun for me, and I decided it was time to leave. As I began walking out, my friends tried to talk me out of leaving, but I was determined to leave and went outside. My three friends soon followed and were now by my side. Each apologized and said they were sorry for drinking the beer and begged me to stay with them. I said that I needed to go home. Dave said that he would drive me home. I told him that I didn't need a ride and that I would walk home. Pam asked me to go home with them. The house was located in a neighborhood close to the high school. I was familiar with it. I had walked this route for a couple of years and knew exactly where I was. It was a house that I passed as I would run home almost every day. I recognized many of the trees that I would climb to eat apples as they would ripen. As I walked, I wondered why people called me an apple. I had to walk about a mile that night to my house. It was dark, and I was feeling lonely again. I walked on the side streets where there was little traffic and continued until I was walking under the freeway. The passing cars lit up the sidewalk for me to see. There was the Old Thunderbird Drive Inn Theater that I had to pass. There was a line of cars waiting to pay their fee to enter. I could see carloads of people driving in. It looked like they were having an enjoyable time. It had a large neon Native Thunderbird sign that could easily be seen by the passing motorist driving on the freeway. I slowly walked past the

sign and looked up at the sign as it lit up the sidewalk in front of me. The movie had already started. I went over the small white bridge that crossed over Quilceda Creek. Once I crossed the bridge, I was on the reservation. I had to walk another 50 yards to our driveway. There was no sidewalk, and it had gotten much harder to see. I walked up our dark driveway, opened the metal gate, then closed it. When I walked into the house, Mom was waiting up for me. She asked me how the party was. I didn't tell her much; I just told her I had a good time even though it was one of the most humiliating things I had ever experienced. She asked about my friends, and I told her that they had gone home. I told her I was tired and wanted to go to bed. I wondered if it was really worth it. I was thinking that maybe I should just have given in and had a little sip with all my friends. I'm so grateful that I had the courage to get past the pointing fingers and snickers of the night. I had read in the scriptures about a group, "and they were in the attitude of mocking and pointing their fingers." I didn't understand why anyone would do that but now I understood what it meant. It made me ponder what I believed in. Now I had to contend with my beliefs as well. It seemed to me like no matter what I was or what I did, there was opposition. I felt grateful for the courage to stand by the promise I had made to myself and God a few years earlier. I had made a commitment to myself that I would never smoke, drink, or do drugs. A commitment

279

that I have kept my entire life. With all my friends in Alaska, we huddled together years earlier, and I had agreed that we would never do that; I had made a promise, a covenant to myself and God.

I scheduled my senior class photos for the yearbook, and I dressed in a black suit and tie. When I received them, Mom loved the pictures that I had taken. She wanted one to carry in her purse. After she cut out a couple of pictures of her own, she gave me the rest of the packet to hand out to all my friends. I gave one to Pam and Cheryl, and that was it. I didn't give a picture to another person. I didn't take my pictures until after I knew for sure I had passed my community college class. Our yearbook was called the Quil Ceda. The yearbook staff received my pictures too late, so my senior pictures weren't included in the Senior picture section. They kept my Junior class picture which was taken by the school photographer, as my school picture. In the yearbook, I'm listed with the Junior class, not the senior class. I didn't really know anybody when they had the junior/senior prom or the homecoming dance. I didn't attend either one of them.

I told Mom that I wanted a new guitar for my graduation. She took me out one day and bought me a new one. It was better than the one I had before. A few days later, Mom and Dad surprised me. For my graduation present, they took me out to go buy a car. I thought that I had already received my

gift when Mom bought my new guitar. They were proud that I had continued my schooling and graduated a year early from high school. I had never thought that they would buy me a car for my graduation. I had never even asked for a car. I didn't think they would be able to buy me one. Up to this point in my life, I had never even had a job, except my newspaper route in Alaska a few years earlier. I was always playing a sport and didn't have a job to earn any money. I had completed my driver's ed training, passed all the tests, and had my Washington driver's license. I had taken my driver's ed class from my last semester's math teacher, and baseball coach, Mr. DeGross. He was a good math teacher and an excellent driver's ed teacher as well. Although he kind of scolded me the first time I went to brake the car, we were driving. He did teach me how to parallel park because he told me how to do it mathematically. That made it easy for me to learn. After he explained the mathematics of parallel parking, I could easily park a car in any spot if it would fit. We went out looking for a car for the entire day. Every car we looked at was not what I wanted to drive. I did appreciate what they were doing for me, and I was excited, but Dad wanted to buy me something inexpensive, and I wanted something that looked nice. The inexpensive ones looked terrible, and the nice ones cost too much. Between what he was looking for and could afford and what I wanted

was a drastic difference. After a while, Mom would say something like,

"Just get him that car, and let's go home."

Dad would tell her it was too expensive. We spent most of the day looking around from one car lot to another. We stopped in a small car lot in Everett, Washington, on Broadway. Dad and I walked in to talk with someone about a car when we noticed they also had motorcycles that were for sale. I saw a green metallic one.

I said," Wow, that's pretty cool."

Dad said, "Well, would you rather have a motorcycle than a car?"

I said, "Yeah, that would be great."

Dad had loved motorcycles from his youth and was happy to buy me one, especially for the price. He had owned and driven Harley's, Honda's and Indian motorcycles throughout his life. We asked the salesman if I could take it for a little spin. He asked if I had a motorcycle license. I told him I had just received my regular driver's license, and he said that would do. Then he asked me if I knew how to drive a motorcycle. I told him that I knew how. I stood up and put all my weight into the kick start, and it started right up. I put on the matching green metallic helmet and asked, "One down and three up?" to which he said, "yes." So we bought

the motorcycle for $500, and I rode it home. It was a metallic green Honda 125cc dirt bike meant to ride on trails. It was street-legal, meaning that I could drive it legally on the streets as well. Dad asked me if I wanted to drive it home or if he should go get our trailer. I told him I wanted to drive it home. I rode around the side streets of Everett, just enjoying the drive with the wind in my face. I took my time getting home. It should have taken me 20 minutes to get home, but it took me about an hour and a half. I met my parents at home on my motorcycle. I took off my helmet, walked in and told them I wanted to show my girlfriend. Mom told me to be really careful. Dad had been in a couple motorcycle accidents and knew that it could be dangerous. She really wanted me to have a car and was hoping that I would be extra careful. I drove it over to my girlfriend's house to show her. I asked her if she wanted a ride, but she said her parents told her never to ride a motorcycle. She said it was cool, but she had better not.

Then with a smile on her face and a twinkle in her eye, she said,

"Let me go and ask my parents if I can ride around the neighborhood."

She went in and asked. They said she could ride around the block with me. I told her to be careful not to burn her leg on the tailpipe. She hopped on, and I drove her around the

block with her holding on tightly. I only had one helmet, so I let her wear it. I took her home and then began driving it around the city and on the reservation.

I drove over and showed my friend Dave the motorcycle. I lived on the reservation right next to a street named 27th Ave NE. When he met me at the house, he said he wanted to race me down that street. It wasn't a busy road, and there weren't many people who lived there at the time. It was a dead end after about half a mile. He got in his car, and I was on my motorcycle, and when we were ready, we took off. A motorcycle is much quicker than a car at the start. It was a small motorcycle, but I took off like a lightning bolt. It only took Dave a few seconds, and he caught up with me and then passed me. It was the last time I ever raced a car or motorcycle. It was just fun and maybe dangerous, but I only did it a couple of times on the road that day.

Chapter 32: Last Days of School

A day earlier was my last day of attending classes, but I met Pam at school in the morning. I wasn't required to attend school that day because I would be graduating later that evening. I hadn't seen my actual junior, sophomore, or freshman classmates for several days because of senior pictures, practice, and other events. My girlfriend had class, so I met her before school. The seniors would need to come to school till later in the day. As we walked the halls, I could see people darting out of the way hurriedly and quietly, whispering while pointing and looking at me. They were almost hiding behind their tall opened locker doors. I heard someone ask another person,

"Is he the one?"

Then a reply by another,

"Yes, he's the one; he doesn't drink."

Originally, I felt ashamed to tell people that I didn't drink or smoke. After the event from a few nights previous, It didn't bother me as much, and we just continued as I walked Pam to class. It was out there, and I was happy to own it. It was like a secret that I was religious, and I didn't want anyone to know, but now I didn't care anymore. Yes, I was a member of the Church of Jesus Christ of Latter day saints and I was proud of it. After walking her to class, I went to

graduation exercises for the seniors. Pam's older sister, Sandy, came up to me after the practice exercises and introduced herself to me. Pam had mentioned her, but we had never met. There was almost no way for the two of us to meet one another during the school year. She had classes with all the seniors, and I had classes with the Juniors. It was one of the first times we could have met. She told me she was happy that Pam and I had gotten together. She asked me if she could write in my yearbook. In the message, she thanked me for being a good example and pleaded with me not to break Pam's heart, which I was not planning on doing. She was the only senior of 330 graduating students that wrote in my yearbook. There were only two or three other native students that I graduated with that year. Only eight people wrote in my yearbook. A friend I played basketball with the year before named Scott, who was a Junior, Pam (who wrote in my book twice), her sister, Sandy, Cheryl, and four of Pam's friends whom she had asked to write in my book. I was aware of who they were but didn't really know them.

On Sunday, we had the baccalaureate program that I attended. It's traditionally a Christian celebration for all the graduating seniors. It was in the afternoon in the gymnasium. Mom, Dad, Oscar, and Lorna attended it with me. I wore my bright red graduation robe, the same color as our school colors. I wore nice slacks, a white shirt and a tie underneath with dress shoes. I know Mom and Dad were proud of me.

When it was over, they asked me if I wanted to stay and visit with everyone, to which I said, "No." I met up with Pam after and agreed to meet her over at her house.

It was May; the next day was Monday, the day of graduation. We went through pretty much the same routine as the baccalaureate program, but everyone received their diploma. When they called my name, they announced that I had received a scholarship to attend Brigham Young University. There were many surprised looks and a few ahh's because very few people in the school even knew that I was graduating. I was the most surprised because I didn't even know if I had been accepted to attend Brigham Young University. Mom and Dad cheered, and Mom let out a big whistle. There were graduates that mentioned to me that they didn't know I was a senior. After the event, I went out and took pictures with my parents and siblings. I can't remember taking a picture with Pam, her family, or her sister Sandy. There was a senior excursion or activity after graduation, but I didn't attend. I just told my parents I would go over to Pam's house and have a little celebration with her. Her sister would attend the senior outing, and I never saw her again after graduation. I had only met her parents a couple of times. When I knocked on their door, her father answered. He had seen me at our graduation. He said he didn't know that I was graduating with his daughter, Sandy. He asked me if I was going on the excursion. I told him that I wasn't going to go.

He congratulated me on graduating from high school. Then he asked me if I wanted to celebrate by having a beer with him. That's when Pam arrived and said,

"Dad, Terry doesn't drink alcohol." He then replied,

"Well, good for him, but let me know if you change your mind."

I said, "No thanks."

Pam and I then went downstairs and watched television for a couple of hours, and then I went home.

The day I graduated from high school, I was still 16 years old. My birthday was in August, and I was always young for my class anyways. I wouldn't turn 17 years old for a few months. The day after graduation, I went with Pam to a church party with her Methodist group after school was finished. She had invited me to go with her and her girlfriends. We hung out with the students there for the day. I saw students that I was acquainted with from classes at school. We were all surprised to see each other attending the event. There were a few people that asked me about not drinking at the party, and they told me that they didn't drink either. I told them that it was good to be around others who felt the way I did. After we had been there for several hours, it started getting dark. I decided I had better get home soon since I was riding my motorcycle home from the party. It

was about ten to fifteen miles from my girlfriend's house. It began to rain. I told Pam that I'd meet her at her house. It continued to rain all the way to her house. Even though I was wearing a helmet, the rain would really sting as it hit my face if I was driving too fast, so I had to slow down. By the time I arrived, I was wet, completely soaked. I couldn't drive too fast because of the conditions, and Pam and her friends were in cars and didn't have to worry about it. When I finally arrived, I stopped to tell her I had made it back safely and then continued on to my house. By the time I got home, I was soaked from head to toe and feeling frozen. That's when I started thinking that maybe I should have gotten a car instead.

I walked into the house, and my Mother and Father were waiting on the couch to greet me. They asked me if I had a good time, and I told them I did, but I was wet from the rainy ride home. I'm sure they could see I was drenched and could tell I was cold as well. They told me that I had received a letter from BYU. I had only applied to two universities, Brigham Young University in Provo, Utah, and The University of Washington in Seattle. I was kind of casual in my reaction. Then they asked if I wanted to know what it said, and

I said, kind of nonchalantly, "Okay."

Mom said, "You've been accepted to BYU to attend college."

I kind of shrugged my shoulders and again said, "Okay."

Then Mom said, "You've been accepted to BYU, and you have to leave tomorrow. We bought you an airplane ticket, and you have to leave in the morning."

I looked at them, shocked, and didn't know what to say.

Wait, I would have to leave in the morning. I was finally feeling okay about living on the reservation. I had a motorcycle; I had a girlfriend that liked the fact that I was a Native. "What's happening?" I wondered. I immediately called my girlfriend and said, "I need to come over and see you." It was late, and she asked if it could wait till the morning.

I said, "That might be too late. Can I come over and see you now?"

She said, "Yeah, come on over."

I grabbed my helmet and went outside, and immediately rode my motorcycle back to Pam's house. It had stopped raining by the time I arrived at her house, but I was still wet and cold. I honked my motorcycle horn, and she came out to meet me. I told her that I had been accepted to BYU and had to leave in the morning to go to school.

She looked at me in disbelief and began to cry and asked in a tearful voice,

"You have to leave tomorrow?"

Then I said,

"Yea, I have to leave tomorrow. Would you like to go with us to the airport?"

She said she would ask her parents and call me when I got home. I was finally comfortable with who I was and where I was living, and it was now time to leave. On the ride home, I wondered over and over in my mind what was happening. Maybe I shouldn't go; maybe I should stay home and go to college at Everett Community College. I didn't know what I was going to do. When I got home, I changed my clothes, took a shower, and then got ready for bed. That night dad came into my room when I was packing and had a talk with me. He gave me about fifty dollars and then said, "Terry, you're a grown man now; you won't ever need to ask me for help with anything again." I wondered what he was talking about. I was only 16 years old. I had barely started shaving and only needed to shave once a week if that. It was those Native genes that made me less hairy than most men. I didn't think I was a grown man. I felt like I was only a teenager going off to college. Dad and I didn't really talk much or often. It felt like he was telling me to leave.

Chapter 33: The Promise

Mom bought me a couple of suitcases earlier that day and told me that was all I could take with me. They knew that I would be leaving and went out and bought me a few things. There was one large and one medium-sized suitcase. I gathered my clothes, shoes and socks, and a few personal items and packed them, then went to bed. Early in the morning, Dad came and woke me up and told me it was time to go. I got up, took a shower, and got ready to go. He said goodbye to me and then left to go to work. I loaded my suitcases and got in the car, and we drove over to Pam's house.

Mom and Dad had met her before. I had brought her to meet them at the house once. She had told me that she wanted to see what it was like on the reservation. It's strange that there are people that live right next to the reservation and don't know what it's like. They often think it's so much different when it's really much the same. There are small communities on the reservation with homes that are similar to the ones that are in town. People can drive through the reservation to participate in different activities or observe, but they usually don't. An individual needs to drive through the Tulalip Reservation in order to get to the beach. It's like it's off-limits to them, but there are some different laws there. Mom and Dad had made a few strange comments

while Pam visited and embarrassed me in front of her. She kind of laughed at their joking, then turned red, but I didn't think it was funny. I didn't really care if she met up with them again after that, so I never took her to my house after that. Now it was different. When we arrived at her house, I went and knocked on the door, and she came with me. She grabbed my hand, and we walked to the car together. Mom was driving, and Oscar was in the front with her. We drove to the Seattle airport, and Pam and I talked in the back seat. Lorna was also sitting back with us. We talked in hushed voices trying to talk but not wanting anyone to hear our conversation. She told me how much she would miss me, and I told her how much I would miss her. We also discussed calling and talking with one another. We arrived, and everyone walked me to the terminal, all the way to the gate. I was at the airport with my mother and girlfriend and was preparing to get on the plane. It was kind of awkward trying to say goodbye to my girlfriend with my mom and siblings standing right there with me. I was 16 years old, and she was 15 years old, and I had to say goodbye to my Mom and family too. Pam and I stood there holding hands, and it was difficult to find things to talk about. My life was about to change, and I didn't know what to say. Then my mother asked me if I would promise her that I would go and see a lady named Janie Thompson at BYU. I said I didn't even

know who she was. She asked me again if I would promise to go see her, and

I said, "Yes."

Mom then asked again,

"Will you promise me that you'll go see Janie Thompson?

I said,

"Yes, Mom, I promise I'll see her."

I was kind of annoyed with her asking me because I wanted to talk with my girlfriend.

Then she said,

"Say these words, 'I promise I'll go see Janie Thompson.'"

I repeated the words that she had spoken and said,

"I promise I'll go see Janie Thompson."

She then handed me a JC Penny's bag with something in it. I looked in, and there was a pair of white Levi Strauss Jeans in the bag. She said I would need them. I told her I didn't wear white jeans, but she insisted that I would need them. I took the bag from her and then gave each family member a hug. Then I hugged my girlfriend, and we gave each other a kiss goodbye. I boarded the plane. I didn't know

if I would ever see her again. She came into my life when things seemed darkest to me. She helped me begin to see the Native person that I was. She liked me for what I was. She had no bad preconceptions of who I was. I was grateful for what she had helped me to see in myself. It seemed eerily similar to what I had already gone through once in my life. I was leaving what I thought was the best part of my life behind. I boarded the plane and looked out the window but couldn't see anyone this time. I was in the middle seat and could only see a few things out the window. I didn't know when I'd see Pam again. We agreed to write to each other, and I told her that I would call her too.

The plane ride was only a couple of hours long. When I arrived in Salt Lake City, I noticed immediately that the weather was so different. It was hot and dry, and I couldn't get enough liquids to drink. My older sister, Gloria, and her husband picked me up at the airport and took me to campus. I stayed with them for the evening. She began attending BYU the year before and had also gotten married. The next day she and her husband drove me to my dorms called Deseret Towers. I checked in for the summer term. I went up to my room and met my roommate, Gordon Wolfe, from Lethbridge, Canada. My world had just changed again. When I arrived to check in, I noticed there were several people outside playing basketball in the hot sun. There were others playing ping pong in the lobby, and everyone seemed

to be doing whatever they wanted to do. I had a room on the third floor. I'd have to take an elevator up to my room. I took the elevator along with my things up to my room. After that, I usually would use the stairs because I hated waiting for the elevator. It was only a couple of flights of stairs which was no big deal to me. It was a small dorm room with only two of us in the room, with my bed on one side and Gordon's on the other side. On each side of the room, there were small drawers and a small closet to hang a few clothes. After I had everything put away, my sister and her husband left me to myself. I brought my new guitar with me too. I took it out of the case and played a quick song, then set it down. After I met my roommate, we talked a little, then I changed clothes and immediately went outside and began playing basketball. I learned that the altitude made it difficult for me to catch my breath. Marysville was at sea level, and Provo, Utah was at 4500 feet above sea level. After playing a few games, I ran to the drinking fountain. I asked somebody if there was a place to get something else to drink. Gordon had changed and had come out to play basketball as well. He showed me where I could get a drink. He took me to the cafeteria and showed me where we would eat three meals a day. I thought to myself, Now this is life.

In the next few days, I had to add classes and register for school. There were long lines everywhere I went. I was one of the new freshmen, and I had to wait for all the other

if I would ever see her again. She came into my life when things seemed darkest to me. She helped me begin to see the Native person that I was. She liked me for what I was. She had no bad preconceptions of who I was. I was grateful for what she had helped me to see in myself. It seemed eerily similar to what I had already gone through once in my life. I was leaving what I thought was the best part of my life behind. I boarded the plane and looked out the window but couldn't see anyone this time. I was in the middle seat and could only see a few things out the window. I didn't know when I'd see Pam again. We agreed to write to each other, and I told her that I would call her too.

The plane ride was only a couple of hours long. When I arrived in Salt Lake City, I noticed immediately that the weather was so different. It was hot and dry, and I couldn't get enough liquids to drink. My older sister, Gloria, and her husband picked me up at the airport and took me to campus. I stayed with them for the evening. She began attending BYU the year before and had also gotten married. The next day she and her husband drove me to my dorms called Deseret Towers. I checked in for the summer term. I went up to my room and met my roommate, Gordon Wolfe, from Lethbridge, Canada. My world had just changed again. When I arrived to check in, I noticed there were several people outside playing basketball in the hot sun. There were others playing ping pong in the lobby, and everyone seemed

to be doing whatever they wanted to do. I had a room on the third floor. I'd have to take an elevator up to my room. I took the elevator along with my things up to my room. After that, I usually would use the stairs because I hated waiting for the elevator. It was only a couple of flights of stairs which was no big deal to me. It was a small dorm room with only two of us in the room, with my bed on one side and Gordon's on the other side. On each side of the room, there were small drawers and a small closet to hang a few clothes. After I had everything put away, my sister and her husband left me to myself. I brought my new guitar with me too. I took it out of the case and played a quick song, then set it down. After I met my roommate, we talked a little, then I changed clothes and immediately went outside and began playing basketball. I learned that the altitude made it difficult for me to catch my breath. Marysville was at sea level, and Provo, Utah was at 4500 feet above sea level. After playing a few games, I ran to the drinking fountain. I asked somebody if there was a place to get something else to drink. Gordon had changed and had come out to play basketball as well. He showed me where I could get a drink. He took me to the cafeteria and showed me where we would eat three meals a day. I thought to myself, Now this is life.

In the next few days, I had to add classes and register for school. There were long lines everywhere I went. I was one of the new freshmen, and I had to wait for all the other

who needed to know and understand others. It was an incredible experience, and I began to better know and understand the gifts of God. I felt an unbelievable powerful feeling as he was telling me about it. It was incredibly enlightening, and I began to cry. I was feeling such a powerful feeling. It felt similar to the feeling that I had felt when I watched the hoop dancers but even more incredible. After a few minutes more of discussion he excused himself and I went about my activities.

I had written Pam a couple of times and called her too. It was difficult to call because not everyone had a phone in their dorm room back then. I had to borrow the person's phone from next door. We had landlines, and each individual had to have a telephone installed in their room. Every day that I thought about us being together, it just didn't seem to work out in my head. The next day I called her and told her I didn't think it would work out with us being so far away from each other. I didn't have a way to get home to see her and didn't know when we'd get together again.

She asked, "Are you dating somebody else there?"

I said, "No, I'm not dating anyone!"

I was too young to be asking girls out on dates because I was only 16 years old, and they were probably 18, 19, 20 years old, or older. She questioned me again, and I told her

that I wasn't seeing anybody. She began crying at the end of the conversation and finally said,

"Goodbye!" and hung up.

I didn't know what to think or what to do. I never heard from her again but I always appreciated how she had helped me feel comfortable with who I was. It was a difficult time for me, and she was a light that I needed when I needed it.

After I had been at school for about a week and a half, I asked my brother-in-law, Bob, if he knew who Janie Thompson was. He said he knew her. I asked him if he could take me to see her and introduce me to her. I had made a promise to my mom that I would go see her.

He said, "Then let's go right now and see her."

We got in his car, and he drove me to a building on campus called the Wilkinson Center. We parked the car, and he walked me to her office. He said he knew who she was and would introduce me. He knocked on the wall next to her opened door. He apologized for bothering her. She greeted us with excitement and a smile.

He said, "This is my brother-in-law, Terry. He just enrolled in school and said he wanted to meet you."

She went from talking to him and turned her attention immediately to me. I didn't know what was going on, but she was sure excited to meet me. She kind of escorted Bob

out the door and then closed it. There was a small rectangular window in the door so people could see out or in. He waved goodbye to me and then walked away. This was an older lady in her fifties or sixties.

Then she asked me,

" Can you sing or dance?"

I said,

"Yeah, I guess I can sing and dance. I dance at the school dances if that's what you mean."

She then asked me to start snapping my fingers to the rhythm of the beat that she led. I snapped my fingers with her, and before long, she had me snapping fingers on both hands. I was wondering what was going on. Within minutes of finding that I had rhythm, she asked me to stand up while snapping my fingers. So I followed her lead and stood while snapping my fingers. She then asked me to start moving my body from side to side while continuing the finger-snapping. Before I knew it, I was following her as we were walking in rhythm around the room while snapping our fingers. She had me stand up, and I began to follow her around the room. I was following a 55-60 year old lady around in a small 10-foot by 12-foot office, snapping my fingers and kind of dancing in rhythm. At one point, I looked out her small window and saw about ten people trying to peek into the

window to see who I was. Within a few minutes, she sat me down at the piano and asked me to sing for her. She wanted to see if I could sing different parts of the song called "Joy To The World." I was familiar with the song sung by the group, Three Dog Night. I began to sing the song with her. After about 15 to 20 minutes with her, she, all of a sudden, stopped in her tracks. She stood up and asked me if I wanted to go on tour with a Native American dance group. They would be leaving in a few days and would be on tour for eight weeks. I told her I had just signed up for classes and would need to finish my classes first. She told me that she would take care of it and asked me again if I wanted to travel with the group. I then told her again that I had just signed up and started classes.

In frustration, she said,

"I'll take care of your classes. Can you go on tour?"

I answered,

"Yeah, I guess I can go."

She said,

"All you need to have is a white pair of pants. Do you have any white pants?"

I said,

"Yeah, my Mom bought me a pair of white jeans just before I left home."

She lifted her hands up in the air and started praising the Lord.

She said,

"I have been on my knees praying for you to come along for the past two weeks."

The crazy thing is, my Mom and Janie never knew each other. They had never talked to each other or communicated in any way. I would have to finish the classes next semester. She told me the first practice would begin later that day. I told her I would be there. At the first practice later in the afternoon, Janie introduced me to the group. She was so excited to have me there. She introduced me to my dance partner, who would be helping me. Her name was Vicki Washburn. I was shown a few steps here and a few steps there, and before I knew it, I was dancing with a group of about 30 students. I didn't know what I was doing, but it didn't seem too difficult. There were several others who began helping me learn the dances, too, and I was catching on pretty quickly. They continued reviewing one dance and then another. We were going through the entire show, and I was learning as quickly as I could. Most of the students knew the routines, but there were a couple of us that were just learning everything. I had forgotten where I was and what I

was doing. I was just watching, learning, and following the best I could. I had different dance partners for different numbers. I was introduced to another partner; her name was Vicki as well, Vicki Bird. People were by my side, constantly teaching me each section. There was a break, and we gathered together later that evening for another rehearsal. We began practicing the second part of the show. It was called the Native section, and that's when it dawned on me that this was the same group I had seen performing in Seattle the year before called the Lamanite Generation.

Chapter 34: Tour

The next day I found myself learning and practicing dance routines with people I had never known before. I had joined the Native American Dance group called the Lamanite Generation. We were a performing group of about forty students. I had never danced formally. For the next few days, all I did was learn different modern and Native dance routines. Some numbers I had to learn as an individual, and other dances I had to learn with a partner. We opened with a number called "Hello To You" with everybody in a pink top and white pants While dancing we had to sing the words, "We want to say hello to you, we want to be your friend it's true, that's why we say, Yaateeh." I wondered what in the world that meant, but I just did my best to keep up. There were several other modern numbers that we performed after that, including;

A Thing Called Love,

United We Stand,

Everybody's Reaching Out,

Put A Little Love in Your Heart,

You Gave Me A Mountain,

The Candy Man,

Cherokee Nation and a few other numbers.

The girls did Cherokee nation to the song by Paul Revere and The Raiders, called Indian Reservation. I remembered the song when I was going to high school and it annoyed me. Now it was one of our numbers and I learned to love the song and the dance that the women did with it.

Then someone asked me if I could fancy dance. I told them that I had been to pow-wows but had never danced. The guys in the group began teaching me how to do the Native American fancy dance. It felt awkward to make the moves that they were showing me. My arms were held out wide in a weird position, and it felt like my body was all over the place. Then I had to shake my head as I was dancing, and it felt pretty weird. I kind of followed what they showed me, but it was difficult for me to commit myself one hundred percent into it. I felt odd but was doing the best I could. All the dancers were Native. That was different for me. I wasn't used to being around other Natives. They just accepted me as I was, were patient, and continued teaching me what I needed to do. Ray Washburn was the main teacher to helping me with fancy dancing.

After a few days of practice, it became time for us to leave. We met early in the morning at the designated place. We packed all the costumes, regalia, and our suitcases on the bus, and we were off touring. I was fitted for each number, and a fancy dance regalia was put together for me to use. It was an outfit that another individual used that hadn't

306

returned. I didn't really know anyone in the group, and most of the other performers knew one another. I was the new kid in town. I found a seat next to somebody on the bus, Tony McCabe, another new guy in the group. He had only joined the group the week before me, but he seemed to know so much more than I did. We talked as we traveled to our first destination. We were both about the same size and the same height. The two new guys, Terry and Tony, and our dance partners were Vicki and Vicki. We talked, I found out his story, and then I shared my own. We became good friends. We were both new and still kind of lost but finding our way together. He helped me with every dance routine that I needed to know. It was something that would happen for the next eight weeks. Between each show, as we would travel on the bus, different people would sit in different places unless a couple began liking each other. After a few days, people kind of sat in the same place, but there was no assigned seating. We would go out and share our Native Culture with the world. A few months ago, a few weeks ago, a few days ago, I didn't even know my native culture. I was so young at the time when I arrived at college and was trying to hide my age. I wouldn't tell anybody how old I was, not that anybody was really trying to figure it out. On Sundays, we would usually offer a fireside for the people living in the area. It was usually held at a local church, and our entire group would participate. The president of the group, Ray

Washburn, would usually conduct the meeting. We would sing songs and offer testimonies to various individuals. Each time there were different people who would speak. I found myself to be more and more like the others. As I heard about their struggles and differences with the places they had lived, I began to see more and more how we were alike. They professed their love for God which inspired me to become more like them. I began to wonder if I really believed in Him. I worked daily to try and find deep inside my heart if I really did believe. I began to kneel and pray on a daily basis and learned for myself that God is real.

Not only did I sing and dance in the group, but I was also a part of the band too. I was the rhythm guitarist. When Janie found out that I could play the guitar, she invited me to go and work with the band. One day it was close to my birthday, and Dave, our drummer in the group, asked me if I'd be going on a mission soon. I told him I wasn't sure if I would be going; I hadn't thought about it much up to this point in my life. He told me it would be good to try and figure it out before I turned nineteen years old. That's the age when young men go out and serve a mission. He had been on a mission and was now pursuing becoming a lawyer and needed to work hard to accomplish that goal. I again told him I wasn't sure if I wanted to go or not. He asked me how old I was. I didn't feel threatened by him at all because we played music together. I told him I was 16 years old. He said

no way, man, let me see your driver's license. Again, I said, I'm sixteen years old. He asked me again to see my driver's license. I pulled out my driver's license to show him, and he said with a loud voice,

"I can't believe that you're only sixteen years old."

To say the least, it wasn't a secret anymore.

Then he said it again even louder while holding up my driver's license,

"I can't believe you're sixteen!"

Everybody in the group now knew that I was sixteen years old. I don't think it mattered to them at that point anyways. The others in the group began talking with me and asking me how I had heard about the group. I said that I didn't really know about the group. I told them that I had seen the group the year before up in the Seattle area. They said that yes, indeed, it was the same group.

I said," It was?"

I couldn't believe I was in the group that had helped me to know, love, and understand my native culture. By watching that group, a light had been lit inside me. Not only had that light begun to flicker inside, but it was also beginning to shine brightly.

One of our first stops was in Sheridan, Wyoming. It wasn't a big deal to me; it was just another place that I had never been. We would be performing at the All-American Indian Days. It was the place where they would pick the new Miss Indian America. That's where the yearly event used to be held. One of our members, Vicki Bird, was a contestant in it and was one of my dance partners. She wound up being crowned the runner-up to Miss Indian America in that pageant. They also had a Native Dance competition for both our hoop dancers and our fancy dancers. Three of our fancy dancers placed 1st, 3rd, and 5th in the competition. They were happy because they won money that they could use for the rest of the tour. I didn't compete. I didn't feel like I was ready to compete, having just learned to Fancy dance. There was a hoop dance contest as well, and our three hoop dancers placed first, second, and third. There were no other hoop dancers competing.

As we traveled for the next two months, just about all the members of the group shared with me their thoughts and concerns. Many of them were just like me. They were trying to find a place to fit in. It wasn't easy trying to be Native in the world at that time. We traveled over the entire western United States. We performed on reservations, at schools, at malls, and across Canada, and with each show, my love for my culture began to grow. We traveled through Utah, Wyoming, Idaho, North Dakota, South Dakota, California,

Nevada, Oregon, Washington, Oklahoma, Kansas, Missouri, Iowa, Montana, Nebraska, Texas, and New Mexico, and through the Canadian provinces of Saskatchewan, Alberta, and British Columbia. At each show, I learned more about my native culture and who I was. We stayed with what we called host families. Families living in the area where we performed would provide us with a place to sleep and a meal or two while we were in their homes for the day. Two people were usually assigned to stay with a family. Sometimes there would be four, six, or eight people at one home. It provided us the chance to stay with different members of the group and get to know one another.

When we traveled to North and South Dakota, we encountered a group called AIM. It was the American Indian Movement. We had discussions with them about what we were doing and what they were doing. They were a radical Native American group trying to bring light to the injustices of Native Americans across the country. We were blessed to have performed in that area before there were problems and shootings with the FBI. They were telling the world that it was time to change the vision for the Native Americans. It wasn't fair, and something needed to be done. They were demonstrating, had guns, and were making demands. We were sharing with the world our culture through song and dance anywhere people would watch or listen. We would parade through towns in our Native Regalia, sing and dance

at parks, on boat trips, and anywhere we found the chance. Janie would never let us hide what we were doing.

At the end of each show, a microphone would be passed to each person in the group so they could identify their Native ancestry. Then a microphone was given to a person that the director, Janie Thompson, had assigned to share their thoughts and testimony with the crowd. The experience helped me really bolstered a love for my Native culture. The other performers were just like me. They, too, had at some time felt lost, alone, or out of place. They shared with me and others how they had come to learn to proudly share their culture and heritage. Each person shared their own perspective on how the group was changing, helping them. The stories were all similar, and I was becoming acquainted with each person from a safe distance. Singing, dancing, speaking, and traveling together brought us together like a family. We weren't really family, but it felt like it. We were becoming good friends, but more than friends.

Chapter 35: Going Home

It was the summer of 1972. It was baseball season once again, but for the first time in many years, I wasn't playing baseball. I would have been playing American Legion baseball if I had been back in Alaska. I had forgotten all about baseball for the past several weeks. Our group took a brief rest at a park. We had been traveling for many hours and on the road for a long time. It was decided that we would take a needed rest. We found a park and decided to have a picnic and just relax. Then somebody suggested that we should have a softball game. Everyone cheered, and we all gathered to play softball. We played basketball now and then in some of the gyms that we performed in. There were a few of us that were pretty competitive, but there were only a few really good athletes in the group. We'd pick teams and play for twenty or thirty minutes. We hadn't yet played softball, baseball, or even played catch. Only a few people in the group had gloves, and the others didn't have one. Nobody told me to bring a ball, bat, or glove on tour. It was the guys and girls, coed; everybody was playing. Teams were organized, and I was that unknown kid in the group all over again. It wasn't the same as all the other times when I had played baseball. We were just having fun. It didn't matter who could play and who couldn't; we were just relaxing. I was assigned to go play in the outfield but I didn't have a glove, but I was still able to catch a softball that was hit to

me with my bare hands. When we had gotten three outs, it became our turn to bat, then the same thing happened the next inning. We didn't even keep score. Each team scored a few runs. After a couple of innings, it was our turn to hit again.

Then somebody yelled, "Terry, you're up."

One of the guys playing in the outfield yelled, "He can't hit; he's only 16!"

They liked to tease me about my age after they found out how old I was. When the underhand pitch was thrown, I hit the ball with all my might, and it went over the left fielder's head. I easily trotted around the bases for a homerun. Some of the members were oohing and awing, and others were laughing at the other team for making fun of me. My life had taken a 180-degree turn; I had grown up wanting to play professional baseball but never tried out for another baseball team after meeting Janie Thompson. I was now casually playing a game of coed softball instead.

Not only did I sing and dance now, but I was part of the band too. The band played most of our music for the group. We had a lead guitarist, Carnes, a drummer, Dave, and a bass player, Joe. I was the rhythm guitar player, and Janie was the piano player and conductor. Occasionally we would have extra time after a show, and we would leave the band equipment set up. If there were several young people in the

audience, we would invite them to stay and participate in a dance with us. Our band would play for the dance. There were several women that would sing for our group as well, including Ima, Jessica, Martha, and Mickey. We weren't the best, but we were decent at the songs we knew and played. I never thought I would be in a band. I was grateful I had learned to play the guitar as a young man. Maybe it was meant to be. After the tour was over, I was able to help make an album by singing and playing the guitar. The proceeds went towards helping the group raise money for future touring. I had never guessed that from learning to play the guitar so many years earlier that I would get that opportunity.

We went to various parts of Canada. There were some destinations that would take us a day and a night of travel on the bus to get to. We slept up in the suitcase rafters or on the seats, sprawled out on the floor. We became more like family during those long trips. The ladies in the group would practice their curler placement on my hair. Some of the guys would let them practice putting their makeup on them as well. Traveling with a big group in a confined area necessitated that we stay busy. We would hold church services and hold our own firesides. We would talk about improvements that we needed to make. We would practice our singing and music on the bus. One day they asked the band to come to the front of the bus and perform the number, The Mountains Cry Out. All of our instruments were

315

underneath the bus. There was a microphone at the front of the bus so that everyone could hear. Dave, the drummer, began with the beat of boom boom chick, boom boom chick. I came in next with bumble bum bum bum bum bumble bum bum bum bumble bum. Joe Natsyway followed with deep bass sounding, bom bom bom, bom bom, bom bom bom bom bom. Then Carnes Burson began playing his intro, da da da da da, da da da da, with a vibrato in this voice. Ima Naranjo and Mickey Mitchel then chimed in with Carnes, myself, and Joe as we sang in harmony, "The Mountains Cry Out, where have they gone? The Prairies cry out, where have they gone? I know, do you? Then some yelled from the back of the bus,

"I see the prairies right out the window; just look!"

The whole bus began laughing and then applauded us for our rendition of the song. The farthest north we went was a place called the Blood Reserve. In Canada, they don't use the word reservation; they call it a reserve. In America, we call the Natives groups tribes, and they call them bands. We arrived at the Blood Reserve and began advertising around the area. The Blood Reserve was next to a town, much like Marysville was next to Tulalip. We set up to do our show in their new hockey rink. It had just been completed; it had a tin roof. Next, we all changed into various modern costumes and regalia from the show parading around the adjacent town for a couple of hours. We placed advertisement cards

everywhere in town and told as many people as we could about the show that night. We prepared for the show and had just about everything set up, with our dressing rooms on the outside of the building. We would have to travel between the building and the outside changing rooms. As we prepared to begin the show, we all noticed that there were huge storm clouds gathering right above the arena. We could see the headlights of the cars as they were lined up from the adjacent town and the reserve. It began to rain. Then it began to pour, and the sound of the rain hitting the tin roof made it almost impossible to communicate with one another. We noticed from all the car's headlights in the distance that people were turning around. Janie called the group together and said we needed to pray. She called for the entire group to gather. The group knelt in prayer. We prayed for the rain to cease and that all who wanted to see our show would be able to. In unison, we all said, "Amen!" and then Janie told everyone to get ready. My dressing room was on the bus. As I left the building, I walked to the bus to make sure I had everything ready and in place for our show. We had several costumes and regalia throughout the program and had to have everything arranged in a certain order. I slowly came to a stop as I gazed at the sky. In a circular manner, the clouds were disappearing. I watched as the circle continued to grow larger by the second. I could see from where I was standing the line of cars returning their drive towards the Reserve. I

was watching a miracle right before my eyes. For many years I have continued to meet people from that particular performance, even to the year 2020. While talking with another hoop dancer, I asked him where he was from. He said he was from a small reserve in Canada called the Blood Reserve. I told him that I had been to his reservation and related the previous story to him. He told me that he had attended that performance. He participated in Native Dancing because of that particular show. He thanked me for being there and honored me with an honor song right then and there. Not only was I learning about my Native culture, but my faith in God continued to grow and develop. I was surrounded by many good religious people who were helping, lifting me and I could feel the light inside of me growing daily. There were many other miracles that I witnessed during that tour that built my faith in God.

We were coming to the end of the tour. We had traveled around half of the country to so many places I had never dreamed about. The director announced that we would be going to Washington State next. I asked where. She said we would be going to the tri-cities area and then to the coast. We stayed in the tri-cities area for a couple of days, and a day of relaxation had been scheduled in our itinerary. The hosts took us out to the Columbia River for boating and water skiing. Everybody was excited to go and have a play day. I had never really done much boating and had never skied.

There were only a handful of people that wanted to ski. Most of the others wanted to sit by the waterside and swim. When they took us out, they asked me if I wanted to ski. I told them I had never skied and would rather watch someone first. I watched a few others ski, and after watching them, I told them I thought I could do it. I jumped out into the moving water of the Columbia River, and they tossed me the skis. Everything was moving together in unison down the river. I struggled to get the skis on my feet, but after a few minutes, I had them on. The boat moved ahead of me, and they told me to give them a signal when I was ready. I gave the signal, and the boat took off. I slowly began to rise up out of the water, and before I knew it, I was water skiing. It was my first time, and I had gotten up. We would next be going to the coast to a place called Mount Vernon. I had participated in a tournament in Mount Vernon, so I knew where it was.

Then I said, "I know where that is!"

We were also going to La Conner, a reservation that was north of the Tulalip reservation. It was one of the teams that I had played against when I played sports with Native teams. We stopped in La Conner and danced on the field for the people participating in a Native men's and women's baseball/softball tournament. It was weird that I was back home. I wasn't there to play ball for once; I was there to share my native culture. Janie asked everyone to get in their pink opener costumes. It felt weird to me to go out and do a

319

modern dance on a baseball field in my pink opener. Janie liked pink because she thought it brought out the dark color or our skin and hair. I didn't mind wearing it for a show, as a costume, but I wasn't too excited to wear pink out on the softball field. After she announced the show lineup, she asked me,

"Terry, what do you think of this lineup?"

I said, "I don't think it's right."

She asked, "What should we do then?

I answered, "I don't know."

She replied, "Then don't say anything." We didn't have any dressing rooms to change in; we'd have to change on the bus. Janie came back on the bus and announced a different lineup.

She asked me again, "Terry, you're from here. What do you think?"

I answered, "I don't think it's right."

She said, "Then what should we do?"

I answered, "I don't know."

She replied again with a little anger in her voice, "then don't say anything."

She went outside and continued to have people prepare to go out and perform.

She came back in and said, "Here's the new lineup. We'll do Cherokee nation; the girls will do Go My Son, and then the hoop Dance."

She came to me again and asked, "Terry, how's that sound?"

I answered, "Sounds good to me."

She announced to the group that I thought it was a good idea and that's what we'd be doing. After we finished, we drove to Mt. Vernon, which was only half an hour away. We arrived and began setting up for the evening show. I had been looking forward to performing there. I called Mom earlier in the week and told her that we were doing a show there. She said she had already heard about it and bought tickets so, she would be there with the family. We arrived early at each venue to prepare our modern costumes and native regalia. We also had a sound system that we would set up for each show, along with lighting and other props. I walked around the building and found a plaque with my name on it. It was for winning the mile run the year before. I had played basketball in that building many times.

One of the girls in the group said, "I just saw your sister."

I said, "My sister is here?"

It was my sister Cherie, who had married and moved to Pennsylvania with her husband years earlier. She had just moved back to Tulalip.

I said, "How did you know it was my sister?"

She said, "She looks just like you."

I was surprised because I had not seen her for about five years. Now I knew that my family was there, including my older sister.

We performed for the audience, and it was a great show. It was almost over; the cast had all been introduced to the crowd. When I said I was a Yakama/Tulalip from Tulalip, Washington, the crowd went wild with cheers. It felt so good. Before the program, the director had asked me to bear my testimony of God to the audience at the end of the show that night. I was usually in the back row. I walked slowly from the back row to the front of the stage. I took the microphone and looked out at the audience; I looked down on the front row, and there was my mother, my sister, and my family all sitting together. I looked around again at the crowd and then looked down at my mother. I could see Her eyes were filled with tears, and she was wiping them away with a Kleenex. I stood there on stage in my Native American Regalia. I was wearing a nice roach on the top of my head, a rocker, with two feathers hanging down along my face. I had a headband that had the letters L G to identify

that the regalia belonged to the Lamanite Generation. Beadwork draped across my shoulders that flowed down beyond my waist. I was wearing two sets of bustles, and feathers, one on the top of my back and another around my waist. The tips of the feathers on the bustles had yellow plums or small feathers. In the middle of the bustles there were mirrors used as ornament. I was wearing Angora, sheepskin, or goat hair leggings with bells tied just above my calves. I had painted lines on my face like war paint. I was wearing a red breach cloth and matching top over my ribbon shirt with gold-yellow fringe all around. I was holding a few things in my hands as well. I stood before the crowd, and they waited and listened for me to speak. I was a Native. That's what they could see. It was the regalia that Mom had always wanted to see me in. I tried to speak but wasn't able to get any words out for a few seconds. With trembling in my voice, I began speaking about how my Mother was a Native American and had brought me up to bear witness of God in all that I did. How proud She was of me representing Her religiously, and through my heritage on stage that night. She had wanted me for so long to learn about our Native culture. I could barely speak. Something so deep and spiritual was happening to me as I stood there on stage. The small light that began growing in me a year ago had grown and was now burning brightly inside of me. It was only a year earlier when I had watched this group perform near

323

Seattle. By now, the entire audience and almost every member of the cast were crying with me. I had found something that I had been looking for. I had found a light within that had changed my life, changed my perception, and changed my attitude. I had learned that I wasn't better than anyone else; I wasn't any worse than anyone else; I had found that I was equal to any other person; it's just who I was. Yes, I was a Native American, and I was proud of it.

Chapter 36: The Truth

After the show we took pictures, cried and laughed. The members of the group began packing up and putting all of our equipment on the bus for the trip tomorrow. We enjoyed each other's company. Then I introduced Janie to Mom and the family. Members of the group gathered around to find out who my family was. Many wanted to meet my mom. I continued to introduce my family to members of the group. Mom was especially happy to have me with so many other Natives from around the country. Mom thanked Janie for helping me to find my way. Janie was not Native, but she had helped me to find my roots. She had given me the things that my mother tried to share but wasn't able to provide. Janie thanked mom for sending me to her when she needed me. That night I asked Janie if I could stay with my parents at home on the Tulalip reservation, even though it was 35 minutes away from Mount Vernon. We had a timetable to keep, we would be going to Vancouver, Canada, the next day, and everyone needed to be ready for the boat trip and be on time. I promised, we promised that I would be there and be on time. I remember thinking that I had found my answer. I finally knew who I was. I was back on the reservation, and it felt like I belonged. I felt proud and knew that my mother was proud of who I had become. I don't know how she knew I would need a white pair of jeans, but I was grateful for it. That night Mom shared with me some

information that I wasn't aware of. Many years earlier, when Mom and Dad visited the Yakima and Tulalip reservation for the first time, her Dad Wilbure gave her something very special. It was a letter and a picture.

From a letter typed by Wilbure that he sent Mom, this was his reply.

It's a letter that I have to this day.

He had typed the following information in the following format.

November 27

mrs. H. C. Goedel

my dear daughter, I have you most welcome letter which ididn't e xpeted to hear, I am very glad to hear that you folks very well . and i am very proud of mr goedel he is doeing his duedy, Government service,I have notice articl here provides that truely reads as follows. # ,, parents and guardians to the custody of thier minor children and wards. You see ther for i am proud of mr. Goedel serving as. Navy

I am going to enclosesame picturs . Which it was taken one picture at Washington D.C. last march12,1954 that when i was there last spring as Delegat for theYakima tribe As with three others YOUsee I am wayup in business for the tribe nowdays. Which In never I thought id ever be one Leader of

such a big tribe amounts to over 4000 indians in yakima Reservation.

Sincerely Yours, truely FATHER ANSWER SOON PLACE

WILBUR E. MENINICK

As she shared the letter with me, tears began to fill up my eyes, and my throat began to hurt. Then she took out the picture of her Dad as chief of the Yakama Indian Nation that he had described. He stood wearing his Chief Regalia along with three other chiefs meeting at a conference in Washington, D.C. Her Dad, my grandfather, had identified her as his infant daughter. The letter and picture identified her as the daughter of a Yakama Indian Chief. I found that my grandfather was a Yakama Indian Chief. We hugged, and the tears flowed. We had both found something that we had been looking for, for so many years.

Mom had endured the hardship years of boarding school that she had tried to conceal, hide, or repress from her Native Heritage and Language. She had found a way to keep the language, the history, and the meaning of what her family had preserved over the many years. What had been held quietly but closely to her heart for many years had found a way to be displayed and expressed. That night I was there to share it with her. She had endured so many difficulties in her lifetime. She told us how she would have to break the ice on

the river during the winter to wash or take a bath. She shared stories about how drunks from town would raid the reservation to molest the Natives, and she would have to go hide in the swamps or the woods. Natives didn't have rights like white people when she was a young girl. There were different bathrooms, and she had to ride different buses because of her ethnicity. Diseases were brought by the white man that the natives hadn't become immune to. There was more sickness and death because of what the white society brought to them. They sent the children to boarding schools and hospitals. Many lost their native language, had to cut their hair and removed their cultural dress. The natives were placed on reservations and promised that the government would provide all their needs. They were introduced to alcohol and other drugs that made their life difficult, and she had conquered it. She wanted to make sure I had a chance to conquer it as well. She had endured the mistreatment of many things in her lifetime. She had fought for her rights over the years in every city she had lived in. It was like beginning over at every port that she had lived in. I had helped her and helped myself to see the beauty, the light, and the Love of our Native Heritage. We weren't better, nor were we less than any other group, but we were equal to all others anywhere on the planet. Yes, we were Native Americans, and we would continue to let the world know that we were proud of it.

Chapter 37: What Comes Around Goes Around

We finished the tour that spring/summer, and I returned to school for the summer term. When I got back, I had to retake all the classes that I had signed up for in the spring during the summer session of school. I still had to go through the process all over again and stand in lines to get my classes. They would give us computerized cards with holes in them to register for the class. I got the classes that I needed and began the semester. I had made so many friends while performing, and now the campus didn't seem as big. I could see somebody I knew here or there. We often greeted each other with enthusiasm and usually with a hug or a hand shake as well. That's when I really began to attend college, even though I had first started a couple of months earlier. I attended classes every day and began to find out what college life was like. I had been touring for eight weeks and hadn't studied once. It was time to hit the books. With so many students in each class, it was hard to get to know anybody. The same people sat in the front row every day, but the rest of the students changed seats almost daily. The professors didn't really care who came to class and who didn't. They didn't take roll; they only passed students according to how well they did on their tests. If I came late

or not at all, the professors really didn't care. Occasionally there would be a group that would meet together to study for a test, but I usually studied independently. I was doing well in my math class because I was familiar with what was being taught. Even though the class seemed to be going at a super-fast, accelerated rate. The Sociology class was a small class with only about 30 students. It was much easier to learn for me in that setting.

I now realized that I was a Native living in a non-native world. I was okay with it now. I was different; I was unique. I enjoyed having long brown hair and dark skin. I had friends that were both Native and non-Native; they were all good. I was good with them, and they were good with me. The daily routine of school, homework, and other activities made the short term go by fast.

After I finished the semester, I went home for a couple of weeks and enjoyed life with my family. I had grown up a little and began to appreciate my family for who they were. I played softball on a local church team. I wasn't trying to win a division or state title any longer. I was only trying to be the best at whatever I was doing. I didn't have to compete for a title, but I still hated losing at anything. There wasn't time to get a job; I would only be home for a couple of weeks. I just tried to relax.

Mom and Dad took me to the bus depot in Everett, Washington. The drive from home to school was about a twenty-hour drive. After I got on the bus, I was ready to return quickly to school. After driving for only about twenty minutes, the bus made a stop near Lynwood, and a few people boarded and exited the bus. After fifteen or twenty minutes, the bus made another stop in North Seattle, and the same thing happened. This continued to happen all the way back to Provo, Utah. It was a thirty-six-hour bus ride, and by the time I returned, I was exhausted. My parents never told me that I'd be stopping continuously on the trip, but it was much cheaper. I've never taken another Greyhound bus trip anywhere.

I enjoyed going back to the fall semester. I called my sister to come and pick me up at the bus station. The University had tried to include more Natives at the school. At the time, there were approximately 22,000 students attending. They were trying to have 500 Native students. There probably never were 500, probably more like 450 Native American students. Ten percent would be 2,200; one percent would be 220 students. That would make about only two percent of the students being Native. They organized smaller classes for the Natives to attend. In some of the regular classes, there could be 1,000 students or more. In our classes, there were only about 35-40 students in each class. I began meeting Natives from all around the country. I hadn't

realized there were so many different tribes across the county and Canada. I met Shoshone, Blackfoot, Blackfeet, Crow, Creek, Cree, Choctaw, Comanche, Cherokee, Cheyenne, Shawnee, Navajo, Hopi, Pueblo, Ute, Paiute, Iroquois, Mohawk, Modoc, Oneida, Seneca, Seminole, Apache, Lumbee, Lumee, Lakota Sioux, Arikara, Hidatsa, Mandan, Grovon, Ho-Chunk, Sac, and Fox and the list continued. Many had accents depending upon where they were from too. The Navajos, Cherokees, and Lumbees had the most distinctive accents. As I began to know them better, they would teach me words in their different languages. I learned more Navajo than any other language because there were more Navajos attending than any other group. I didn't meet someone from every tribe, but I did meet Native students from all around the country. There are over 570 Native tribes across America. We had been gathered, and the stories were all similar. We were each trying to break the negative stigmatism that Native Americans didn't go to college or graduate. Many were the first ones in their families to attend college.

I attended school dances and participated in intramurals, which was like a new awesome world for me. Somebody who was Native invited me to attend what was called an Arizona Stomp dance. It was basically dancing to western music. I didn't really care for western music, but there were a lot of crossover songs at the time. They would play songs

that I considered rock and roll, but others considered western music. The Arizona Stomp was a partner's dance. They would dance around with steps that seemed to me, like a two-step. The actual rhythm would be step, hop, step, hop, step, step. When I arrived to my first dance, a Native girl asked me if I knew how to do the Arizona Stomp. I told her that I had never done it but was willing to try. I watched for a minute and said, "I think it goes like this." Away from the main dance floor, she showed me the basic step, and then we began dancing all around the floor. The group as a whole would dance around in a big circle. Then dancers would incorporate different partner moves. I watched, and within a few minutes, I was stomping around the dance floor with my partner. After a few girls saw that I could dance, I had partners for the rest of the night. It was pretty basic to me, and I was having a good time.

During the semester, I would be living in the Helaman Halls dorms for the semester. There was a basketball court right outside my room. I would be on the first floor this time, and I wouldn't have to wait for an elevator. I brought a few more things from home to display in my dorm room. Pictures of home, family, and memories of living in Washington. In my senior year at Marysville, I lettered in baseball and pinned the big letter "M" on the corkboard at my desk. I had my guitar sitting in the corner of the room and now had a sound system in there too. It wasn't big but It included a

record player, a radio, and a cassette player. It didn't get any better than that. I could listen to my music anytime I wanted as long as it didn't bother my roommate. I could go out and play basketball every day if I wanted to. I pretty much did till it got too cold, and then I learned about everybody playing pickup basketball in Richard's building. There were still three meals a day at the Cannon Center too.

I began to make friends in the dorms, but my time became more focused on tryouts for the Lamanite Generation, which were in a couple of weeks. When we got together as a group, it was wonderful, but not the same. A few students from the group had graduated, a few got married, and a few went here and there, but we had the majority of our group back together again. I was now 17 years old, and I was one of the old guys. Everyone else was still older than me, but I wasn't so timid anymore. I had gained the confidence that I had been missing before. I was assigned the same routines I had performed the year before and given a few additional numbers, and I was still the rhythm guitarist for the band. I was also included in singing different parts in various numbers. I had to sing one song with a girl named Mary Ann Gambler. I would walk out singing the song with her, and we would meet in the middle of the stage. She would begin, and I would sing harmony during the chorus. That's when I'd walk out and meet her in the middle of the stage. There were others singing in the

background as well. Janie taught me my part and had me practice it over and over. After I knew the words and how to harmonize them, I really enjoyed it. I didn't know that I could sing. Janie had a way of pulling out of each of the performers in the group every ounce of talent they possessed. Most of the other performers didn't have any experience on stage either. Many had participated in pow-wow dancing at most. There was a fall program called the Fieldhouse Frolics. All the performing groups from the University would perform a number. Janie chose that number for us to perform. It was fine until I broke my ankle playing basketball. They put a walking cast on me. I asked Janie if she still wanted me to participate. She said she did. On the night of the performance, I limped out on stage with my walking cast. It wasn't for the whole song, I only sang the short harmony part with her during the first chorus.

The group began making an album In the fall and I was honored to be able to go in and learn about studios. As the individuals in the group were given different assignments there was still one thing left that I needed to do. The director assigned one of the new members of the group the one thing that I wanted. He grew up as a fancy war dancer on his reservation and she thought he would be able to do exactly what she needed. In the fall and winter semesters we went on short tours which helped us prepare for the following summer tour. It was right before the fall tour and we were

having a full rehearsal for the show. It was going well until it came to the Native American Hoop Dance.

Then Janie said,

"I need the hoop dancers to show us their number."

Then the individuals that she had chosen prepared to dance. One dancer, the one she had chosen, hung his head and said,

"I can't do it."

Janie said,

"Just show us what you've been practicing."

He said,

"I can't do it," and he took his set of hoops and laid them on the floor.

She went over and picked up the hoops and said,

"I can't just go and get a new hoop dancer just anywhere."

I gingerly raised my hand and quietly said,

"I'll do it."

The director continued by saying she couldn't find a hoop dancer just anywhere.

Then I raised my hand and said, in a louder voice,

"I'll do it."

She lifted the hoops and said,

"Is there anyone that wants to hoop dance?"

Then I raised my hand as I stood and said with a loud voice,

"I'll do it."

Janie quickly walked to me and handed me the twenty-one hoops, and said,

"Here, you have five days to learn the hoop dance routine."

I grabbed them and held them tight, not really knowing what to do. Then one of the other hoop dancers, Tony McCabe, said, "I'll teach you."

We began immediately, and it was like I couldn't learn the routine fast enough. I had five days to learn the hoop dance routine. It was the one thing that I wanted to do. I practiced day and night for five days. The material we used for our hoops was ratan, which came from Vietnam. It was the best material that could be used. They needed to be soaked in water so the cane wouldn't be brittle. Years ago, Natives made hoops out of willow branches, but we didn't have willow. I began practicing in the common dorm showers and would wear a pair of shorts that I didn't mind

getting wet. I'd turn the showers on and let the hoops soak in the water they needed. Every now and then, someone would come in during the middle of the day to use the shower, and I'd be in there with my hoops. We were usually both surprised, and I'd usually gather my hoops and go practice in my room for a while.

It came time for our mini-tour, and I was as ready as I could be. I still had to practice and remember all the other dances and songs that I had learned. In between numbers we only had a few seconds to change. I now had a new number to prepare for. I was always worried that I might forget part of a routine or words to a song. Now I had to think about hoop dancing too. I made it through the show without any major mistakes. The hoop dance was the last dance of the program. It was considered the grand finale. I couldn't mess it up. As I placed my hoops on the stage, my mind went back to the day I watched the three hoop dancers for the first time. I was now one of three hoop dancers on the stage, sharing a message with the world. There was Jasper Yazzie, Tony McCabe, and myself. The music began, and I began to dance. I was doing my best to keep up with Tony. He seemed to be able to use the hoops with such grace. There were parts that I knew so well and other parts that I was still struggling with. One dancer would usually lead the routine and the others would follow. It was the same routine, but usually, the quickest one would lead, and it was usually Tony. I began

338

jumping through the first hoop, moving the hoops through and around my body. There weren't any real mistakes, maybe a couple of hiccups but nothing noticeable. We went to the second hoop, and I was doing pretty well. It was almost mathematical to me. I could see where the circles crossed, they were like Venn diagrams that I had used in math. It made it easier for me to remember where to create a space and place my arm or foot. It was like memorizing a math formula. I was holding my own. Sometimes I was even quicker than the other two dancers. As we continued, it began to flow. I was dancing, I wasn't worried. I had prepared and was managing pretty well. We went to four, then five, seven, eight, then eleven hoops. Then we picked up the final ten hoops. I was forming an eagle using the hoops. The audience began to applaud our performance. I could hear cheering from the sides of the stage. The group was encouraging me as they watched. When we finished, I had difficulty taking the final hoops off for a moment, but then I was finally ready. The other two dancers were waiting for me. They were smiling and watching as I finished performing the hoop dance for the first time in my life. The music stopped and we held our hoops up high to the audience. The crowd stood and we received a standing ovation. It wasn't applause just for the hoop dance it was for the entire program. It was a magical moment in my life. I had hit home runs during important baseball games in my

life, and it was similar to that feeling but so much more. There were people in each audience waiting for the moment when either me or another person would come along. I had made it; I was a Native American hoop dancer. After the show, members of the group surrounded me and praised my performance and effort. It wasn't perfect, but for five days of practice, it was pretty good. It had come back to me. I had found the one thing that gave me the confidence I needed, to share my Native Heritage with the world.

I was a Native American Hoop Dancer. I was excited to share the news with my family. At Thanksgiving time, I began looking for a way to get home and share the news with my family. There was a ride-share board at the Wilkinson center. Students would write their name on a three-by-five index card soliciting either for a ride somewhere or for riders to any particular destination for the holidays. There was a huge map of the United States showing regions where individuals needed to go. I continued to monitor the board and finally, the day before Thanksgiving break, I found a ride home. I called the guy and found out that we would be leaving Wednesday night after classes were over. It was the day before thanksgiving. When the driver picked me up at my dorm, there were two young ladies in the car with him that he had already picked up. He said I could go free if I was willing to drive. After I put my suitcase in the trunk and got in the car, he reminded me that I would need to drive. I

agreed that I would be able to drive. Then he asked me if I could drive a stick shift, to which I replied, "yes." I had never driven a stick shift. It was a three in the tree; I would need to be able to shift from the steering column, not from the floor. I told him that I could drive it, even though I had never driven a shift. I was confident that I could drive it because I knew how to shift on a motorcycle. Neither one of the girls knew how to drive a stick shift, so they had to pay additional money for gas. Gas was about .36 cents a gallon at the time, and his car was a gas hog. I sat in the front with him, and the two girls sat in the back. I watched him as he shifted the gears and knew that I would be able to drive the car. He had a big car, but it was pretty packed from everybody taking their things back to Washington. He drove for a few hours and then asked me to drive. He said he was tired and needed to sleep. It was late and dark, we stopped and gassed up, and then I got in the driver's seat and began driving. He assisted me on the route to take and then went to sleep. The girls in the back used the road map to help guide me on the route. Then I looked at the speedometer and saw that it didn't work. The speed limit was pretty much 60 miles an hour the entire way. I didn't want to get a ticket, and so I tried to calculate how fast I was driving by the other drivers. Then I saw a green mileage sign on the side of the road. I looked at the second hand of the clock in the car and watched for the next mileage marker. It took us a minute and two seconds. I told

the girls in the back that we were going a little faster than the speed limit, but we'd be okay. They asked me if the speedometer had begun to work, and I told them I had calculated it in my head. I told them I had watched the mileage marker and we had traveled one mile in 60 seconds, so that would calculate to 60 miles in an hour. They quickly glanced at each other, laughed, and said, "Okay." I continued to drive through most of the night. At one point, I got a little tired, and they asked me if I wanted them to rub my back. I told them that wouldn't help me stay awake; it would make me more sleepy. They stayed up and talked with me for the rest of the night. We talked about our classes, school, home, and our lives. It helped me to stay awake and alert. We were getting low on gas, so I told the owner of the car, and he had us pull over and gas up at about five o' clock in the morning. We switched places, and I went right to sleep in the passenger's seat. A few hours later, the girls woke me up and asked me if I wanted to ride with them. I asked them what they were talking about. During the morning hours, the car had problems, and we pulled over to a gas station. It would have to remain there for a couple of days to get fixed. I asked them where we were, and they said, "We're in Portland." I then asked them who we were riding with. They pointed to a nice car and said that car over there. I agreed that I would go with them. When we got in the car, there were two sailors that had gotten permission to visit home or leave for

Thanksgiving. The girls had talked to them and told them their situation, and so they offered to take them to Seattle. That's where they were headed too. When I got in the car, they asked where I had come from. They told them that I was traveling with them.

The guys said, "You didn't say anything about a guy riding, too."

They agreed to let me go, and off we went. I was still tired, so I leaned my head against the window and fell asleep. A few hours later, the girls were waking me up.

They said, "You need to sit up; the cops are coming."

I questioned, "The cops? What's going on?"

They told me the guys were speeding. The driver was going 100 miles an hour. They said it was the second time they had been pulled over. I slept through the first stop. After the ticket, they proceeded to drive to Seattle. There was an exit by the University of Washington where the girls met their ride. The guys drove to the next freeway-on ramp and stopped.

Then they said, "This is as far as we're taking you."

I got out of the car and took my suitcase, and walked towards the freeway entrance. I put my suitcase down and stuck my thumb out to see if I could get a ride home. The first car that came by offered me a ride to Everett. That was

close enough to Marysville for me. They took me close to downtown Everett, and I got out of the car with my things and thanked them for the ride. I walked a few feet and put my suitcase down and put out my thumb again. A truck pulled up and asked me where I was going. It was a Native guy. I told him that I was going to Tulalip. He told me he was going that way, and I could hop in the back of the truck. I told him that I was the first house on the reservation. When we arrived at our road, he pulled over, and I hopped out of the truck with my things. I thanked him and waved goodbye. I walked to the house, opened the door, and said, "Surprise!" I hadn't told my family I was coming home for Thanksgiving. Mom and Dad were surprised and grateful to have me home. I told them about the events that had occurred for me to get home, and they laughed that I could be so lucky. I shared with them the hoop dance and began teaching my younger brother how to hoop dance over the next few days. I tried my hoops on everyone, my sisters, Cherie, and Lorna, my brother Oscar, nephews Joe and Aaron, and my mom. I tried to put all the hoops on her. There were twenty-one hoops. After I attempted to put on the ten bottom hoops, she said she had done enough. She was getting claustrophobic.

We enjoyed our Thanksgiving feast. We went out to the tribal hall to visit for dinner too. I still didn't know many people, but I felt more at home. Mom began telling everyone that I had learned the hoop dance, and they started

suggesting that I come back home and share with the Native community. I told them I would dance whenever the opportunity presented itself. Everyone was just as excited as I was.

Mom asked me how I was going to get back to BYU. I told her I didn't know what I'd do. Saturday night, I got a call from the owner of the car that I had ridden with. He said he would pick me up Sunday afternoon. I told him that I would be ready to drive again if he needed me to. He told me the two girls had decided to fly back and wouldn't be going back with us. I made it back to school and finished my first full semester at school.

I have pondered the importance of the Native voice available in the world today. I look at the world and see almost every ethnicity represented. You'll find African-Americans, Asians, Latins, Hispanics, German, French, Italians, and the list continues. They're in arts, movies, music, sports, news, politics, and government, and our society is very aware of who they are. Yet think of one Native, modern-day actor, singer, artist, politician, or leader that our society knows as a whole. Most people can't identify one unless they're also Native American. The hoop dance is a joy that has continued in my life for the last fifty-one years. It is considered a healing dance. The Natives call it the Circle of Life. It provides me the opportunity to be a small voice for Natives across the country and around the world. I'm not

speaking for every Native; just sharing my story. We each have our own story and perspective. It healed me when I needed it most. It brought light and hope into my world and gave me the desire to share that light with the Native and non-native alike, from small audiences of only a few people to groups with tens of thousands of people. It is The Light that I found in my Native Heritage! Millions have gone before me, leading the way with that same light. The light is given to every man that comes into this world. It is a part of all things; the earth, the sun, the moon, the stars, the motion of the planets, the plants, and animals. I felt the light when I was a youngster and have experienced it throughout my life. It continues to be the light I share with people from all walks of life. As I share in school assemblies, with natives in workshops, or in performances around the world. It is the dance that I perform but the light is what I try to share with people around the world. When I watched the hoop dance for the first time, I felt that light. The dance opened my heart to provide the light the opportunity to penetrate and be written in my heart. The world wasn't any more unfair to me than it is to any other person. I'm grateful to my mother for teaching me about my Native culture. She lived in a time when the Natives had no voice and very few rights. Her generation bore the brunt of the injustices. We all have our trials and difficulties. I have learned one real truth. We all have to find our own way. It isn't easy. There will be trials,

problems, and difficulties, but there is a light inside of each one of us. When we access that light, it gives us the strength and the hope to move forward. It is one step at a time. Oftentimes those steps we take are in the dark, and we feel all alone. Help is always around the corner, just waiting for the asking. We all have difficulties trying to live life, and I've experienced my share of problems. We all have ups and downs, but sometimes, we need to be able to see or feel the light from others. I dance for those who can't dance and now write for those with no voice, to share that light with them and anyone else who feels alone. The light is what gives us the hope and motivation to push on to greater heights. If you watch the Hoop Dance, it's amazing. If you feel the light from within, it's spiritually moving. This is the light I share with the world. It is The Light From My Native Heritage, the light from the Native American Hoop Dance.

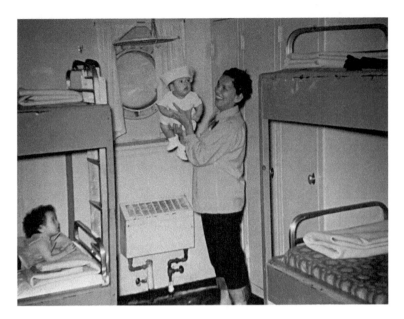

Mom holding me as a baby on a ship

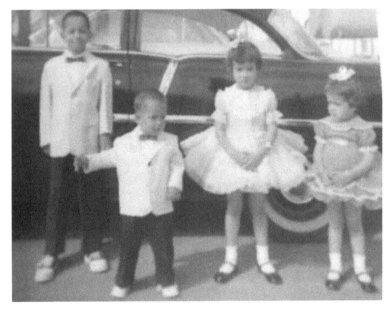

Jerry, Terry, Cherie and Gloria by the 55 Chevy.

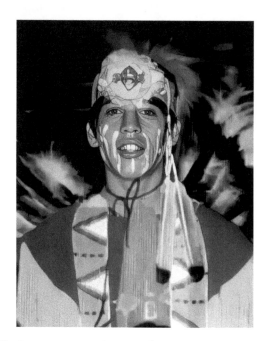

Regalia I was wearing when I spoke on stage before my family

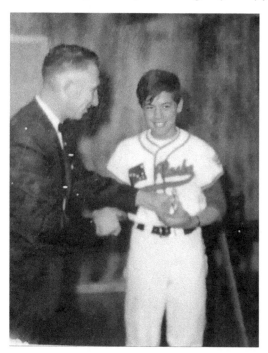

Mr Wilson awarding me my State Championship trophy

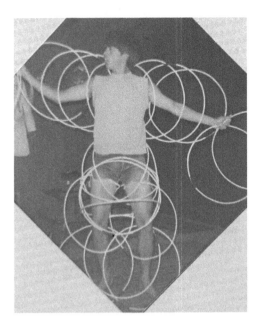

Thanksgiving 1972 at home after I learned to hoop dance.

My everyday outfit in high school, t-shirt, jeans, waffle stompers and a light jacket.

350

My graduation outfit in May of 1972 as a 16 year old graduate.

After our State Championship banquet with the team with Roxy in the middle.

Dance partners, Terry Goedel, Vicki Washburn Tony McCabe and Vicki Bird at Sheridan, Wyoming All-American Indian Days.

Our Sophomore basketball team at Marysville. I'm number 23.

352

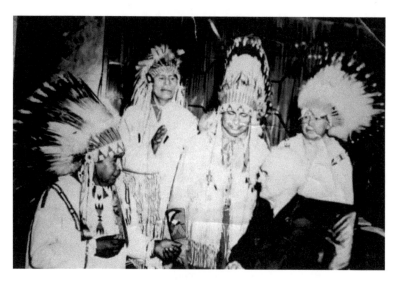

The Yakama chiefs in Washington D.C. with Wilbure Meninick 2nd from the left.

Jerry in his cowboy outfit. We were always the cowboys.

353

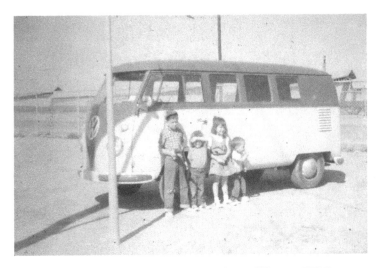

(l to R) Jerry, Gloria, Cherie and myself by our VW Bus.

Me and Mike Stratton receiving our award at Regionals in Vancouver, WA 1968.

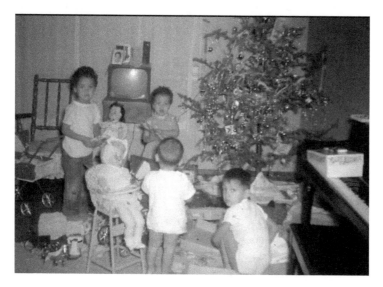

Christmas morning in front of the Christmas tree, (L to R) Cherie, Gloria, myself and Jerry.

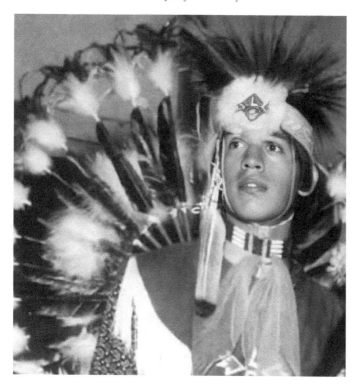

Black and white of me in Lamanite Generation Regalia

Me about the age when I crawled into the refrigerator.

Team picture in Vancouver, WA after with the regional tournament was over

Printed in the USA
CPSIA information can be obtained
at www.ICGtesting.com
LVHW051703030524
779164LV00041B/873